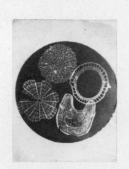

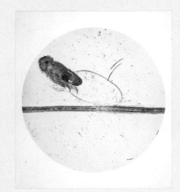

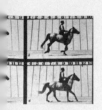

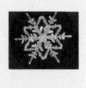

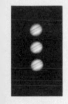

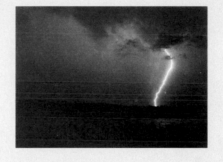
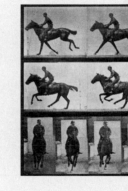
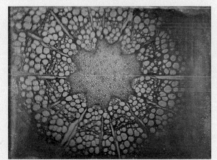

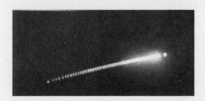
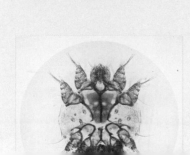

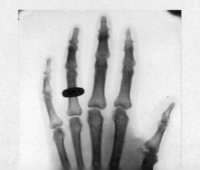

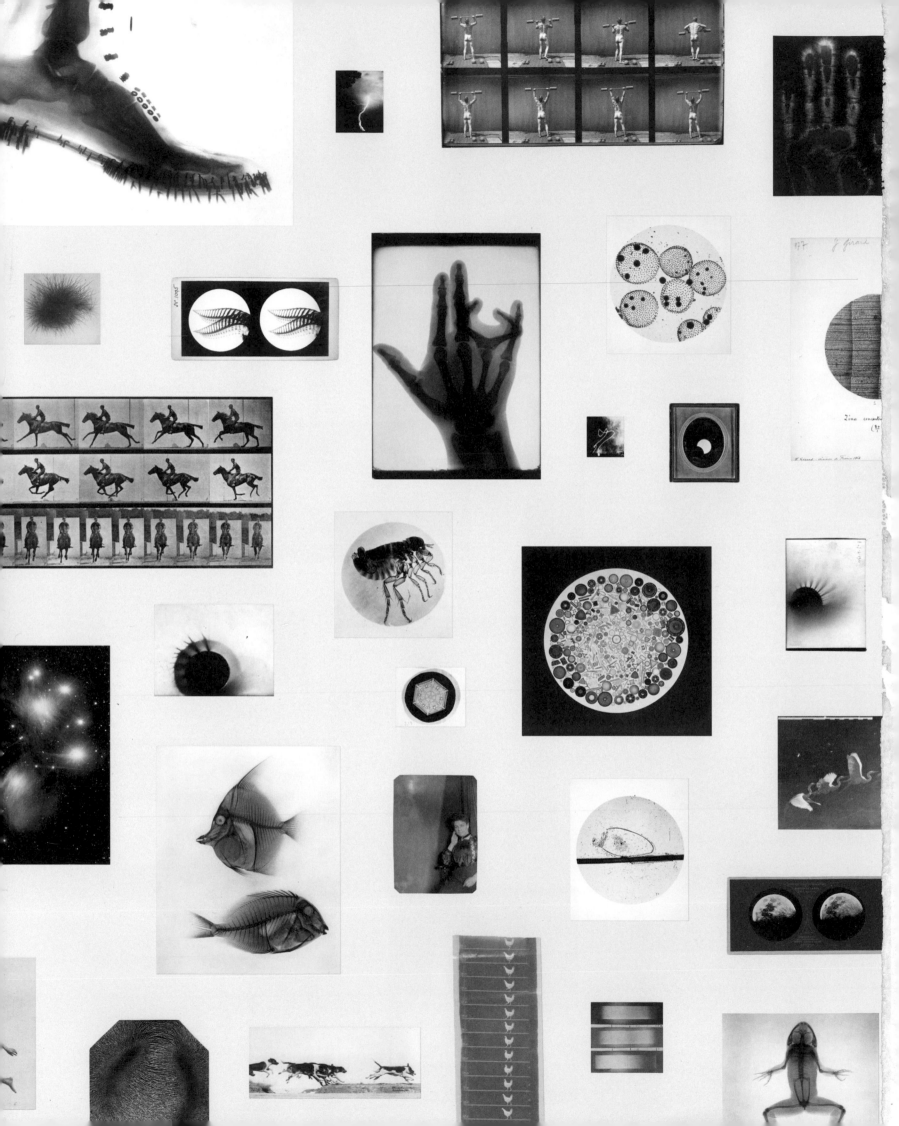

BROUGHT
TO
LIGHT

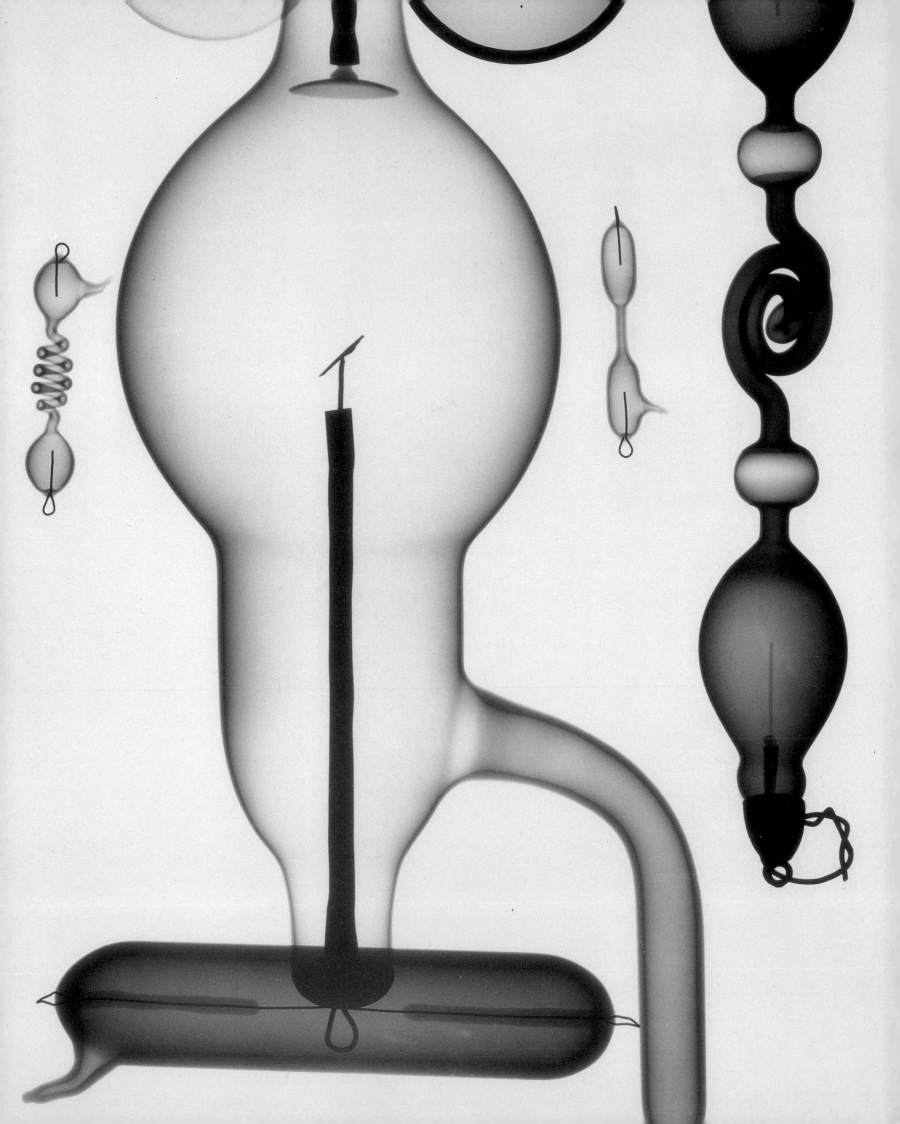

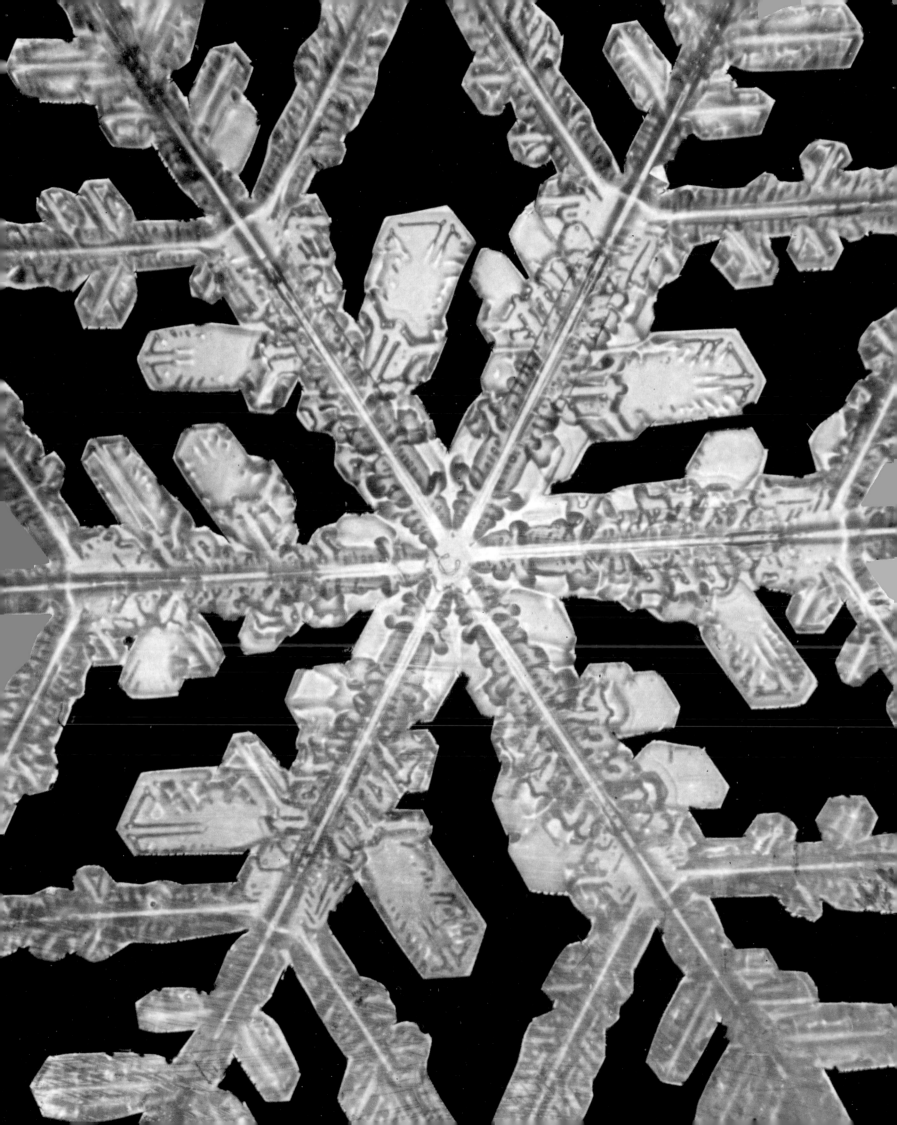

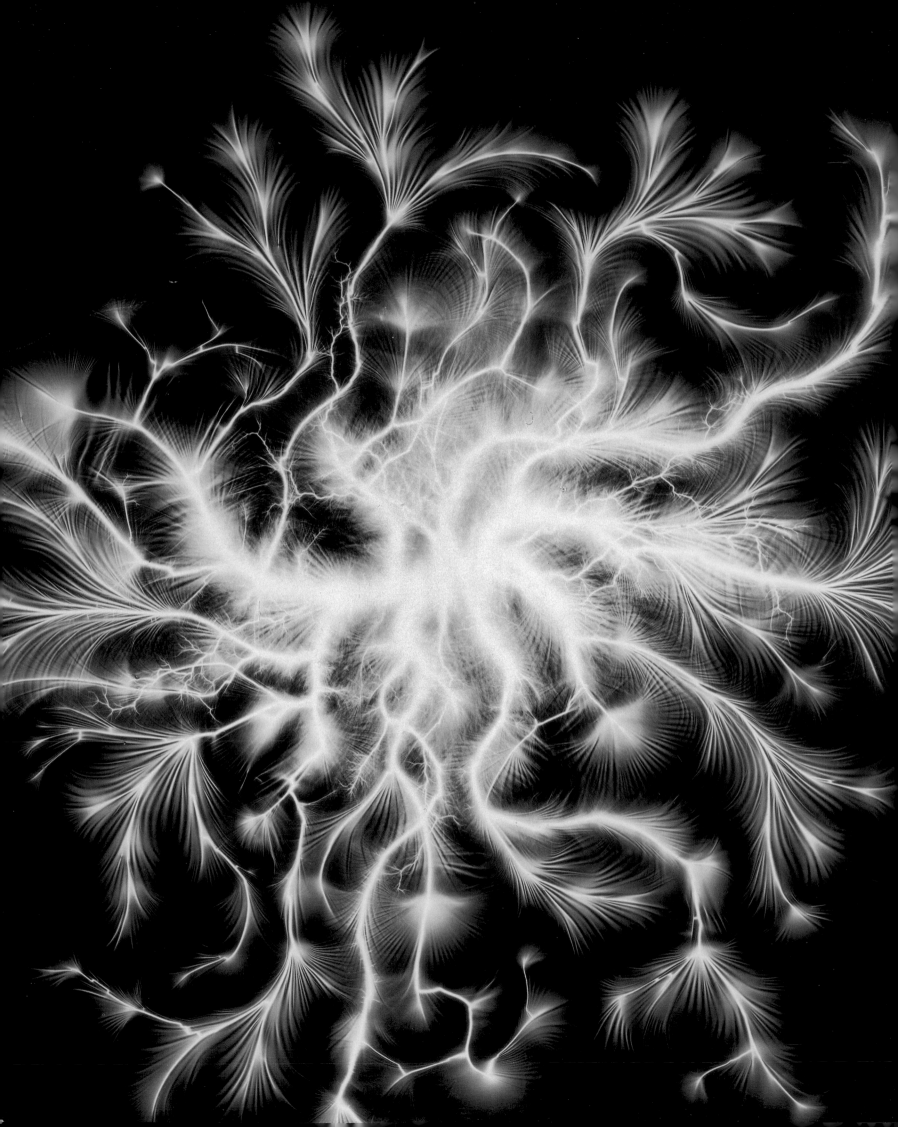

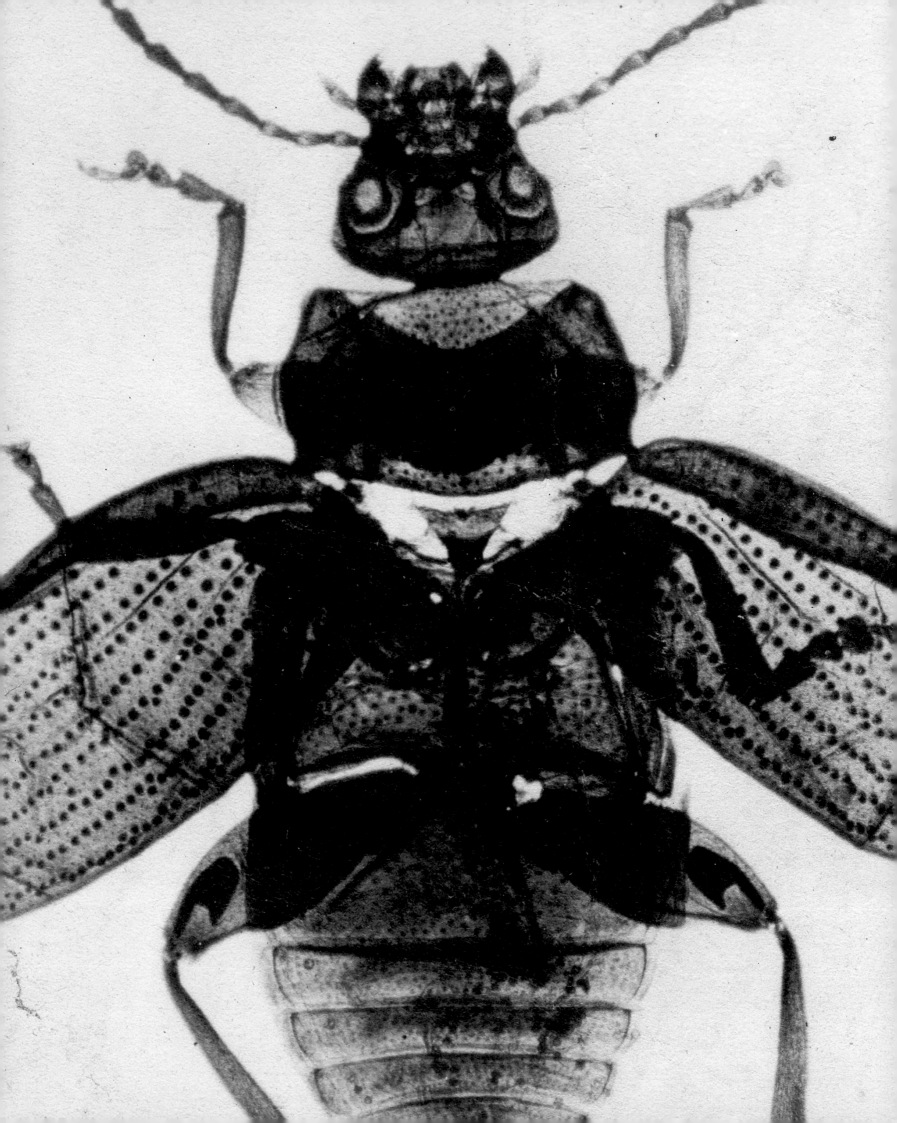

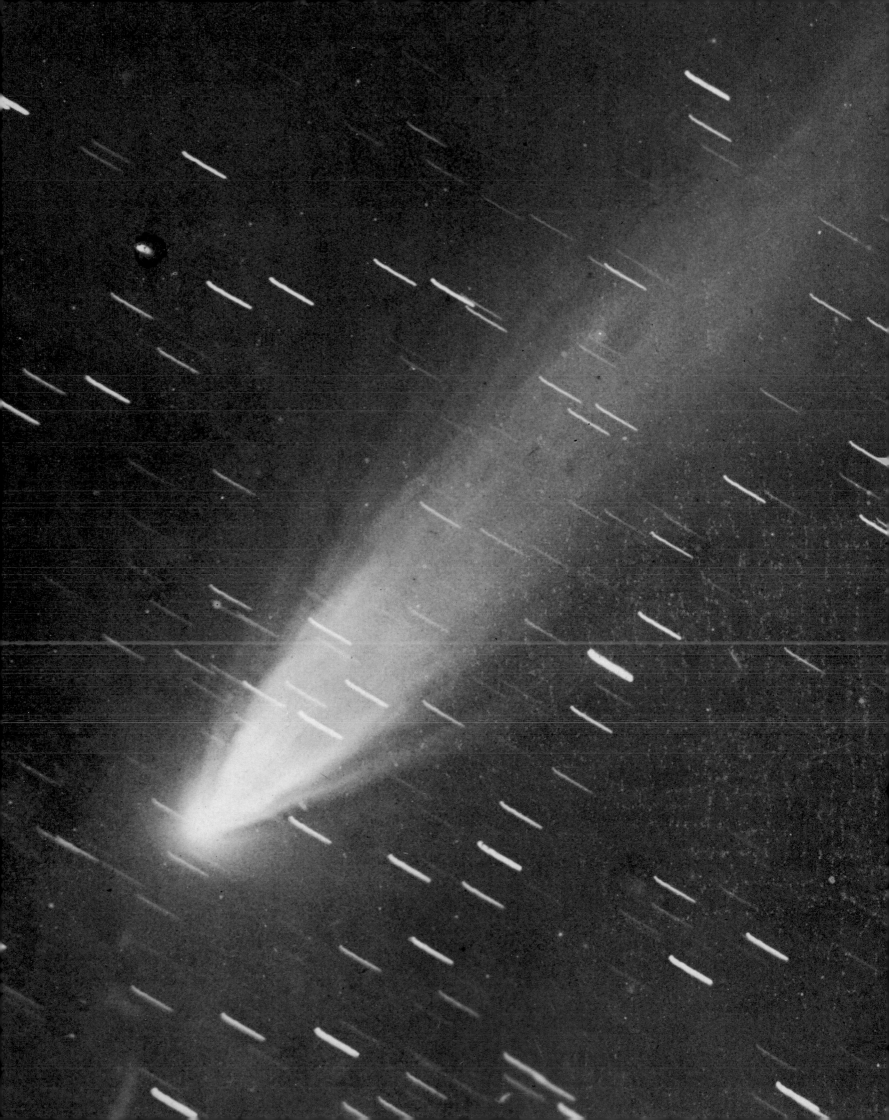

San Francisco Museum of Modern Art

in association with Yale University Press, New Haven and London

Edited by COREY KELLER

With essays by JENNIFER TUCKER

TOM GUNNING

MAREN GRÖNING

BROUGHT TO LIGHT

PHOTOGRAPHY AND THE INVISIBLE 1840–1900

Backman, Jeanne Friscia, and Don Ross kindly assisted with
onsite imaging needs. I would also like to thank Clément Chéroux,
Sarah Cucinelli, Alison Doane, Lynn Gamwell, Paul Hertzmann
and Susan Herzig, Peter Hingley, Kiersten Jakobsen, Alain Paviot,
and Tom Vine for going above and beyond the call of duty in
assisting us in the assembly of illustrations. The entire
Publications team joins me in thanking essayists Tom Gunning,
Jennifer Tucker, and Maren Gröning for enriching the catalogue
with their thoughtful contributions. Marie-Sophie Corcy, Erin
O'Toole, and Carole Troufléau-Sandrin have also graciously
shared their expertise and the book is much better for it.
Our great appreciation, too, goes to Patricia Fidler and her
colleagues at Yale University Press for their enthusiastic
partnership in this project.

Finally, my heartfelt thanks go to Gwen Allen, Frish Brandt,
Leah Dickerman, Wes Mitchell, Gabriela Müller, Liz Siegel, and
Dana Ospina for their continued and unwavering support.
My most profound gratitude is to my parents, whose belief
in me has never waned, and to Craig and Zoë, to whom this
book is dedicated.

COREY KELLER

ESSAYS

SIGHT UNSEEN: PICTURING THE INVISIBLE

Corey Keller

IT IS DIFFICULT TO IMAGINE A HISTORICAL PERIOD RICHER IN SCIENTIFIC DISCOVERIES than the years between 1800 and 1900. Indeed, it would not be much of an overstatement to say that most of what we now consider common scientific knowledge was discovered or proven during this hundred-year span. During this "wonderful century," as the naturalist and evolutionary theorist Alfred Russel Wallace dubbed it in his 1898 survey of the age's achievements, the industrial miracles of the railroad, steamship, bicycle, telegraph, phonograph, sewing machine, typewriter, dynamite, and machine gun (to name but a few) were invented. Anesthesia was introduced into surgery, and the notion was advanced that disease was caused by identifiable microbes rather than by indescribable forces afloat in the air.

At the same time that science and technology promised better transportation, more efficient labor, greater material comfort, and improved health, it also brought about a radical reevaluation of man's place in the universe. Discoveries in astronomy revealed the vastness of the universe and the earth's relative insignificance within it: the human population could be compared to the millions of microorganisms now understood to be teeming in a drop of water (see fig. 18). Many of the new theories advanced in the nineteenth century contradicted deeply held philosophical and religious beliefs. The geologist Charles Lyell's studies of the fossil record in the 1830s, for example, proved that the earth was much older than biblical accounts allowed, while Charles Darwin's *On the Origin of Species,* published in 1859, argued that human evolution was the result of natural selection, not divine intervention. Equally disconcerting was the revelation of forces operating beneath and beyond the threshold of human perception.

Étienne-Jules Marey
**Charvier, test with Prony brake
(twelve kilograms force),** ca. 1894
Detail of pl. 82

Infrared and ultraviolet wavelengths of light were discovered; the speed of light was calculated, as was the rotation of the earth on its axis. By the end of the century the electron, X-rays, and radioactivity had been identified. Although these revolutionary discoveries were novel and exhilarating, they were also fundamentally destabilizing.

It was out of and into this heady scientific moment that photography emerged in 1839. For Wallace, as for many others, photography was among the most noteworthy of the era's scientific achievements. He devoted an entire chapter of *The Wonderful Century* to the new medium, predicting that the timing and magnitude of this invention would be equally recognized by future generations.[1] The flowering of science and the photographic medium over the course of the nineteenth century was not only coincident but also intimately related. Photography, a picture-making medium grounded in both physics and chemistry, shaped scientific practice and knowledge as much as it was shaped by them. From the time of its invention it was imagined as both an object of science (its early practitioners were as interested in chemistry and optics as they were in the quality of their images) and a powerfully modern tool for scientific observation.

Brought to Light looks at a variety of uses of photography in science, from the official announcements of the medium's invention in 1839 to its maturation as an industrialized process by the end of the nineteenth century. More specifically, however, it considers a very particular subset of scientific photographs: those made of phenomena invisible to the naked eye. In so doing it highlights photography's role within a new scientific culture in which seeing and knowing were understood to be inextricably linked—a relationship that grew increasingly complicated in light of rapidly accumulating evidence of the limitations of the human eye and of forces operating below the threshold of perception. It also draws attention to the complex and sometimes contradictory metaphors that were developed over the nineteenth century to make sense of the photographic medium and its unique relationship to truth, nature, and the visible world. Beginning with pictures made through the two key optical devices of early modern science, the microscope and the telescope, and culminating with the discovery of X-rays at the century's close, the exhibition considers what it meant in the nineteenth century to "see" photographically. Equally importantly, it invites viewers to imagine what pictures of the invisible might have meant at a time when the worlds revealed by modern imaging technologies such as scanning electron microscopes, satellite imaging, and PET scans were utterly unimaginable.

It is crucial to point out that neither science nor photography can be considered a fixed or monolithic category during this formative period. In order to fully understand these pictures and the issues that surrounded them, we must not only attempt to recover the vast conceptual distance between ourselves and the nineteenth century, but also acknowledge the important changes that occurred between the early 1800s and its later decades. Over the

1 See Alfred Russel Wallace, The Wonderful Century: Its Successes and Its Failures (New York: Dodd, Mead, and Company, 1898), 39.

course of the century, the ways in which both photography and science were practiced changed dramatically, moving on almost parallel tracks from the elite province of the educated amateur to the arena of the specialized professional. In photography this meant a shift in practice from a highly experimental amalgam of chemical processes to a standardized and professionalized activity whose materials were mass-produced; in science it meant a shift from the studies of polymath gentlemen-scholars to a cluster of increasingly specialized fields organized around professional societies and laboratories.[2]

Significantly, in both cases the push toward professionalization was accompanied by gestures toward the amateur or lay population. In photography this took the form of the Kodak camera. Designed in 1888 to make snapshooters out of millions of ordinary citizens, it brought photography into the everyday experience in an unprecedented way.[3] In science the century witnessed the flourishing of a popular scientific movement intended to make complex ideas accessible to a broad public. Photography played an important role not only in the work of the professional scientist, but also in the crusade to engage general audiences in the debates and discoveries of the day, whether through exhibits in industrial fairs, slide projections during public lectures, or, as printing technologies improved, illustrations in inexpensive books and scientific magazines.

To accommodate these important developments in both photography and science, for the purposes of this exhibition I have very broadly defined a scientific photograph as a picture of a natural phenomenon made with light-sensitive materials for the documentation, illustration, or dissemination of information to a specialized or amateur audience. It is a sweeping definition, to be sure, but one that appropriately suggests the wide range of scientific applications of photography in the nineteenth century as well as the multiplicity of audiences who saw the pictures.

THE SECRETARY AND RECORD KEEPER OF SCIENCE

It should come as little surprise that science ranked high among the applications first proposed for the nascent photographic medium, as so many of its early practitioners were scientists themselves. Photography's potential contributions were seen as twofold: as a mechanical replacement for the draftsman's arduous task of manually transcribing visual observations, and as a corrective for the human tendency toward subjective interpretation.[4] Though the practice of science in the nineteenth century was riven by philosophical and methodological disagreements, its "dizzying diversity," as the historian of nineteenth-century science George Levine has characterized it, was united by a universal "quest for law."[5] One common thread was an increasingly vehement reaction against an eighteenth-century metaphysics founded on the

2. It is interesting to note that in 1834 the philosopher and historian of science William Whewell first used the term scientist, an etymological construction designed to parallel artist and intended in its inclusivity to combat the fractiousness of an increasingly specialized community. See Dennis Danielson, "Scientist's Birthright," Nature 410 (April 26, 2001): 1031.

3. As Jennifer Tucker discusses in her essay in this catalogue, this revolution in amateur photography had important consequences for science, too, by expanding the pool of observers gathering evidence.

4. Lorraine Daston and Peter Galison argue that the suppression of artistic subjectivity through mechanically produced images became a hallmark of scientific atlases in the second half of the nineteenth century. See Daston and Galison, "The Image of Objectivity," Representations 40 (Fall 1992): 81–128.

5. George Levine, "Defining Knowledge: An Introduction," in Victorian Science in Context, ed. Bernard Lightman (Chicago: University of Chicago Press, 1997), 20.

conception of truth as independent of sensory experience. Over the course of the nineteenth century, this worldview was replaced by a scientific culture in which knowledge could be obtained only through empirical observation of the material world, an approach that found its fullest expression in Auguste Comte's philosophy of positivism, published in six volumes between 1830 and 1842 as his *Cours de philosophie positive*. Comte's ideas were broadly disseminated and adapted across Europe; they came to dominate not only scientific practice, but also inflected a wide range of intellectual disciplines, from sociology to literature. "Seeing is believing" may be a hackneyed phrase today, but in the nineteenth century it specifically acknowledged the drive of science to bring the natural world to view, where it could be documented, classified, and ordered. [6] Photography's perceived capacity for the direct and unbiased observation of nature positioned the medium as the ideal positivist tool. [7]

Despite photography's close ties to scientific materialism, as a technology that made pictures it also entered into contemporary discussions surrounding art and the aesthetic theories that governed them. The medium offered a radically new kind of image, one that fundamentally challenged the way pictures were understood to depict nature, present evidence, and communicate visual information—in short, to *represent*. Photography found itself wedged rather uncomfortably between the discourses of art and technology, and its relationship to both was vigorously debated for the better part of the century. For those who felt that the photograph merely replicated nature rather than translating or interpreting it (the job of art), science was photography's *only* appropriate application. Charles Baudelaire's 1859 assessment of the medium's unimaginative fidelity to description is but the most eloquent example of a critique frequently leveled at the time:

> Let photography quickly enrich the traveller's album, and restore to his eyes the precision his memory may lack; let it adorn the library of the naturalist, magnify microscopic insects, even strengthen, with a few facts, the hypotheses of the astronomer; let it, in short, be the secretary and record-keeper of whomsoever needs absolute material accuracy for professional reasons. [8]

The advantages photography offered science, however, were to Baudelaire precisely what disqualified it from being art. Others took a less hard-line view of the medium and viewed the representational status of the photograph in a somewhat more generous light, dubbing it an "art-science" and acknowledging the ambiguity that such a hybrid category connotes. In 1851, at the Great Exhibition of the Works of Industry of All Nations at the Crystal Palace in London, the jury recognized the difficulty of neatly categorizing photography, writing in its summary:

6. Michel Foucault's **Birth of the Clinic: An Archaeology of Medical Perception**, trans. A. M. Sheridan (London: Tavistock, 1973), foregrounds the link between vision (the gaze) and knowledge in nineteenth-century scientific discourse. Kate Flint, in her study of Victorian visual culture, argues that scientific discourse "provided an endless source of comments filtering into popular culture about how the invisible could be brought to view, and how knowledge and control over the natural world could thus be obtained." Flint, **The Victorians and the Visual Imagination** (Cambridge: Cambridge University Press, 2000), 8.

7. Carol Armstrong, in **Scenes in a Library: Reading the Photograph in the Book, 1843–1875** (Cambridge, MA: MIT Press, 1998), gives a far more complex analysis of the relationship of photography and positivism, particularly its manifestations in England, than can be attempted here.

8. Charles Baudelaire, "The Modern Public and Photography" (1859), in **Classic Essays on Photography**, ed. Alan Trachtenberg (New Haven, CT: Leete's Island Books, 1980), 88.

"It holds a place at present intermediate between art and science, a position eminently favorable to development in either direction."[9]

The genre of scientific photography thus affords an excellent vantage point from which to consider more generally photography's unique position at the nexus of technology, science, and art in the nineteenth century. The scientists who used photography counted on its mechanical origins and aura of objectivity to lend credence to their claims and to communicate their ideas to colleagues. But these photographs also circulated outside the laboratory and observatory, where their meaning was expanded beyond their evidentiary function and they entered into a larger discourse about how pictures in general should be read. This exhibition fits within a burgeoning category of recent scholarship that examines images that are not art (a category that includes not just scientific illustrations and diagrams, but also the vast majority of nineteenth-century photographs); considers the way these pictures look as well as the way they function; and—most importantly—examines the intersection between the two.[10] In this respect, a consideration of scientific photography also highlights the limitations of traditional art-historical methodologies in making sense of photography and its complex and inseparable set of technological, functional, social, and aesthetic concerns.

As modern viewers we experience a certain anxiety when faced with the insistent beauty of these purportedly documentary images. We have been conditioned to read scientific pictures as information, rather than as images with the potential to affect us emotionally. This confusion is heightened when such pictures are seen within the walls of a museum, a context that seems to make a claim for their status as art. Nineteenth-century scientists and popularizers of science, however, did not see the layman's response of wonderment and pleasure as inappropriate, but rather counted on this reaction to encourage scientific interest among the general public.[11] Then, as now, these photographs operated on multiple levels, depending on their audience and context for meaning. To consider what they looked like is by no means to assimilate them into the category of art, though they did have a significant impact on the artists of their time.[12] It is rather to recognize that despite their origins as scientific information, these photographs must be considered first and foremost as pictures, governed by conventions different from those that apply to words. If they appear remarkably modern to us, it is in large part because science and photography have determined our idea of what modernity looks like.

INVISIBLE OBJECTS, PENCILED BY NATURE'S OWN HAND

In his introduction to the exhibition catalogue *Iconoclash: Beyond the Image Wars in Science, Religion, and Art*, the historian of science Bruno Latour argues that scientific pictures are powerfully affective because they are more than mere images; they are, as he puts it, the

9. *Great Exhibition of the Works of Industry of All Nations, 1851: Reports by the Juries on the Subjects in the Thirty Classes into Which the Exhibition Was Divided* (London: Spicer Brothers / W. Clowes and Sons, 1851), 1:597.

10. See, for example, James Elkins, "Art History and Images That Are Not Art," *Art Bulletin* 77 (December 1995): 553–71. The snapshot occupies a similar position to the scientific photograph in its resistance to questions of authorship, intention, function, and audience. Douglas R. Nickel addressed the polysemy of snapshots and their difficult fit within a traditional art history in *Snapshots: The Photography of Everyday Life, 1888 to the Present* (San Francisco: San Francisco Museum of Modern Art, 1998).

11. Anne Secord argues that the importance of visual pleasure in scientific illustration has been largely overlooked in recent studies of popular science. See Secord, "Botany on a Plate: Pleasure and the Power of Pictures in Promoting Early Nineteenth-Century Scientific Knowledge," *Isis* 93 (2002): 28–57.

12. See, for example, Marta Braun's discussion of the impact of Marey's motion studies on Marcel Duchamp and other artists in *Picturing Time: The Work of Étienne-Jules Marey (1830–1904)* (Chicago: University of Chicago Press, 1992). On the influence of X-rays, see Linda Dalrymple Henderson, "X Rays and the Quest for Invisible Reality in the Art of Kupka, Duchamp, and the Cubists," *Art Journal* 47 (Winter 1988): 323–40.

"world itself."[13] This sense of being the world itself, rather than merely describing it, adheres in particular to photographic images. We tend to view photography as a special class of imagery, since it produces highly mimetic pictures that are the direct result of light reflected off the subject represented. But in the nineteenth century this idea that the photograph had a special and direct relationship to its real-world referent had a very particular cast. The metaphor most widely used to characterize the photographic process was that of nature "drawing her own picture"—a peculiar rhetorical construct that implies an unmediated translation of the natural world into a self-generated representation, removing any notion of authorship.[14] As such, the photograph could be understood as replicating and standing in for the scientific specimen rather than merely representing it. So deeply did Oliver Wendell Holmes believe in the photograph's ability to substitute for the object it represented that he suggested that the original, once photographed, might be destroyed: "Give us a few negatives of a thing worth seeing, taken from different points of view, and that is all we want of it. Pull it down or burn it up, if you please."[15]

When Dominique François Arago, a physicist and astronomer, presented Louis-Jacques-Mandé Daguerre's invention to the French Chamber of Deputies in 1839, he listed numerous possible applications for the new medium, but he was especially sanguine about its potential usefulness in his own field:

> Never have the rays of the moon, we do not mean in its natural condition, but focused by the greatest lens or the largest reflector, produced any perceptible physical effect. The plates prepared by M. Daguerre, however, bleach to such an extent, by the action of the same rays . . . that we may hope to be able to make photographic maps of our satellite. In other words, it will be possible to accomplish within a few minutes one of the most protracted, difficult, and delicate tasks in astronomy.[16]

Arago appreciated that photography would not only be more efficient and accurate than drawing, but also that it could produce images of astral bodies inscribed by their own light. He likened the camera to the microscope and telescope, two optical instruments playing a newly central role in the nineteenth century's scientific renaissance (due largely to the development of achromatic lenses in the 1830s), yet whose vast possibilities were only just beginning to be recognized. Little did he know that photography would revolutionize astronomy over the course of the century, producing visual records of stars too faint for the eye to register and recording spectra outside the range of visible light.

13. Bruno Latour, "What Is Iconoclash? Or Is There a War Beyond the Image Wars?," in Iconoclash: Beyond the Image Wars in Science, Religion, and Art, ed. Bruno Latour and Peter Weibel (Karlsruhe, Germany: ZKM Center for Art and Media; Cambridge, MA: MIT Press, 2002), 19.

14. For an excellent discussion of the complexity of this metaphor, see Geoffrey Batchen, Burning with Desire: The Conception of Photography (Cambridge, MA: MIT Press, 1997), 57–69. See also Douglas R. Nickel, "Talbot's Natural Magic," History of Photography 26 (Summer 2002): 132–40, which explores the theological implications inherent to the concept of nature drawing her own picture.

15. Oliver Wendell Holmes, "The Stereoscope and the Stereograph" (1859), in Photography: Essays and Images, ed. Beaumont Newhall (New York: Museum of Modern Art, 1980), 60.

16. Dominique François Arago, "Report" (1839), in Trachtenberg, 20–21.

Arago's coupling of photography with the microscope and telescope clearly underscores the important scientific role he foresaw for the new medium. But by likening the camera to devices that help visualize the invisible, he also located photography within a new visual culture. The analogy was not his alone: at the 1851 Crystal Palace exhibition, as at many other such industrial expositions, photography was classed with "Philosophical Instruments and Processes," a category that included eyeglasses, telescopes, microscopes, stereo viewers, kaleidoscopes, and other optical devices. These instruments all served to transform the experience of looking, whether by correcting defective vision, magnifying minute objects or rendering distant ones near, or transforming ordinary sight into hallucinatory spectacle. As both an image-producing machine and an optical instrument, the camera contributed in multiple ways to this nineteenth-century fascination with the visual and the visible. However, as the historian Kate Flint has pointed out, the scholarly focus on the primacy of visual experience in the Victorian period—what the film theorist Jean-Louis Comolli famously described as the "frenzy of the visible"—has deflected attention from visibility's antirational other, the invisible.[17] Photography's embeddedness in a scientific project of bringing knowledge to sight did little, in fact, to suppress its equally compelling association with magic and wonder. From the time of its invention, viewers marveled at the surfeit of visual information provided by the daguerreotype, frequently described as a "mirror with a memory." By the end of the century, with the discovery of X-rays, the photograph's ability to exceed vision verged on the uncanny.

In its early decades photography's promise as a scientific tool far outpaced its capabilities. Heeding Arago's clarion call, photographers tackled the heavens as one of their first scientific subjects. They were plagued by technical challenges: despite being the closest heavenly body—and easily visible without a telescope—even the moon proved to be an uncooperative sitter. Its faint rays registered only weakly on the relatively insensitive photographic plate, producing a blur as the earth rotated. This difficulty was compounded by the distortion of the moon's light by the earth's atmosphere and by the unequal receptivity of the emulsion to different wavelengths of light.[18] Daguerre's own attempt has not survived, but in 1840 John Draper was able to make a daguerreotype of the moon. Samuel Humphrey's 1849 daguerreotype of a lunar eclipse (pl. 43), though received with praise and wonder, recorded few of the features easily apparent to the naked eye. It was not until March 1851 that George Phillips Bond, son of the director of the Harvard College Observatory, and John Adams Whipple, a Boston daguerreotypist, were able to capture a detailed likeness of the moon's surface, using Harvard's state-of-the-art, fifteen-inch Great Refractor telescope equipped with a mechanism that moved the instrument in tandem with the earth's rotation. They repeated their experiment

17 See Flint, 25; Jean-Louis Comolli, "Machines of the Visible," in The Cinematic Apparatus, ed. Teresa de Lauretis and Stephen Heath (New York: St. Martin's, 1980), 122.

18 For a contemporary account, see Warren De la Rue, "Report on the Present State of Celestial Photography in England," in Report of the Twenty-Ninth Meeting of the British Association for the Advancement of Science: Held at Aberdeen in September 1859 (London: John Murray, 1860), 130–53. See also Christopher Phillips, "'Magnificent Desolation': The Moon Photographed," in Cosmos: From Romanticism to Avant-Garde, ed. Jean Clair (Montreal: Montreal Museum of Fine Arts, 1999), 144–49.

successfully several times (see fig. 1).[19] Whipple exhibited one of their daguerreotypes at the enormously popular Crystal Palace exhibition, where he won a gold medal. Bond spent much of that same year visiting European observatories, distributing copies of their pictures and establishing Harvard's reputation. The daguerreotypes' extraordinary beauty garnered great admiration by the public and the scientific community alike. Even today we can imagine how miraculous these photographs must have first appeared, the moon emerging, at once solid and evanescent, from the mirrored plate. Whipple himself wrote, "Nothing could be more interesting than [the moon's] appearance through that *magnificent* instrument: but to transfer it to the silver plate, to make something tangible of it, was quite a different thing."[20] Enshrined in the leather and velvet case typically used to frame the familiar visage of a loved one, the moon's "self-portrait" must have made quite an impression indeed.

Despite the technical achievement these daguerreotypes represented, they were something of a dead end in astronomical terms, contributing little to the extant knowledge about the moon. Recording information that was either difficult or impossible for the human observer to glean otherwise, John Draper's 1840 daguerreotype of the solar spectrum and Hippolyte Fizeau and Jean Bernard Léon Foucault's 1845 daguerreotype of the sun's surface (fig. 2) turned out to be more predictive of photography's future role in astronomical science, though it would not be realized for several decades.[21] But the moon pictures were useful in other ways, sparking an international race to improve astrophotography (the impetus was particularly strong for the Europeans, who were not about to be bested by the Americans). Technical obstacles did little to dampen the spirits of these photographic pioneers, who felt that Arago's dream of a photographic map of the heavens would soon be within reach. Equally importantly, the exhibition and discussion of these photographs helped to secure the interest and enthusiasm of the general public for astronomy. The power of photography to make science visible played an increasingly important role over the course of the century as various scientific factions competed for funding and audiences.[22]

At the same time that photographers were attempting to make portraits of distant celestial bodies, they were also turning their attention to the world of the infinitely small that could be seen through the microscope. Although the microscope had been in use since the seventeenth century, it was not until the early 1800s that it became a routine instrument in laboratory science. The intensification of scientific interest in microscopy (and the new, concomitant activity of teaching students to "read" what they saw through the device)

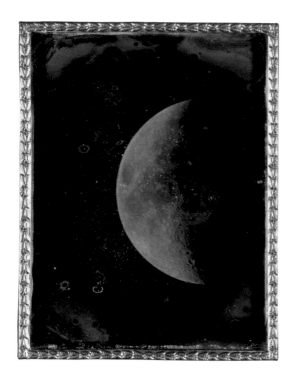

fig. 1 John Adams Whipple and George Phillips Bond
View of the moon, February 26, 1852, 1852
Daguerreotype
4 ¼ x 3 ¼ in. (10.8 x 8.3 cm)
Harvard College Observatory

19. See M. Susan Barger and William B. White, The Daguerreotype: Nineteenth-Century Technology and Modern Science (Baltimore: Johns Hopkins University Press, 2000), 88–89. See also Melissa Banta, A Curious and Ingenious Art: Reflections on Daguerreotypes at Harvard (Iowa City: University of Iowa Press, 2000), 35–41.
20. John Werge, The Evolution of Photography (London: Piper and Carter, 1890), 197, quoted in Banta, 39.
21. See Barger and White, 86–87.
22. On competition for audiences, see Aileen Fyfe and Bernard Lightman, introduction to Science in the Marketplace: Nineteenth-Century Sites and Experiences (Chicago: University of Chicago Press, 2007), 1–19. On cultivation of public support for astronomy, see Barbara Larson, "The New Astronomy and the Expanding Cosmos: The View from France at the End of the Nineteenth Century," in Clair, 168–73.

coincided with the early decades of photography, and a number of practitioners naturally turned their attention to the task of making pictures through the microscope. Their goal was to relieve the illustrator of the laborious task of drawing while peering through the eyepiece, while at the same time accumulating a collection of permanent specimens drawn by nature herself. Whipple, the author of Harvard's moon daguerreotypes, also recognized the medium's advantages to microscopy:

> By this most simple means it is in the power of every daguerreotypist to greatly aid the naturalist in his researches, giving him in a few moments drawings of invisible objects penciled by Nature's own hand, which it would be impossible for him to obtain in any other way, and he also possesses himself with an invaluable collection of natural objects that would be of great interest to the public.[23]

This was precisely what motivated the physician Alfred Donné and his assistant Jean Bernard Léon Foucault to produce their *Cours de microscopie complémentaire des études médicales,* an 1845 text for medical students containing engravings from daguerreotypes made through the microscope.[24] In his introduction Donné enumerated photography's advantages, chief among them their "rigorous fidelity" to the original object, untainted by the intervention or preconceived ideas of the draftsman. He also pointed out that unlike drawings, which often edited out extraneous information for the purpose of clarity, the photograph reproduced the microscopic field in its entirety and therefore offered a more realistic training experience.

Early photomicrographers faced challenges of light, focus, and speed similar to those that confronted astronomical photographers. Yet they were convinced that their medium would prove useful to this vital branch of modern science. Auguste-Adolphe Bertsch is perhaps the most important—and certainly the most prolific—of the early photomicrographers.[25] His extraordinary enlargements of diatoms, crystals, and insects were truly technical tours de force. Not only did Bertsch construct an original device to couple the camera and microscope, but he also conducted extensive experiments to arrive at the optimal chemical composition for his wet collodion negatives. His pictures highlight photography's advantages—not only its

fig. 2 Hippolyte Fizeau and Jean Bernard Léon Foucault
**Image of the sun made on April 2, 1845,
at 9:45 a.m.,** 1845
Daguerreotype
5 7/8 x 8 1/16 in. (15 x 20.5 cm)
Musée des arts et métiers, Conservatoire national
des arts et métiers, Paris

23 John A. Whipple, "Microscopic Daguerreotypes," Photographic Art-Journal (October 1852), quoted in Secrets of the Dark Chamber: The Art of the American Daguerreotype, by Merry A. Foresta and John Wood (Washington, DC: Smithsonian Institution Press, 1995), 262–63.

24 The following year Foucault collaborated with his schoolmate Hippolyte Fizeau to produce the first photograph of the sun (fig. 2). He went on to make numerous contributions to science, including proving the wave theory of light. Foucault is also the inventor of a device known as the Foucault pendulum, which demonstrates the rotation of the earth.

25 For the best account of Bertsch's career, see Carole Troufléau, "La légende d'Auguste Bertsch: Infortunes de la photomicrographie," Études photographiques 11 (May 2002): 93–111.

efficacy but also its immediacy. In his images of lice, mites, flies, wasps, and caterpillars, every hair, pincer, and claw is delineated in exquisitely creepy detail (see fig. 3; pls. 6, 11–14).

Microscopy, like astronomy, was not the exclusive province of the scientist. Good-quality microscopes were available relatively inexpensively and were often found in upper-class Victorian homes, where they were used for both research and visual entertainment.[26] That William Henry Fox Talbot, one of photography's inventors, chose to include microscopic specimens among his first exhibited photographs is evidence of the familiarity of the educated classes with microscopy and of the recognition that photography might have something to contribute to it (see fig. 19; pls. 1–3). Photography was thus poised to enter not only scientific practice, but also an established tradition of popular illustration. Scores of books with lavish drawings encouraged amateurs to discover the marvels of nature through the microscope in the eighteenth and nineteenth centuries. Though Bertsch and his contemporaries intended their photographs as aids to the professional scientist, their choice of subject matter often seems designed to appeal as much to the pleasure of the eye as to the intellect. They offered few scientific revelations: most of Bertsch's subjects, for example, had been known since Robert Hooke and Antony van Leeuwenhoek first looked through the microscope in the seventeenth century, and the iconography of lice, mites, and other insects was by then standard fare for microscopists, professional and amateur alike. Hooke was one of the first, in fact, to recognize the popular appeal of microscopic images; he illustrated his bestselling *Micrographia* (1665) with exquisite engravings accompanied by equally evocative text (see fig. 4). Improvements in photomicrography allowed the authors of *The Wonders of the Microscope, Photographically Revealed* (1861) to locate their book—illustrated with photomicrographs of fly feet, bee stingers, and spider jaws as well as diatoms, blood cells, and cross sections of human bones—within this tradition of illustrated books as aids to both the scientist and the amateur, "revealing the wonders of a world which, to many, has hitherto been wholly invisible."[27]

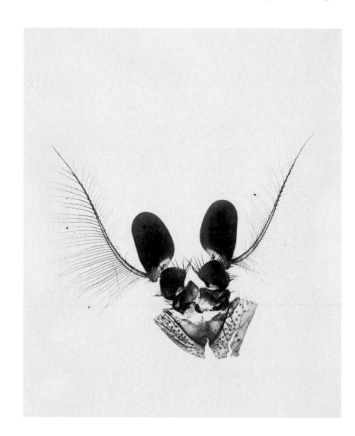

fig. 3 Auguste-Adolphe Bertsch
Antennae of a hoverfly, ca. 1853–57
Albumen print
7 7/16 x 6 in. (18.9 x 15.2 cm)
Société française de photographie, Paris

THE TRUE RETINA OF THE SCIENTIST

Paired with the microscope and telescope, photography contributed to a compelling body of visual evidence of worlds that existed beneath the threshold of human perception. It did so, however, largely as a substitute for drawing, providing mechanical transcriptions of observations

26 See Frances Terpak, "Objects and Contexts," in *Devices of Wonder: From the World in a Box to Images on a Screen*, by Barbara Maria Stafford and Frances Terpak (Los Angeles: Getty Research Institute, 2001), 210.

27 Preface to *The Wonders of the Microscope, Photographically Revealed*, by Olley's Patent Micro-Photographic Reflecting Process (London: W. Kent and Co., 1861), n.p.

that could be made with an instrument-aided eye. This changed around the 1870s as improvements in camera technology and photographic emulsions—the invention of the gelatin dry plate in particular—allowed photographers to overcome many of the technical challenges that had beset the medium's first practitioners. Unlike early photographers, whose subjects, though invisible to the naked eye, could be seen with the aid of optical instruments, this second generation undertook a far more radical project: photography of phenomena that could not be seen at all. Their subjects—distant nebulae, the legs of running horses—were too faint or fast to register on the human retina, but could nonetheless be recorded on the photographic plate. In some cases pictures were made with wavelengths of light to which the photographic emulsions were sensitive but the eye was not. In offering visual documentation of subjects that escaped human perception, photography was for the first time untethered from its relationship to both vision and the visible world. As the photography historian Joel Snyder has pointed out in his commentary on Étienne-Jules Marey's motion studies, these pictures did far more than substitute for an imperfect human observer: they revealed that observer to be utterly irrelevant.[28]

Though it was made possible by new technologies, it is important not to read the powerful impulse toward photographing the invisible world as merely an exercise of the medium's improved capacities. Rather, this drive must be seen as the registration of a critical shift, requiring first an awareness that there was a great deal more to the world than the human senses could perceive and, equally importantly, that it was both necessary and possible to make pictures of imperceptible phenomena. To understand the radical significance of this, we need to consider more specifically the relationship of photography to vision, both physical and metaphorical.

Photography's authority as a scientific tool hinged not only on its unique ability to produce records of nature drawn by her own hand, but also on its perceived relationship to human vision. As early as 1844, when Talbot published *The Pencil of Nature*, the physical structure of the camera (itself based on the older optical device of the camera obscura) was likened to the anatomy of the human eye, with the lens compared to a pupil and the light-sensitive plate to a retina. The metaphor worked in reverse, too: not only did the camera work like a human eye, but the eye worked like a camera. The literature elaborating upon this analogy is vast, ranging from scholarly treatises such as Arthur Parsey's *The Science of Vision* (1840) to popular articles

fig. 4 Engraving in **Micrographia, or, Some physiological descriptions of minute bodies made by magnifying glasses** (1665), by Robert Hooke, showing a flea as seen through a microscope

28. See Joel Snyder, "Visualization and Visibility," in *Picturing Science, Producing Art*, ed. Caroline A. Jones and Peter Galison (New York: Routledge, 1998), 379–97.

like "The Eye and the Camera" (1869) and "Two Wonderful Instruments" (1886). Thus the camera's physical construction and mode of making images provided scientists with a model for the study of vision and an analogy to help convey their new ideas to the public in terms general audiences could understand.

Vision itself became an object of study in the nineteenth century. Beginning in the 1820s, a new branch of scientific inquiry sought to understand not only the mechanics of human vision, but also how the images produced by the eye were processed into information.

The investigation of optical phenomena such as binocular vision, retinal afterimages, and complementary colors revealed that a great deal of the visual experience was not inherent in the object observed, but rather was produced within the body of the observer.[29] The model of eye-as-camera led to a number of explorations of the mechanics of vision, in which the photographic plate was literally substituted for the retina. In 1890 the physiologist Sigmund Exner made a groundbreaking discovery when he photographed through the compound eye of a firefly. The resulting picture (fig. 5) supplied proof for a contested theory that the multiple images produced by the insect's compound eye resolved into a single retinal picture, and that the image was upright (unlike the inverted image produced by a human eye).[30] In 1897 Georges Sagnac used the similarities between the camera and the eye to simulate the conditions of various vision defects, such as myopia, in order to better understand their physiological origins.[31] The comparison of the eye to the camera was in such common use that it could be taken to ridiculous extremes. The 1800s witnessed a number of forensic claims to have identified an assassin by examining the retinas of his victim, which supposedly retained, as if a photographic plate, an image of the last thing seen. These reports were widely discussed in both medical and photographic journals and subjected to rigorous testing well into the twentieth century.[32]

Within a scientific culture that placed great weight on empirical observation, this idea of the camera-eye served not only as a physical model, but also as a metaphor that underscored the relationship between visibility and knowability. Although the astronomer Pierre Jules César Janssen's 1877 description of the photographic plate as the "true retina of the scientist" is perhaps the most famous formulation of this idea, it was hardly original at the time.[33] As we have seen, the camera and the eye had been linked from the medium's invention. But by the time Janssen made that statement it had become a much more complicated analogy:

fig. 5 Sigmund Exner
Photomicrograph of the erect retinal image in the eye of the firefly (Lampyris spl.), 1890
Albumen print
2 7/8 x 2 5/16 in. (7.3 x 5.9 cm)
San Francisco Museum of Modern Art,
Accessions Committee Fund

29. Jonathan Crary's Techniques of the Observer: On Vision and Modernity in the Nineteenth Century (Cambridge, MA: MIT Press, 1990) remains the seminal text on the discovery of the subjective nature of vision and its relationship to visual culture in the nineteenth century.
30. See Sigmund Exner, The Physiology of Compound Eyes and Crustaceans: A Study (1891), trans. Roger C. Hardie (Berlin: Springer-Verlag, 1989).
31. I thank Denis Canguilhem and Hans Kraus for bringing Sagnac's work to my attention.
32. See "Médecine légale: Etude photographique sur la rétine des sujets assassinés," Revue photographique des hôpitaux de Paris 2 (1870): 73–82, for an example of one such report. See also Bill Jay, "The Strange Case of the Final Vision," American Photographer 15 (July 1985): 74–76.
33. "La véritable rétine du savant." Quoted in Françoise Launay, "Jules Janssen et la photographie," in Dans le champ des étoiles: Les photographes et le ciel, 1850–2000, by Quentin Bajac (Paris: Editions de la Reunion des musées nationaux, 2000), 26. See also Andre Gunthert, "La rétine du savant: La fonction heuristique de la photographie," Études photographiques 7 (May 2002): 29–48.

the eye had been largely discredited as an observing instrument (in no small part by photography itself), and photography, due to the increased sensitivity of the plate, was no longer constrained by any correspondence to visual experience.[34] Janssen's metaphor must be understood against the backdrop of a new awareness of the invisible world, the shortcomings of the human eye, and the expanded capacities of photography. As Douglas R. Nickel explains, "Photographic practice after 1880 began to outstrip the very concepts that had made it seem rational, legible, and empirically verifiable even the decade before, as it pushed past the horizons of visibility that previously defined it."[35]

The retina that Janssen described had little to do with the eye at all; indeed, his camera-as-eye cannot be understood as a reduplication of vision, but rather as a corrective for the limitations of the human instrument and as an extension of its capacities. Talbot, who had been one of the first to compare the camera to the eye in his *Pencil of Nature*, was aware of the existence of wavelengths outside the visible spectrum. He imagined that ultraviolet light might someday be harnessed to photography to expand the camera's vision beyond that of man: "For, to use a metaphor we have already employed, the eye of the camera would see plainly where the human eye would find nothing but darkness." In 1844 this sort of photography was outside the range of possibility, though he mused that it would make for a gripping scene in a novel: "Alas! that this speculation is somewhat too refined to be introduced with effect into a modern novel or romance; for what a dénouement we should have, if we could suppose the secrets of the darkened chamber to be revealed by the testimony of the imprinted paper."[36] What for Talbot was the stuff of fiction was largely realized by the 1880s. Photography's demonstrated ability to transform numerous disciplines of science was widely hailed, but its representation of the invisible also had a profound effect on the cultural imagination, calling into question the ways in which people made sense of perception, knowledge, and sight and providing a new model for the representation of the real.

THE PHOTOGRAPHIC EYES OF SCIENCE

Astronomy had been one of the first disciplines to enlist the camera in its practice; it was also the field most decisively transformed by the medium's improved capacities in the 1870s. The photographic plate's new sensitivity to wavelengths outside the range of visible light, coupled with its ability to accumulate light over periods of time, meant that the negative was able to record far more information than the eye—aided or unaided—was able to see. Richard Proctor, a well-known popularizer of astronomy, referred to photography's supernumerary vision as "the photographic eyes of science," with a deliberate emphasis on the plural. He argued that with "the eye of keenness, the eye of patient watchfulness, and the eye of artistic truth,"

34. Janssen himself was well aware of recent studies of the physiology of vision, as it was the subject of his own doctoral dissertation, "La transmission de la chaleur rayonnante obscure dans les milieux de l'œil" (1860). See Launay, 26.

35. Douglas R. Nickel, "Photography and Invisibility," in *The Artist and the Camera: Degas to Picasso*, by Dorothy Kosinski (Dallas: Dallas Museum of Art; New Haven, CT: Yale University Press, 1999), 36.

36. William Henry Fox Talbot, *The Pencil of Nature* (1844–46; repr. New York: Da Capo Press, 1969), n.p.

photography would safeguard astronomers from error and "detect truths which otherwise would escape us." Given the advantages of improved photographic technology, astronomy would now be "Argus-eyed," alluding to the hundred-eyed giant of Greek mythology.[37]

Though Arago had hoped photography would enable astronomers to make visual records of known celestial bodies, he could hardly have predicted that it would enable them to discover new ones. In the 1880s, however, astrophotography transcended mere documentation to become a form of revelation. Through photography astronomers made substantial advances, most notably in the study of nebulae, where the photographic plate provided evidence both of their presence and, through spectral analysis, of their makeup. This proof of the enormity of the universe excited not only astronomers but the general public. Camille Flammarion, one of France's most visible astronomers and an ardent popularizer of science, described the impact of the new knowledge in typically breathless prose:

> [Astronomy] emerges from numbers to become living. The spectacle of the universe transforms itself before our astounded thoughts; these are no longer inert blocks turning in silence in the eternal night that the finger of Uranus shows us at the far reaches of the heavens; it is life, enormous life, universal, eternal, unfolding on harmonious waves to the inaccessible horizons of the infinite which still elude us![38]

Flammarion's writings were widely known, as were the dramatic pictures of the far reaches of the cosmos reproduced in popular magazines such as *L'Illustration* and *Harper's Monthly*. The art historian Albert Boime has argued convincingly that the popular discourse about astronomy in France in the 1880s fired the imagination of Vincent van Gogh, whose iconic painting *Starry Night* (1889) binds together the new physical descriptions of the skies that photography provided and the metaphysical implications of those discoveries.[39]

Photography offered proof not only of an expanded universe, but also helped to transform radically the conception of time. With the invention of gelatin dry plates, moving objects that had for forty years frustrated photographers by refusing to leave anything more than a blur on the negative could now be registered clearly. But beyond merely deconstructing movement, the motion studies of Eadweard Muybridge, Étienne-Jules Marey, Ottomar Anschütz, Thomas Eakins, and Albert Londe produced pictorial records that were irreconcilable with visual experience. One of the earliest attempts at high-speed photography was made in 1858 by Thomas Skaife using a pistolgraph, a device that anticipated Marey's photographic revolver. Created on a wet collodion negative, the picture of cannon fire (fig. 6) is more remarkable

37 Richard A. Proctor, "The Photographic Eyes of Science," *Longman's Magazine* 1 (1883): 462.
38 Camille Flammarion, *Astronomie populaire* (1879; repr. Paris: Ernest Flammarion, 1911), 4 (my translation).
39 See Albert Boime, "Van Gogh's *Starry Night*: A History of Matter and a Matter of History," *Arts Magazine* 59 (December 1984): 86–103.

for its atmospheric clouds of smoke than for its stop-action effects. The language Skaife used to describe his photograph, however, is instructive: he argued that "epochs of time inappreciable to our natural unaided organ of vision, could be made evident to our senses by a photographic camera as decidedly as the presence of animalculae in blood or water is by a microscope."[40] Once again the camera is figured as an optical device with the ability to expand the visual field beyond the range of human sight.

Though Skaife's ambitions perhaps exceeded the medium's abilities at that time, in 1878 Muybridge successfully used a bank of cameras, each triggered by a trip wire, to fragment action into a series of still images (see fig. 21; pls. 76–78). By dissecting a single motion into split-second frames, he was famously able to settle a bet for the railroad baron Leland Stanford regarding the position of a running horse's hooves, contradicting both popular belief and centuries of painterly representation. Marey, a physiologist, took a different tack; adapting the photographic revolver used by Janssen to record the transit of Venus across the sun in 1874 (see pl. 59), Marey used a single, moving plate to register movement not only through time, but also across space. His chronophotographs, as he called them, do more than break down movement into its component parts; they decompose it into an abstract graphical trace (see fig. 22; pls. 79–84). As the historian Marta Braun has argued in her pioneering study of Marey's work, the photograph functioned for him not as a picture but as self-inscribed data, marking a significant reconfiguration of photography's traditional role.[41] In these motion studies, as in many astrophotographs, the photograph no longer represented or even approximated the experience of the observer, but instead constituted the only visual record of an otherwise imperceptible subject. It revealed rather than described, presenting data rather than representing the visible world.

If over the course of the 1880s the photograph's relationship to vision became increasingly attenuated, in 1896 it appeared to have come completely unhinged. When Wilhelm Conrad Röntgen discovered X-rays at the end of 1895, the text he circulated to his scientific colleagues just after Christmas was accompanied by a shocking picture—a photograph of the skeletal hand of his wife—that demonstrated the profundity of his discovery in ways that words never could. Surrounded by a ghostlike aura of flesh, only the bones of her hand and the shadow of her heavy rings were visible. Röntgen, while performing experiments with a Crookes tube,

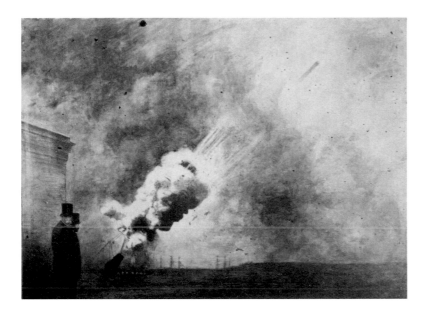

fig. 6 Thomas Skaife
Bombshell in Transitu, 1858
Albumen print
2 ¼ x 3 in. (5.7 x 7.6 cm)
Royal Astronomical Society Archives, London

40 Quoted in Jon Darius, **Beyond Vision** (Oxford: Oxford University Press, 1984), 30. See also Peter Geimer's discussion of Skaife's photograph in "Picturing the Black Box: On Blanks in Nineteenth-Century Paintings and Photographs," in "Writing Modern Art and Science," ed. Linda Dalrymple Henderson, special issue, **Science in Context** 17, no. 4 (2004): 478.
41 See Braun, 61.

had inadvertently discovered a form of electromagnetic radiation whose properties were utterly unlike those of visible light; he called them X-rays to denote their mysterious origins. Though the eye could not perceive them, the rays exposed photographic plates as they passed through opaque substances such as flesh, wood, and leather, leaving shadows of impenetrable materials like bone and certain metals.

fig. 7 Henri van Heurck
X-ray of a hand with a ring, 1896
Printing-out paper print
6 ¾ x 4 ½ in. (17.2 x 11.5 cm)
Courtesy Galerie GÉRARD-LÉVY, Paris

News of the discovery reached the press in January 1896, and Röntgen's pictures were widely reproduced; the bony, beringed hand of Frau Röntgen soon came to stand for the X-rays' revelatory power. His experiments were easily and eagerly repeated, resulting in a remarkable body of photographs that revealed the hidden contents of change purses and wooden boxes and the skeletal structures of fish, snakes, and other creatures (see pls. 115–40).

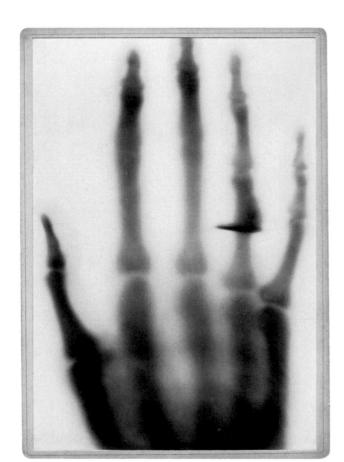

The human hand remained a popular subject for practical as well as aesthetic reasons. The hand's relative flatness offered minimal resistance to the rays, and the sight of the human skeleton was arresting—particularly if it bore the shadowy trappings of its owner's jewels or embedded foreign objects (see figs. 7–8; pls. 129, 131).

Today we are hardly shocked by the sight of our own bones, but the remarkable public response to these pictures indicates that they possessed extraordinary visual power, simultaneously suggesting an assault on privacy and conjuring the specter of death. Though X-rays were widely hailed as the "new photography," the visual model they offered was severed from any connection to human vision, and the pictures they made were visual records of unverifiable truths. Nature had indeed drawn her own picture, but it was like nothing the world had ever seen.

Despite our ever-increasing knowledge of the natural world, these early pictures still retain a hold on our imagination. As the current debates over stem cells and intelligent design attest, uncertainty and anxieties about our place in the grand order of things persist. So does our appetite for pictures of parts of the universe beyond our reach. Rather than disenchant the world with increasingly rational explanations of the hitherto inexplicable, nineteenth-century science revealed the unseen forces surrounding humanity, from microbes lurking in the water to electromagnetic waves passing through the ether. Photography played a sometimes contradictory role, working to bring these invisible forces under scientific control at the same time that it helped unleash the wonders and terrors of an unfathomable universe on the public

imagination. Most importantly, however, photography contributed to a radical reevaluation of human vision. The faith once placed in the human eye has today been replaced by a near-total dependence on technologically inflected vision, resulting in a disconnect between seeing and knowing so pervasive that it goes almost entirely unacknowledged. Our willingness to trust the visual data produced by such imaging technologies ultimately depends on a system of belief rooted in the discourses of nineteenth-century scientific photography.

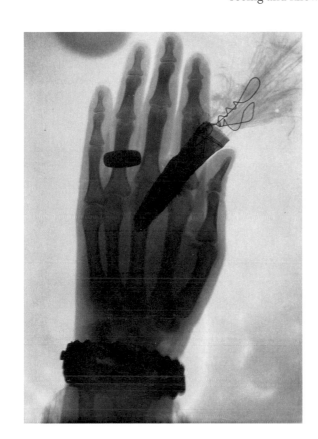

fig. 8 Walter König
**X-ray of a gloved woman's hand
with bracelet and bouquet,** 1896
Printing-out paper print
8 ⁷⁄₈ x 6 ⁵⁄₁₆ in. (22.5 x 16 cm)
Albertina, Vienna, permanent loan of the Höhere
Graphische Bundes-Lehr- und Versuchsanstalt,
Vienna

THE SOCIAL PHOTOGRAPHIC EYE

Jennifer Tucker

THE GENRE ONCE REFERRED TO AS THE PHOTOGRAPHY OF THE INVISIBLE FASCINATED THOUSANDS around the globe in the nineteenth century, a time when the potential of science and technology seemed, to many, unlimited. In the wake of political revolutions and social upheavals across Europe and the United States, the lives of people from all social backgrounds were affected by developments that ranged from crises of empire, to struggles to redefine citizenship, to challenges to traditional forms of authority, including the church. As scientists and scientific institutions bid for more cultural authority and expanded roles in shaping policy, science, technology, and medicine moved to the center of conversations about the world's future. Public debates about new technologies such as photography consequently attracted a wide variety of opinions about their future applications and social impact.

Photography of the invisible became a cause célèbre that spurred widespread interest and aroused heated controversy in different social and cultural worlds, including the overlapping but distinct domains of science, crime, law, religion, and the supernatural. As it was understood more than a hundred years ago, the genre of photographs of unseen or elusive subjects was a very broad category that encompassed the documentation of varied phenomena: comets, bacteria, lightning, ghosts, invisible writing, smallpox, stars, human and animal locomotion, eclipses, experiments in fluorescent photography, X-rays, spectroscopy, and solar prominences. All of these were domains where, as one contemporary put it, the camera could "render visible phenomena which without its aid would escape observation."

1. Quoted in a discussion of Warren De la Rue's photographs of the solar eclipse in "Abstract of the Report of the Kew Committee," The Photographic News (September 27, 1861): 459 (hereafter cited as PN).

This essay explores the basis for the broad scientific and cultural appeal of photographs of the invisible during this pivotal historical period. After a brief introduction to nineteenth-century attitudes toward new imaging technologies, I will examine how the development of—and formation of boundaries between—professional and amateur science influenced the practice of scientific photography. I will then turn to the social context for the display of the images, for the presentation of scientific photography in such venues as world's fairs and illustrated newspapers played a crucial role in establishing the photographs' cultural importance. Central to this discussion is what I will call the "social photographic eye": the idea that photographic seeing in science, as with other kinds of artistic vision, was a socially and culturally conditioned activity.

PHOTOGRAPHY AS A NEW MORAL AGENT

Few technologies attracted such contrasting attitudes in the nineteenth century as photography. On the one hand, it was widely believed to be a technique that would create a new and more objective basis for empirical knowledge. One journalist expressed the view of many others when he asserted that the medium was "moulding the world into new forms" and changing the "face of society" as it "detects crime, distributes intelligence and perfects knowledge." The camera was praised as the "handmaid of the knowledge of the visible world," while photography was celebrated as a new form of proof of things that were unseen or hard to detect: "traces" of fleeing felons or forgeries as well as natural phenomena—including comets, lightning, and bacteria—that "left no trace of [their] presence." As one commentator remarked, "If a figure or character has been erased to the eye, it by no means follows that the camera cannot see it." The noted European photographer Hermann Wilhelm Vogel, a professor at the Technische Hochschule of Berlin and the author of *The Chemistry of Light and Photography* (1875), declared, "Not only does photography reproduce with absolute perfection details which the most scrupulous eye-work could not trace without error, but it actually sees what is invisible; the sensitive plate receives impressions which altogether escape the human eye."[2]

It was in part because photography was thought to turn photographers into spectators of "nature's grand spectacle" that its invention was considered among the "grand discoveries" of the nineteenth century—one that would "immortalize" the era.[3] On the other hand, photography was hardly welcomed with uniform praise and awe. It was not only a new way of seeing; it was also a tool for being seen in novel, unaccustomed, and at times very unwelcome ways. Someone with a camera was "behind every window curtain," complained one person in the 1880s, around the time of the popularization of photographic methods. "Life, indeed, now contains a new terror," a contemporary put it, adding that the sense of

2. M. A. Belloc, "The Future of Photography," PN (September 17, 1858): 13–14; Rev. M. J. Morton, "Photography as a Moral Agent," PN (September 16, 1864): 452; "Photography the Best Detective," PN (May 29, 1868): 264; "Forgeries and Photography," PN (August 1, 1879): 361. Vogel is quoted in William Mathews, "Tichborne—An Exploit for Scientific Photographers," PN (May 23, 1879): 361.
3. See, for example, Belloc.

being watched made some "morbidly nervous."[4] Moreover, social reformers blamed photography for corrupting and degrading public morals. As the medium transformed and expanded the visual culture of pornography, numerous reformers in Europe and the United States fought to censor the photographic "underworld." Some debates over obscenity touched on "scientific" photographs such as ethnological pictures.[5] Photography furthermore was criticized for degrading public taste in matters of portraiture and art. The flood of "inferior" pictures that entered the market in the 1850s and 1860s after the relaxation of patent restrictions on photography infuriated many elite portrait photographers, among others, who worried about how to stem the apparent tide of "bad taste" in photography (a tendency that most often was pinned on "worthless" or unscrupulous practitioners and "sentimental" or "unknowledgeable" young women).[6] Photography was also widely associated with many kinds of forgeries and other impostures and deceptions.

Any consideration of photography as a tool for rendering visible new objects in nature must consider how the medium reflected contrasting hopes and fears about the future, as well as different views of the role that science and technology might play within it. As we turn to focus on the ambitions for photography in scientific research and investigation, it is worth examining how different moral tropes circulated around scientific images versus other genres of photography at the time, and how research with the camera was not only important for science, but also for efforts to improve photography's often precarious social status and public image.

THE CAMERA AS EYE OF DISCOVERY

In the midst of fundamental changes in how scientific enterprise was conducted in the nineteenth century, scientific observation with a camera came to be seen as more than a technique for acquiring knowledge. It was a practice associated with authority, leadership, and superior powers of scientific seeing. During the second half of the nineteenth century, many forms emerged that are associated today with modern professional science, from the creation of societies devoted to singular disciplines and the rise of laboratories and professional publications to the expansion of university-based instruction in the experimental sciences.[7] "Men of science," as they were often called, came to be seen as better leaders than many military heroes, social reformers, and politicians for solving the relevant problems of the day. As one contemporary declared, "In this new world, where . . . observation suffices to put us on the road to discovery, we never pause, but always advance."[8]

Scientific interest in photography during the nineteenth century was inextricably connected with the rise of the experimental program as an established and widely

4. "Notes," PN (October 22, 1886): 681.
5. "Immoral Photographs," PN (August 10, 1860): 180. See Elizabeth Edwards, Raw Histories: Photographs, Anthropology, and Museums (Oxford: Berg, 2001), 154n28, for concerns raised about scientific photography in relation to obscenity laws. For censorship of nineteenth-century visual culture, including pornography, see Lynda Nead, Victorian Babylon: People, Streets, and Images in Nineteenth-Century London (New Haven, CT: Yale University Press, 2000).
6. See Jennifer Tucker, Nature Exposed: Photography as Eyewitness in Victorian Science (Baltimore: Johns Hopkins University Press, 2005), 36–41.
7. On the history of late-nineteenth-century science and its institutional reorganization, see, for example, T. M. W. Heyck, The Transformation of Intellectual Life in Victorian Britain (London: Croom Helm, 1982), Ron Numbers and Charles E. Rosenberg, eds., The Scientific Enterprise in America: Readings from Isis (Chicago: University of Chicago Press, 1996); and Frank M. Turner, Contesting Cultural Authority: Essays in Victorian Intellectual Life (Cambridge: Cambridge University Press, 1993).
8. "How to Commence Photography," PN (September 17, 1858): 23.

trusted aspect of scientific research around the world. Photography was part of the routine work of many professional scientific specializations, from astronomy and medicine to chemistry and physics. Pictures were used for making discoveries, reporting results, archiving facts, and publicizing research. Not every nineteenth-century scientist was a photographer, but many were trained to interpret photographs. Illustrated scientific atlases, for example, as Lorraine Daston and Peter Galison show, drilled the eye of the beginner and refreshed the eye of the specialist, creating repositories of "working objects" that informed practitioners what was worth looking at, how it looked, and how it should be looked at.[9]

Bacteriology exemplifies a new scientific specialty in the nineteenth century that relied heavily on the making and circulating of photographs. A relatively new field associated mainly with medical botany, by the 1880s the study of bacteria incorporated material and social practices associated with distinctive professional scientific disciplines. The Prussian scientist Robert Koch is credited with converting many skeptics to the germ theory, developing new plate techniques for studying colonies of bacteria, isolating the cholera bacterium, and persuading public-health officials and doctors that healthy humans were potential carriers of living pathogens. Perhaps because of the challenges he faced in convincing cynics that bacteria were morbific agents (causes and not just symptoms of disease), Koch became a pioneer in using photographs to document bacteria's existence and communicate findings among germ researchers. In 1873 he wrote to the botanist Ferdinand Cohn, requesting permission to visit him in Breslau and show him his experiments on the developmental stages of anthrax bacillus. While there he made photomicrographs of bacteria endospores in order to better communicate the results of his investigations. Koch came to view photomicrography as essential to bacteriology. He held that photography functioned as a trustworthy arbiter of disputes, a "harmonizing mediator" among argumentative microscopists, and an "instructress" of novice observers.[10]

Several things marked photography as a distinctive scientific instrument. First, it seemed to satisfy the emerging new ideal of mechanical objectivity in the natural sciences. As Daston and Galison explain, this was consistent with the nineteenth-century aspiration for a "wordless" science. Wary of human intervention between nature and representation, nineteenth-century scientists "turned to mechanically produced images to eliminate suspect mediation." They enlisted photographs "and a host of other devices in a near-fanatical effort to create atlases—the bibles of the observational sciences—documenting birds, fossils, human bodies, elementary particles, and flowers in images that were certified free of human interference."[11] In other words, photographs often carried more authority than earlier forms of virtual witness, such as watercolors and drawings, because they seemed to satisfy new conditions for trusted scientific knowledge.

9. Lorraine Daston and Peter Galison, **Objectivity** (New York: Zone Books, 2007), 22–23.
10. Quoted in Jon Darius, **Beyond Vision** (Oxford: Oxford University Press, 1984), 13. On Koch's experiments with scientific photography, see Thomas D. Brock, **Robert Koch: A Life in Medicine and Bacteriology** (Madison, WI: Science Technology Publications, 1988), 25–30, and Tucker, 163–70.
11. Lorraine Daston and Peter Galison, "The Image of Objectivity," **Representations** 40 (Fall 1992): 81.

Also favoring the use of photography in the new experimental and field sciences was the fact that photographs could be reproduced fairly easily in the form of extra prints, thereby satisfying the growing demand for scientific communication and education.

Scientists praised photography as a method for conducting scientific exchanges with colleagues. When one did not wish to part with the original specimen, photographs could be printed and circulated with remarks. Indeed, the photographs themselves came to be referred to as specimens.[12]

Although Koch often struggled to make good photographs of microbes and continued to rely on drawings to represent bacteria, he thought photography should be used when it could be: "I think no one will blame me for only accepting with great reserve drawings of micro-organisms, the accuracy of which I cannot substantiate by examining the original preparation," he stated, adding that others should support their work with "the convincing proof afforded by photographic illustrations."[13] Koch eventually published several of his photographs in a widely distributed 1878 book about bacteria, but his photomicrographs also circulated independently of this textbook because so many scientists were eager to see the originals. He took photomicrographs with him, for example, when he traveled to London in 1876 to meet Charles Darwin and John Tyndall and publicize his views.

By the 1880s photography of bacteria was being done in European and North American medical schools and other places where bacteriology was taught as part of a public-health curriculum. (This was part of a wider trend toward the use of photography in routine scientific and medical education, from physics and psychology to physiological studies of human and animal locomotion.) Edgar Crookshank, who founded one of the world's first bacteriological laboratories for human and veterinary pathology in London in 1885, became a dogged advocate for the use of photography in the teaching of bacteriology. He was so convinced photography would train bacteriologists better, in fact, that he wrote a textbook, *Photography of Bacteria* (1887), which was devoted solely to teaching medical students how to take pictures of bacteria that possessed scientific value. In the book, which contained eighty-six images reproduced in autotype (see figs. 9–10), Crookshank stressed the superior value of photography for scientific demonstrations and education, declaring that "any structure, form, or shape which may be represented, is actually what exists, and not what may have been evolved by unconscious bias in the mind of the observer."[14]

figs. 9–10 Details of a plate in **Photography of Bacteria** (1887), by Edgar M. Crookshank, showing Crookshank microphotographs of **Bacillus figurans**

12 See Edgar M. Crookshank, **Photography of Bacteria** (New York: J. H. Vail & Co., 1887), 8, 61.
13 Quoted in ibid., 9.
14 Ibid.

Crookshank's statement resonates nicely with the nineteenth-century claim that machines such as the camera offered scientists freedom from the dangerous aspects of subjectivity. And yet it was precisely Crookshank's own subjective identity—as a scientific expert and medical instructor as well as a skilled photographer—that gave his statement meaning and authority. The professional identities of both the scientist and the scientific institution were important in determining the credibility of claims about photography's mechanical objectivity. Photography of the unseen was strongly associated at the time with scientific professionalization and expertise and with access to special instruments, equipment, and knowledge. Judgments on photographs necessarily entailed assessments of the subjectivity of their makers and interpreters, even if the rhetoric surrounding them elided this information.

Despite the prevalence of professional scientists in the practice of scientific photography, amateurs, too, were valued for the special role they could play in the advancement of scientific knowledge. Indeed, the nineteenth-century elaboration of the role of the amateur as an especially valuable scientific contributor, including in the domain of picturing the unseen, is an important aspect of this genre of photography. In the nineteenth century science in many fields was coming to be conducted on a large geographic scale, and thus required the participation and resources of individuals and institutions outside traditional scientific organizations to help make maps, record data, and collect specimens. Especially in Europe and the United States, scientific institutions had a special interest in advancing disciplines such as meteorology, astronomy, geomagnetism, and geology—pursuits that depended on the cooperation of many observers, some of them with little or no specialized training.[15]

The rise of photography both paralleled and intersected with these developments in the sciences. From the beginning, advocates for photography linked it to the practices of democratic participation—especially after the 1880s, when many photographic processes became cheaper and more widely available to the middle classes. In 1888 George Eastman set out a new philosophy of amateur photography in an advertisement for the Kodak camera that he had designed and produced. "The principle of the Kodak system," he announced, is "You push the button, we do the rest."[16] Amateur photographers scrambled to take pictures out of doors, many of them documenting details of nature (trees, birds, clouds, and storms) because doing so fit with current theories of nature study, which stressed the virtues of direct observation over book knowledge.[17]

Many scientists declared that, in properly scientific conditions and with proper training, *anyone* could take a photograph that might be valuable to science, especially if (as in many field sciences, including anthropology) they could record and document data that were remote or otherwise inaccessible. Although some complained that the infusion of

15. See, for example, O. J. R. Howarth, *The British Association for the Advancement of Science* (London: British Association, 1931), and Roy MacLeod and Peter Collins, eds., *The Parliament of Science: The British Association for the Advancement of Science, 1831–1981* (London: Science Reviews, 1981).

16. Discussed in Reese V. Jenkins, *Images and Enterprise: Technology and the American Photographic Industry, 1839–1925* (Baltimore: Johns Hopkins University Press, 1975), 112.

17. See Tucker, 143–58.

"inferior" practitioners would, as one photographer put it, bring the "whole art" under "reproach," the dominant opinion was that the expansion of photography into the middle classes offered a powerful basis for a future in which many could contribute to scientific advancement under the supervision of the scientific elite.[18]

figs. 11–12 Illustrations in James Nasmyth, "On the Form of Lightning," **Report of the British Association for the Advancement of Science** 25 (1856), comparing artist's lightning (top) with a pattern observed in nature (bottom)

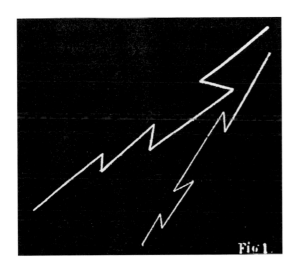

Meteorology is one example of a growing nineteenth-century science that relied on contributions from amateur photographers to document elusive phenomena such as lightning and clouds. Indeed, by the late nineteenth century a significant number of lightning and cloud photographs in the collections of meteorological societies had been taken by nonspecialists. Meteorologists recognized early on that photography could become a powerful ally in their attempts to record and classify weather phenomena. From at least the early 1870s, meteorologists around the world worked hard to teach amateur nature photographers how to make pictures of the weather that possessed scientific value. They instructed amateurs to record the exact time, circumstances, and location of each picture as well as to include a portion of landscape or roof in order to indicate scale and distance. Some meteorologists also took upon themselves the task of reviewing art exhibitions, especially in England and France. They circulated photographic representations of lightning and sought to disprove the existence in nature of zigzag (or "artist's") lightning (see figs. 11–12).[19]

A major argument that surfaced concerning the place of amateurs in scientific photography centered on who could contribute. A good example here is the genre of spirit photography. Today, spirit photography is generally not commemorated in books on historically valuable scientific photographs. However, during the second half of the nineteenth century, as Tom Gunning discusses in his essay in this catalogue, spirit photography was a practice that became the focus of intense scientific and public scrutiny around the world. To those who argued that supernatural phenomena could not appear in photographs because they did not exist in reality, supporters countered that whenever scientific observers applied a new instrument like the camera to the study of nature, they hoped for a host of discoveries, and that in such matters one could count on the unexpected. Spirit photographs might have been difficult to explain, and at times even fraudulent, but for many that did not make them always untrue.

By the 1870s scientists and photographic experts who had helped lay the foundation for public faith in photography and its democratic possibilities faced the difficulty of explaining why spirit photography was so controversial. To scientists who supported the

18. For fears about the devolution of photography in England, see, for example, "The 'Quarterly Review' on Photography," PN (October 28, 1864): 519; "The Photographic Nuisance," PN (August 16, 1861): 383; and "Photographic Dens and 'Doorsmen,'" PN (August 16, 1861): 389. Support for the scientific education of photographers was expressed, for example, in "To Our Readers," PN (August 24, 1860): 103–4; "Photography: Its Social and Economic Position," PN (January 25, 1867): 43–44; and "Education for Photographers," PN (February 1, 1878): 54.

19. See Ralph Abercromby, "On the Photographs of Lightning Flashes," Quarterly Journal of the Royal Meteorological Society 14 (July 1888): 226–34. For scientists' attacks on zigzag lightning, see "Meteorology and Art," Symons's Monthly Meteorological Magazine (May 1880): 49–51; discussed in Tucker, 141–42.

belief that the spiritual world was both real and photographable, scientist-skeptics such as
T. H. Huxley seemed uncurious and dogmatic. Conversely, the skeptics accused the scientists
of credulity when they (for example, the leading evolutionary biologist Alfred Russel Wallace
and top physicist William Crookes) held that spirit photography was plausible and, in certain
cases, genuine. One British photographic expert defended the practice by saying, "Spirit
photographs may seem absurd now but so did scientific discoveries ridiculed in other ages."
Another asked, "If the spiritual phenomena is a reality—and as a reasonable man I cannot
reject the evidence in its favor—why should the announcement that spirit photographs had
been obtained come upon us as a 'good joke,' or even excite our astonishment?" Those who
thought it nonsense to imagine that there was any scientific test condition that could ultimately
decide the veracity of spirit photography invoked the seventeenth-century natural philosopher
Francis Bacon's injunction to accumulate observations, even those that at first seemed insignifi-
cant. One photographer-scientist implored: "Let us be Baconian, even to our ghosts," and
signed his letter, "I am not a Spiritualist, but ONE WHO WAITS FOR FACTS."[20]

Although photographs were widely associated with mechanical objectivity,
the practice of photography itself was regarded as a technique requiring skill and knowledge.
Therefore, deliberations over the veracity of photographs were often suffused by claims of
subjective intervention—some of which reinforced appeals to scientific authority and some of
which undercut those appeals. Debates often pitted scientists against one another, as in the case
of spirit photography, which attracted interest from many of the century's leading authorities.
Recent research on science and technology suggests that scientists often use boundary-defining
language in order to distinguish between science and nonscience and to allocate the right to
interpret science in ways that further their own interests. This is especially true in the case of
photographs of phenomena at the threshold of human vision, which did not always achieve
social consensus about meaning or interpretation. In trying to address and resolve conflicts that
arose over the interpretation of photographic evidence, nineteenth-century scientists scrutinized
not only the images, but also the techniques used to acquire them. Investigations of photo-
graphic productions took into consideration the circumstances under which the pictures were
made, as well as the skill and judgment of the photographers. Since such discussions typically
took place inside conference rooms or in the context of scientific demonstrations, their content
is recoverable only by looking in detail at records such as the minutes of scientific meetings.

Nineteenth-century science was characterized by both the appeal to visual
evidence and the need for confirmation by the testimony of eyewitnesses. The latter explains
why scientists pursued public viewings of their photographs by means of illustrated slide
lectures, exhibitions, and reproduction in newspapers and magazines. The next section of this

20. "Spiritual Photographs," PN (June 11, 1869): 285; M. Carey Lea, "Letter to the Editors: Spirit Photography," British Journal of Photography (May 31, 1872): 260; and "Spirit Forms and Photography,"
PN (August 15, 1873): 395.

essay looks at some of the places where photographs of the invisible were presented during the nineteenth century, and considers how and why public viewings of such pictures became central to their cultural importance.

MULTIPLE AUDIENCES, MULTIPLE SCIENCES

There were many reasons for scientists to exhibit photographs in the nineteenth century. Two primary motives were to expand the pool of ocular witnesses and to gain more public support for their theories and the scientific enterprise in general. The historians of science Bernard Lightman and James A. Secord have shown that the nineteenth century was not only an era of professionalized science, it was also a time when ordinary people from across the social spectrum sought the opportunity to participate in science for education, entertainment, or both. In Victorian Britain, for example, science could be encountered in a myriad of forms and in countless locations: in panoramic shows, exhibitions, and galleries; in city museums and country houses; in popular lectures; and even in domestic parlor conversations that revolved around the latest scientific instruments, books, and periodicals.[21]

fig. 13 Engraving in **L'Illustration** 76, no. 1958 (1880), showing the projection of a photomicrograph during a public science lecture

Against this backdrop, illustrated lectures became one of the primary ways in which scientists and laypeople circulated newsworthy research (see fig. 13). The advantage of making photographs available via magic lantern projection, according to one scientist, was that the lecturers could use photographs to "fix the attention" of their audiences, whereas with ordinary paper diagrams the viewers' eyes tended to "listlessly wander."[22] Rather than storing lantern slides in boxes, where few would see them, this lecturer urged for them to be displayed more publicly, either in museum display cases or mounted in windows in scientific institutions. Such was the popular and scientific interest in the slides that, by the end of the nineteenth century, most of the photographs in the possession of scientific organizations, medical libraries, and teaching hospitals were part of boxed collections of magic lantern slides, which were sometimes made available for viewing or circulation.

Beginning around 1860, the world's scientific photography was also displayed in international exhibitions. Recent scholarship on photographic exhibition and display by Julie K. Brown has shed light on how institutions in the natural sciences and medicine made scientific research visible by means of photography.[23] There was initially a great deal of confusion about

21. See Aileen Fyfe and Bernard Lightman, eds., Science in the Marketplace: Nineteenth-Century Sites and Experiences (Chicago: University of Chicago Press, 2007); Bernard Lightman, Victorian Popularizers of Science: Designing Nature for New Audiences (Chicago: University of Chicago Press, 2007); and James A. Secord, Victorian Sensation: The Extraordinary Publication, Reception, and Secret Authorship of Vestiges of the Natural History of Creation (Chicago: University of Chicago Press, 2000).

22. Samuel Highley, "The Application of Photography to the Magic Lantern Educationally Considered," PN (September 30, 1864): 43–44.

23. See, for example, Julie K. Brown, Making Culture Visible: The Public Display of Photographs at Fairs, Expositions, and Exhibitions in the United States, 1847–1900 (Amsterdam: Harwood Academic Publishers, 2001), and Contesting Images: Photography and the World's Columbian Exhibition (Tucson: University of Arizona Press, 1994).

where, exactly, to display the photographs: with instruments and machines, or with artworks? One 1861 injunction advised exhibition organizers in Great Britain to separate photographic apparatuses from the photographs themselves; as this critic put it, "The mixing up of the photographic pictures with the instruments employed to produce them . . . is a gross philo-

sophical error." In 1861 a British photographic society refused to help with an exhibition unless the photographs were presented as artworks.[24] After an industrial exhibition in Marseilles, France, another critic complained that photography had been "relegated to the department where are shown pomatum pots, forcing pumps, and garden engines."[25] There was also a desire expressed by many photographers to differentiate clearly between pictures that had been retouched and those that showed no trace of manipulation, and between those that had previously been displayed in shop windows and those that had not. In the context of these debates photographers sought to differentiate further between scientific and artistic photographs. A typical complaint was that scientists showed little interest in or support for the advancement of photography itself, although as one noted, "Our big-wigs are always quite ready to use it to help their investigations on other sciences."[26] Yet some scientists, such as the astronomers Henry Draper, Warren De la Rue, and James Glaisher, for example, actively took part in the display and circulation of scientific photographs, saying that such exhibitions awakened public awareness of the utility of science, suggested areas for future scientific work, and served to publicize its results (see fig. 14).

Finally, illustrated newspapers and magazines were also important venues for making scientific photographs more widely available to the public. Several publications in Europe and the United States competed for the right to reproduce the first photographs of scientific discoveries, especially in popular subjects such as astronomy and meteorology. The first successful Mars photographs offer a good example—they were eventually circulated widely in all three formats for public viewing: slide lecture, exhibition, and print media.

The first successful photograph of Mars was made by Percival Lowell in the spring of 1905. Lowell was an amateur astronomer from Boston who moved to Flagstaff, Arizona, specifically to establish an observatory for viewing Mars. Lowell succeeded in capturing the first photograph of the planet after many had tried and failed during the 1880s and 1890s. To take the photographs Lowell and his associates, including Carl Otto Lampland, devised a series of experiments involving the aperture of the telescope, the required exposure time, and the

fig. 14 Charles L. Bristol
University of the City of New York exhibition at the Chicago World's Fair [featuring astrophotography by Henry Draper], 1893
Bromide print
8 x 10 in. (20.3 x 25.4 cm)
New York University Archives, Photography Collection

24 See, for example, "Photography and the International Exhibition of 1862," PN (June 14, 1861): 236. For complaints by French photographers about the English Commission's classification of photographs with cameras before the 1862 International Exhibition, see "French Photographers and the Exhibition," PN (July 12, 1861): 334. They pointed out, for example, that "silks are not put with looms."
25 "Photography at the Industrial Exhibition of Marseilles," PN (May 23, 1879): 242.
26 "Photography at the Royal Society," PN (January 30, 1880): 49.

grain of the plate (see fig. 15). Because the images on the photographic plate were so small and hard to see, they did not reproduce well. (This was a common problem: details that were faint on the negative were practically impossible to see when reproduced in print.[27])

In such situations editors were often obliged to compensate either by replacing photographs with engravings or lithographs "based on photographs," or by interpreting them for readers by means of diagrams or in some cases cartoons (see fig. 16). For example, newspaper and magazine articles popularizing scientific research in the new specialty of bacteriology frequently employed drawings and texts to compensate for photography's limitations. In one case an artist teamed up with a scientist to illustrate scenes of germ warfare "based on" knowledge acquired by means of photography; in the process viewers were encouraged to see bacteria as dark-skinned enemies that invaded the human body en masse and could only be defeated by white-skinned leukocytes and phagocytes, represented in words and pictures as "soldier heroes."[28] In this and other examples, racial and gender stereotypes, no less than the tropes of photography, became resources for rendering the truthfulness of scientific facts about bacteria when photographs proved inferior to represent them.[29]

In the case of Lowell's Mars photographs, the images were reproduced widely and in different settings (both with and without retouching to make the lines stand out more clearly). Lowell held that they provided proof of intelligent life (indeed, that they were "doubt-killing bullets"), asserting to a journalist for the *Wall Street Journal* that they offered evidence

fig. 15 Carl Otto Lampland
Twenty-eight views of Mars, 1907
Gelatin silver prints mounted on board
Overall: 4 7/8 x 6 3/4 in. (12.4 x 17.2 cm)
San Francisco Museum of Modern Art, Accessions
Committee Fund

fig. 16 Story in the **New York Herald** (July 30, 1905),
including illustrations based on the Lowell
Observatory's Mars photographs

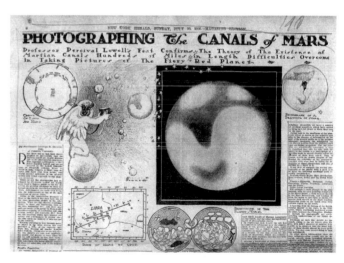

"of the same strength that might convict a criminal accused of murder in cases where there had been no actual witness of the deed."[30] Here, as in other similar cases, Lowell was forced to explain how the photographs had been made; in attesting to the mechanical objectivity of the

27. Discussed in William Graves Hoyt, **Lowell and Mars** (Tucson: University of Arizona Press, 1976), and Tucker, 207–33. For a wonderful discussion of the wider context of nineteenth-century visual representations of Mars, see Maria D. Lane, "Geographers of Mars: Cartographic Inscription and Exploration Narrative in Late Victorian Representations of the Red Planet," **Isis** 96 (December 2005): 477–506.
28. "The Army of the Interior," **Pearson's Magazine** (January–June 1899): 264. An example appears as fig. 4.8 in Tucker, 190.
29. See Tucker, 188–93.
30. Quoted in "Review and Outlook," **Wall Street Journal,** December 28, 1907.

pictures, however, his descriptions of the process compelled attention to the subjectivity, skill, training, and judgment required to see them properly. Furthermore, the special problems involved in reproducing photographic details in print put a special premium on their being seen in other venues, such as exhibitions and slide lectures. Lowell's reaching out to the reading public won him many supporters, including the science critic and essayist H. G. Wells, whose 1898 novel *The War of the Worlds* had made a literary case for the idea of life on Mars. Inspired by Lowell's work, Wells even wrote an article registering scientific views of what Martians might look like (illustrated by the artist William Leigh).[31]

As with other scientific experiments in the public eye, practitioners had to strike an elusive balance between science and showmanship. Public displays of scientific work were essential for bringing together multiple disciplines and for heightening public awareness (and financial patronage) of science. As with so many other scientific endeavors, however, it was also incumbent on scientists to help define the boundaries between "scientific" and "unscientific" ways of seeing or representing nature. When scientific photographers seemed to attract too much attention to their artistic compositions or technical skills, they risked being accused by peers of showmanship. As those who made pictures for scientific and medical atlases learned, even photographs in "objective" publications could be accused of having a "show" character that, according to critics, detracted from their scientific value.[32]

Seeing photographs, as nineteenth-century contemporaries discovered, did not always result in assent to the claims made for them; nor could scientists themselves be certain that their own interpretations of photographs would hold with viewers. As the historian of scientific photography Jon Darius perceptively writes: "Photographs, and *a fortiori* scientific photographs, utter sterling truths no more than do galvanometer readings."[33] Comparing different images that purport to show the same phenomenon is herefore instructive.

CONCLUSION: THE SOCIAL PHOTOGRAPHIC EYE

An understanding of the social boundaries of nineteenth-century science helps make sense of a certain paradox within contemporary attitudes toward photography of the invisible. The ideal of mechanical objectivity in documenting visual knowledge demanded the elimination of the artist-observer and all of the subjectivity implicit in drawing by hand. And yet there was little consensus as to how, or even if, this epistemic virtue could be achieved in practice. Contrary to what we might expect about scientific photography, disagreement over photographers' practical expertise, interpretive skills, and powers of judgment suffused scientific and popular discussions about photography of the invisible during the nineteenth century. Objectivity, it seems, was in the eye of the beholder.

31 H. G. Wells, "The Things That Live on Mars," *Cosmopolitan* 44 (March 1908): 335–42.
32 See discussion of Charles Slater and Edmund J. Wells's *An Atlas of Bacteriology* in "Reviews and notices on books," *Lancet* 153 (February 4, 1899): 309–10.
33 Darius, 19.

The conflicts around the interpretation and role of scientific photographs were at heart disagreements over what was known, how it was known, and what the knowledge was for.[34] Earlier in this essay I suggested that these issues might best be understood through the rubric of the social photographic eye, for the questions about knowledge and legitimacy raised by the genre were never the sole province of professional scientists. Photographic seeing in science was above all a social activity, and scientific photographs of the invisible were based on practices that were shaped by both artists and scientists, a fact that reflects the close intertwining of science and culture in the nineteenth century. Each of these fields was marked by intense variability in its professional practices and in the public understanding of its goals, standards, and spheres of knowledge. Nineteenth-century figures' diverse strategies for undertaking and disseminating scientific photography can thus be understood as evidence of the challenges inherent in navigating these ever-shifting conditions.

34 For a discussion that raises similar questions about the social processes of knowledge making and knowledge holding in the history of early modern science, see Steven Shapin, The Scientific Revolution (Chicago: University of Chicago Press, 1996).

representing Spirit from the higher
visiting those in darkness. Obtained
. C. Lacey, London, Aug. 1903.

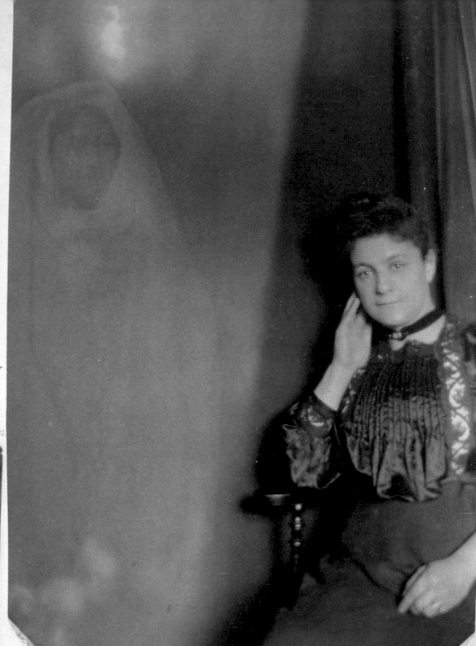

Spirit supposed to be the mother of
the Sitter, Mrs. N. Jacobs of London.
Boursnell, Photo-Medium, London, Sept./03

INVISIBLE WORLDS, VISIBLE MEDIA

Tom Gunning

I. SCIENCE AND THE INVISIBLE WORLD: PHOTOGRAPHY DISCOVERS NATURE

William J. Pierce
Details from the album
Spirit Photographs, ca. 1903
See also pls. 143–46

It was worse than anything. Mrs. Hall, standing open-mouthed and horror-struck, shrieked at what she saw, and made for the door of the house. Every one began to move. They were prepared for scars, disfigurements, tangible horrors, but *nothing*! The bandages and false hair flew across the passage into the bar, making a hobbledehoy jump to avoid them. Every one tumbled on every one else down the steps. For the man who stood there shouting some incoherent explanation, was a solid gesticulating figure up to the coat collar of him, and then—nothingness, no visible thing at all!
—H. G. Wells, *The Invisible Man* (1897)

AT THE TURN OF THE CENTURY H. G. WELLS OFFERED VISIONS OF THE FUTURE that balanced credible (if highly speculative) attempts at scientific explanation with scenarios that terrified his readers: evolution gone berserk, producing monsters; an extraterrestrial universe inhabited by alien beings intent on humanity's destruction; a mad scientist who achieves invisibility and initiates a reign of crime and terror. Compared to the more optimistic views of technological progress that his rival Jules Verne had offered some decades earlier, Wells's world of new technology seemed grim. Traditionally, invisibility had often been associated with ghosts and

phantoms, but Wells gave it a new material basis. His antihero, Griffin, is not a supernatural entity, but rather a scientist who attains invisibility through a series of experiments involving the nature of light and pigments in the human body. Once he has achieved invisibility through the manipulation of chemicals, however, Griffin goes beyond scientific demonstration to become a source of terror, an unseen nemesis prowling the English countryside. The ideology of scientific progress still held sway in the latter part of the nineteenth century, but the magical possibilities of technology also revived some of the dread associated with traditional supernatural beliefs. Science and technology envisioned a reality that teetered on the brink of nothingness. Rather than rational reassurance, the invisible realm revealed through scientific discovery generated a sense of deep uncertainty, an entrance into a new, unfamiliar world that seemed ghostly and insubstantial.

As the nineteenth century turned into the twentieth, two technological marvels were introduced to a broad public not only as scientific advances, but also as theatrical spectacles: projected motion pictures and the X-ray. Throughout the 1800s science demonstrators attracted crowds fascinated by the unusual spectacles they offered, while increasingly sophisticated visual technology in theater, opera, and magic shows attracted the attention of viewers intrigued by modern mechanical inventions. Moving pictures provided simultaneous entertainment and scientific novelty. In 1895 a number of technician-showmen projected cinematic images to paying audiences, culminating in the most successful and influential: the premiere of the Cinématographe by the Lumière family in Paris in December. In November of that same year Wilhelm Conrad Röntgen demonstrated his X-rays (see fig. 17). Throughout 1896 and 1897 cinema and X-ray machines were purchased not only by scientists, but also by entrepreneurs who displayed to ticketholders the skeletal structure lying beneath the flesh (while often unknowingly delivering fatal doses of radiation) or projected animated views of trains arriving at stations. Some impresarios thought X-rays showed even greater entertainment potential than "animated pictures"; in the 1890s show business trade journals carried advertisements placed by traveling exhibitors who wanted to exchange their motion picture projectors for X-ray equipment. Both technologies became part of a widespread culture of display and demonstration that ranged from educational science lectures at venues such as the Polytechnic Institute in London or the Cooper Union in New York to the magic theaters helmed by Georges Méliès in Paris or John Nevil Maskelyne and George Alfred Cooke in London.

fig. 17 Wilhelm Conrad Röntgen demonstrating X-rays, ca. 1900

The cinema and the X-ray demonstrated contradictory yet intertwined aspects of the modern technological world: the recording of ephemeral visual events and the revelation of invisible processes. Both media displayed visual experiences previously relegated to the realm of fantasy or magic. Projected cinema supplemented the still photograph with a new dimension of time and motion; the eye of the camera captured a moving memory that could outlast life itself and was endlessly repeatable. The X-ray, on the other hand, was an eye that rendered the surface of the body transparent, seeing through skin and flesh to bone and organs, penetrating to the core of things by stripping the visible world of its opacity. Although the two inventions may strike us as antithetical, they were occasionally fused in the public imagination. Some early journalistic accounts even claimed that cinematic images were produced using X-rays. Together the new inventions permitted vision beyond the horizon of human perception.

In the early twentieth century Sigmund Freud described modern technologies of communication and transportation as having transformed the human being into a "prosthetic God." Such developments had supplemented and magnified the innate human capacities of mobility, vision, hearing, and speech, much as the introduction of the microscope and telescope in the seventeenth century had multiplied the powers of the human eye with the aid of lenses and the optics of enlargement. This enhancement of human vision represented another step in scientific progress and the triumph of the rational, but it also produced a profound sense of vertigo. The finite visible and tangible world of material things was transformed into the mere surface of an infinite universe; the microscope and telescope revealed a limitless, expanding, and decentered space in which silence reigned. As the philosopher Catherine Wilson has shown, the microscope's discovery of whole worlds beneath the visible surface of things dissolved the ancient sense of the universe as operating according to an observable, God-given order, substituting instead a material reality that had to be objectively investigated and quantified. At the same time, both microscopes and telescopes had to overcome a longstanding prejudice against lenses, which were traditionally viewed as devices for tricking rather than aiding the eye—as barriers to truth and means of distortion rather than tools of knowledge.

In the latter half of the nineteenth century the new visual medium of still photography—and somewhat later the cinema and the X-ray—seemed to arm mankind with new tools of vision, following in the pathway of the telescope and microscope. Those technical devices not only aided scientific research, but also enlarged the dimension of the visual world beyond its seemingly secure boundaries, revealing previously unimaginable realms in which invisible threats might lurk. Since the invention of the microscope, caricatures in the popular press had teased laymen with the perils presented by the microscopic life hidden in a seemingly

1. Sigmund Freud, Civilization and Its Discontents, vol. 21, The Complete Psychological Works of Sigmund Freud, ed. and trans. James Strachey (London: Hogarth Press, 1955), 92.
2. See Catherine Wilson, The Invisible World: Early Modern Philosophy and the Invention of the Microscope (Princeton, N.J.: Princeton University Press, 1995).

innocent hunk of cheese or drop of water (see fig. 18). But the caricatures were inherently fanciful, and throughout most of the nineteenth century the microscope and telescope remained primarily technical instruments in the hands of professionals (and a few wealthy amateurs) who knew how to operate them. The objective nature of the microscope was only guaranteed by its combination with photography. Pioneers such as William Henry Fox Talbot created photographs with the aid of solar microscopes even before the middle of the nineteenth century

A DROP OF LONDON WATER.

(see fig. 19; pls. 1–3). Soon afterward, others succeeded in producing astronomical photographs, a somewhat more difficult achievement due to the low levels of light given off by heavenly bodies. Microscopic and telescopic photography combined new technologies of vision capable of recording as well as enlarging and also made the scientist's vision widely accessible for the first time via classroom and public lectures. Scientific photographs were exchangeable and storable, and they possessed a greater degree of accuracy than drawings. Although some scientists preferred the clarity and selectivity that drawing offered, photographs made using microscopes and telescopes placed the vast expanse of the material universe within the sight and grasp of the public.

While microscopic views allowed a rationalized survey and instrumental exploitation of nature, the occult worldview that the scientific gaze had banished could still be imagined lurking beneath the surface, possibly taking refuge in the human psyche. In his delightful novella *Master Flea* (1822), the German Romantic author E. T. A. Hoffmann imagined a battle between two seventeenth-century proponents of the microscope, Antony van Leeuwenhoek and Jan Swammerdam, over the possession of a magical flea, one of the tiny insects that optical enlargement had converted into a visually looming monster for the amusement of curious and terrified audiences (see pls. 11, 16–17, 20–21). In this technological fairy tale, the flea places a magnifying lens into Swammerdam's eye that allows the bug to examine not only the microscopic construction of the human eye, its "curious nerves and filaments whose wondrously tangled course he was able to follow far into the brain," but also, through this enlargement, to penetrate and discern the thoughts that brain contained.[3]

fig. 18 John Leech cartoon in **Punch** magazine (May 11, 1850) lampooning the microbes teeming in a drop of London water

Thus, from the middle of the nineteenth century on, photography intertwined with other visual devices not simply to record a recognizable world, but also to provide images of a previously invisible one. One could claim that these photographs offered a reassuring anchor for the dizzily enlarged knowledge of forces impinging on human life that had been

3 E. T. A. Hoffman, "Master Flea," in Three Märchen of E. T. A. Hoffmann, trans. Charles Passage (Columbia: University of South Carolina Press, 1971): 313–14

ushered in by scientific change. Throughout the nineteenth and early twentieth centuries these forces seemed increasingly to slip beneath the limits of vision. Magnetism and electricity ceased to be explained by the flow of particles and were now understood as dependent on large-scale, invisible force fields; Hertzian radio waves were revealed to be moving through the atmosphere, allowing the development of wireless communication; and subatomic particles became increasingly central to scientific theory. Older optical devices for aiding vision seemed almost reassuring in their visuality: telescopes and microscopes could produce legible images, but no device could show what electricity or radio waves really looked like.

In this brave new world, photography occupied a transitional point in which the invisible seemed not simply to haunt but possibly to control the visible. Thus the photographs of scientific specimens and astronomical phenomena included in this exhibition carry complex and even contradictory meanings. They may strike the contemporary eye with their abstract beauty, a result of their elementary arrangement of form and matter. But their usefulness for science lay in objectifying a vision doubly mediated through the magnifying lens and through the sensitive plate of the camera. Had science reached a point where the visual could only be trusted when it had been filtered through optical technology? The camera seemed to remove the vagaries of the human hand from the transcription of a specimen, but as the historians

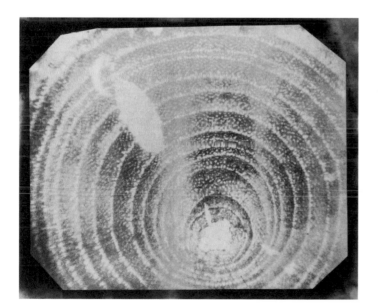

fig. 19 William Henry Fox Talbot
Slice of horse chestnut, seen through the solar microscope, 1840
Salt print
7 5/16 x 8 7/8 in. (18.6 x 22.5 cm)
Courtesy Hans P. Kraus, Jr., Inc., New York

Peter Galison and Lorraine Daston have shown, scientific illustration often had to balance the desire for complete visual accuracy with the need for clarity.[4] In some cases, very accurate photographs might not convey scientific information as clearly as abstract diagrams or drawn illustrations. Anything but a neutral medium, photography has played a major role in the history of modern technological vision, having transformed our sense of perception and reached beyond the boundaries of the visible.

In the middle of the nineteenth century, photography presented a scientific marvel: a seemingly magical transcription and preservation of the kind of images that had been captured for centuries by the camera obscura. Devised in the sixteenth century (although its phenomena had been observed since antiquity), the camera obscura used light entering through a small aperture (eventually enhanced with a lens for further concentration and focus) to project an image of the outside world onto a surface within a dark room or box (the "dark chamber" that gives the apparatus its name). The colorful moving images produced by the camera obscura provided entertainment, opportunity for scientific

4 See Lorraine Daston and Peter Galison, "The Image of Objectivity," Representations 40 (Fall 1992), 81–128, and Galison, "Judgment against Objectivity," in Picturing Science, Producing Art, ed. Caroline A. Jones and Peter Galison (New York: Routledge, 1998), 327–59.

observation, and guides for drawing (see fig. 20).⁵ Yet they remained as ephemeral as the play of light itself. Artists used them for producing drawings or even paintings, thus preserving them in a way, but the problem of how to seize and fix the images without the intervention of the artist's hand obsessed many researchers. The sensitivity to light of certain chemicals (such as silver nitrate) seemed to offer a possibility for capturing these images, but, as experiments showed, that very sensitivity would eventually darken the pictures to obscurity, condemning photography to a slow fade to black. The inventors of photography triumphed over time itself, first capturing the optical play of the camera obscura in a single fixed image and then preserving that image, like a mummified corpse, from the ravage that light wrought over time. Once fixed, a photograph presented an image of the world inscribed by light rather than by the hand of man (Talbot called the medium "The Pencil of Nature"). As the film theorist André Bazin put it, photography embalms time.⁶ But did it put time's phantoms to rest?

As part of the dialectic of modernity, photography could not retain its monumental status beyond the realm of time. Instead, throughout the nineteenth century the medium engaged in a struggle with temporality and became ever most closely entwined with, to use a phrase of Charles Baudelaire's, "the smack of the instant." What I am calling the monumentality of early photography rests partly on the long exposure time initially required to make an image, ranging from more than an hour for some early examples to the scores of seconds that became common by the point of photography's commercialization. (Portraits made in studio settings took so long to make that subjects required neck rests to hold their poses, resulting in a corpselike rigidity of body and expression.) The first photographers necessarily selected their subjects from the static and unmoving: sculpture, architecture, ruins, and landscapes. Pictures of the details of nature took on the appearance of emblematic specimens. Reducing exposure time became a major preoccupation in an era when chemical and optical processes represented a significant part of the craft (and, indeed, one of its main attractions). From the 1860s to the end of the century, photography entered a race against time that ended in a decisive victory. Yet the paradoxical relation of time, vision, and photography continued to occupy the medium's practitioners.

fig. 20 Gerard Vandergucht
Frontispiece of **Osteographia, or the Anatomy
of Bones** (1733), by William Cheselden
Etching with engraving
4 ⁵/₁₆ x 8 ¹³/₁₆ in. (11 x 22.3 cm)
Wellcome Institute Library, London

5. A concise summary of the camera obscura can be found in Philip Steadman, Vermeer's Camera: Uncovering the Truth behind the Masterpieces (Oxford: Oxford University Press, 2001), 4–24.
6. See André Bazin, "The Ontology of the Photographic Image," in What Is Cinema?, vol. 1, trans. Hugh Gray (Berkeley: University of California Press, 1967), 14.

fig. 21 Eadweard Muybridge
Mahomet, from **The Horse in Motion**, 1878
Albumen print
5 ½ x 8 ½ in. (14 x 21.6 cm)
San Francisco Museum of Modern Art, purchased
through a gift of Elizabeth Gates and Accessions
Committee Fund

The camera obscura presented a moving image. To fix that image meant to freeze it. Photography initially naturalized this violation of normal perception by imitating compositional schemes familiar from the pictorial arts. However, as photographers increasingly aspired to capture the instant, the medium moved farther away from pictorial models (although pictorial models were also being transformed, and the influence ran both ways) as well as from ordinary human perception. When, in the 1870s, Eadweard Muybridge succeeded in photographing a horse with all four hooves off the ground, seemingly suspended in midair (fig. 21), he did not portray a moment of a visual perception. No one had ever seen—no one could see—this frozen instant of motion. Muybridge's photograph proved the position of the horse in motion (and became a model for equestrian painters such as Jean Louis Ernest Meissonier and Frederic Remington), but it did not correspond to the phenomenon of human perception. Photography rendered visible what had been perceptually invisible by suspending the flight of time in a way no human eye could accomplish. The ability of photography to grasp the most instantaneous phenomenon with new speeds of exposure was demonstrated not only though images of animal and human bodies in motion (see pls. 76–94, 96–97), but also by capturing emblems of the instantaneous such as the lightning flash and electrical spark (pls. 102–9, 112–14).

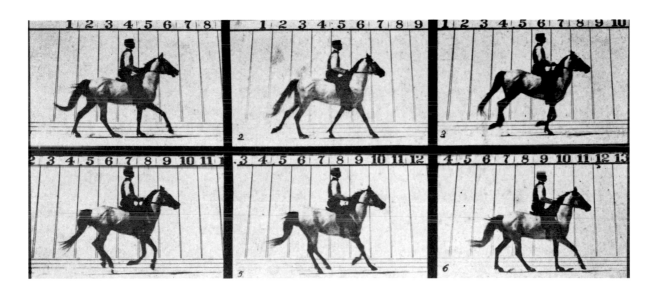

As a tool of preservation and pedagogy, photography did not simply offer a better way to present microscopic specimens; when subjected to the regimens of evidence that professional science had evolved, it also became a tool of empirical discovery. The French physiologist Étienne-Jules Marey used photography to record and analyze motion, employing a more strictly scientific approach than Muybridge had. Marey not only mastered rapid exposure

7 On the use of photography and cinematography for scientific purposes, see Scott Curtis, "Still/Moving," in Memory Bytes: History, Technology, and Digital Culture, ed. Lauren Rabinovitz and Abraham Geil (Durham, NC: Duke University Press, 2004), 218–54.

but also managed its regularity, so that a moving body could be sliced into a predictable series, marking the phases and positions of ongoing movement (see fig. 22; pls. 79–85). Scientific photography could measure time with regular exposures, as the astronomer Pierre Jules César Janssen demonstrated by photographing the transit of Venus in 1874, capturing the planet moving across the sun at regular one-second intervals (pl. 59). Marey's chronophotographs, or "pictures of time," rendered visible the effects of time and motion, but the images remained haunting. As scientifically grounded as his pictures were in terms of method and purpose, their strange, often semitransparent appearance—their repetition of a single body across a trajectory of motion—seemed uncanny. His figures resembled phantoms even as they demonstrated principles of anatomy and physics.

II. ANOTHER INVISIBLE WORLD: CAN PHOTOGRAPHY CAPTURE SPIRITS?

> "Yes, Geert, but are you so sure there's no such thing?"
>
> "I wouldn't say that. It's one of those things you either believe in, or preferably, don't. But assuming there is such a thing, what harm does it do? The fact that there are germs floating around in the air, as you'll have heard, is much worse and much more dangerous than all this spectral activity. That is if specters are active and such things really exist."
>
> —Theodor Fontane, *Effi Briest* (1895)

As it developed over the nineteenth century, photography extended human vision beyond its physical possibilities, showing things that no person could see. The invention was undoubtedly a triumph of technology and science, yet its strange intertwining of the visible and the invisible also produced the apparently irrational deviation of spirit photography. If today we find the concept of photographing ghosts risible, we have to wonder if this is simply because we no longer believe in spectral activity, or if it is because we have learned more about photography. In the second part of the nineteenth century, both the conception of ghosts (or spirits) and the practice of photography were in the process of redefinition. By the turn of the century, photography had moved from providing a record of our visual experience to becoming, as the photography historian Michel Frizot puts it, "in the most scientific way possible, the proof of the reality of the invisible." Though we may think belief in ghosts is archaic, in the mid-nineteenth century there emerged a new attitude toward spirits that saw itself less as the survival of ancient superstition than as the avant-garde of a new rationality fully in concert with recent

8 Theodor Fontane, Effi Briest, trans. Hugh Rorrison and Helen Chambers (London: Penguin, 1995), 58. My thanks to Malika Maskarinec for drawing my attention to this exchange in Fontane's novel.
9 A New History of Photography, ed. Michel Frizot (Cologne: Könemann, 1998), 282.

scientific technology and theory. The ghost itself moved from a terrifying phantom to a figure of reassurance and consolation whose presence could be scientifically established.

Known as Spiritualism, this movement of redefinition originated in the United States and drew on a number of sources: traditional Protestantism (especially Calvinist doctrines); the writings of Emanuel Swedenborg, who claimed to communicate with divine beings about the nature of heaven and hell; mesmerist conceptions of animal magnetism, trance healing, and revelations; and the inspiration and prophecy practiced in popular enthusiastic religions, ranging from Methodist revivals to the extremes of the Shakers and Mormons. The core beliefs of the Spiritualist movement included the survival of the human soul after death and its ability to communicate with the living. Spiritualism took a more beatific and gentle view of the afterlife than Calvinism did; it had a forgiving attitude toward human weakness that included a faith in the possibility of continued perfection even after death. Although a variety of Spiritualist churches and associations appeared, the movement never adopted any official creed or institutionalized hierarchy of churchly offices. Perhaps closest to radical Quaker movements, it valued individual revelation and divine communication over doctrine, and founded itself in manifestations of the spirit world rather than in rituals.[10]

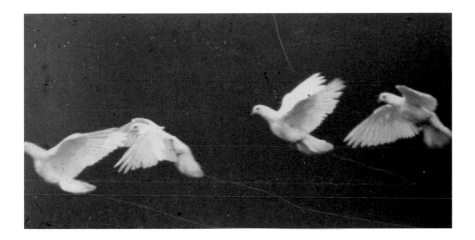

fig. 22 Étienne-Jules Marey
Pigeon in flight, ca. 1888
Glass lantern slide
1 3/4 x 3 3/8 in. (4.4 x 8.6 cm)
Courtesy Susan Herzig and Paul Hertzmann,
Paul M. Hertzmann, Inc., San Francisco

While the mundane nature of these manifestations now makes Spiritualism seem an aberrant episode in the history of world religion, for its adherents the movement's reliance on evidence demonstrated its modernity and scientific nature. Although the degree of credulity Spiritualists possessed may seem astonishing today, the movement did not view itself as a faith, but rather as a metaphysics founded on empirical inquiry. Spiritualism detoured around the tangle of faith, grace, damnation, and justification that tormented the American Puritan and Calvinist traditions, substituting direct testimony from the spirits themselves (like Swedenborg's angels) for systematic theology. And although writers such as Andrew Jackson Davis in America and Alain Kardec in France tried to fashion a Spiritualist system, direct communication and the spectacle of manifestation explain Spiritualism's worldwide popularity. Spiritualism promoted values that went beyond mere materialism, but it also maintained that its tenets could be confirmed by scientific investigation, leading to a modern synthesis of knowledge and religious belief.

10. The accounts of Spiritualism that first shaped my sense of the movement were Ann Braude, Radical Spirits: Spiritualism and Women's Rights in Nineteenth-Century America (Boston: Beacon Press, 1989); R. Laurence Moore, In Search of White Crows: Spiritualism, Parapsychology, and American Culture (New York: Oxford University Press, 1977); Janet Oppenheim, The Other World: Spiritualism and Psychical Research in England, 1850–1914 (Cambridge: Cambridge University Press, 1985); and Alex Owen, The Darkened Room: Women, Power, and Spiritualism in Late Nineteenth-Century England (London: Virago, 1989). These have been supplemented by Robert S. Cox, Body and Soul: A Sympathetic History of American Spiritualism (Charlottesville: University of Virginia Press, 2003); and Bret E. Carroll, Spiritualism in Antebellum America (Bloomington: Indiana University Press, 1997).

Bereft of rituals, Spiritualism's main practice lay in demonstration and manifestation—in something that could be described as a spectacle and that eventually became known by the French term *séance*. Initially, in the era before the Civil War, these manifestations were primarily aural and verbal. The medium, the person (most frequently a woman) through whom spirits communicated, played a central role; however, as the term implies, she served primarily as a means by which the spirit phenomenon could become manifest. The first communications used cracking or thumping sounds, which gave practitioners the name of "spirit rappers." The medium interpreted the rapping noises through codes that allowed spirits to be asked about their identity and deliver messages to inquirers. Although metaphysics was often discussed, the most frequently sought-after communications included proof of an existence after death—personal reassurances that loved ones were doing well in the afterlife and were concerned about those on earth, offering advice and the hope of an ultimate reunion.

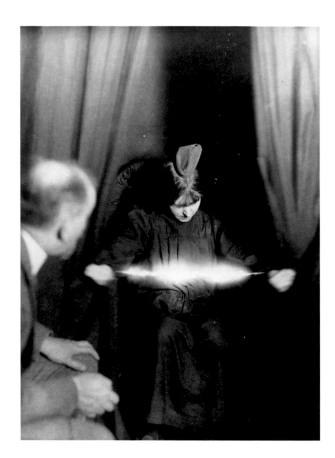

As Spiritualism developed after the Civil War, it increasingly displayed physical and visual phenomena. The audience's senses could be affected by the smell of perfumes, the sensation of touch (including caresses, kisses, slaps, and even hair pulling), the sounds of musical instruments, and a variety of visual phenomena, from disembodied hands floating through the air to full-bodied manifestations of spirits that walked around the room or levitated. Spirits sometimes left behind physical signs: formless ectoplasm extruded from the orifices of their medium, gifts of fruit or flowers ("apports" from the spirit realm), or impressions in wax or plaster. Some spirits put on a rousing good show, as musical instruments sailed through air cacophonously or unexplained lights and sounds assaulted the members of the séance. These events were so spectacular that they were often presented in theaters with audiences of both believers and skeptics paying to witness them. Indeed, modern stage magic received a major impetus from Spiritualist séances; nearly every major illusionist of the nineteenth century offered a "fake Spiritualist" show aimed at debunking rivals by presenting the same phenomena as illusions, exposing the means pretend séances used to achieve their effects.[11]

Given Spiritualism's emphasis on evidence and modernity, it was perhaps inevitable that the movement would enlist photography as a medium of manifestation that carried an association with science and veracity.[12] Photography underwrote Spiritualist claims

fig. 23 Albert von Schrenck-Notzing
The medium Eva C. with a materialization on her head and a luminous apparition between her hands, 1912
Gelatin silver print
9 7/16 x 7 1/16 in. (24 x 18 cm)
Institut für Grenzgebiete der Psychologie und Psychohygiene, Freiburg im Breisgau

11 The relation between magicians and Spiritualism is documented in The Mediums and the Conjurors, ed. James Webb (New York: Arno Press, 1976), and is treated particularly thoroughly in a forthcoming book by Matthew Solomon, Disappearing Tricks: Silent Film, Houdini, and the New Magic of the Twentieth Century (Urbana: University of Illinois Press).

12 Spiritualist interest in modern media went beyond photography to the telegraph (which supplied an analogy for the spirit rappers) and eventually to radio and television, as has been explored by Jeffrey Sconce in Haunted Media: Electronic Presence from Telegraphy to Television (Durham, NC: Duke University Press, 2000).

in a number of ways. Most compellingly, photographs were used to record Spiritualist manifestations at séances. Perhaps the most famous of these were the pictures of séances with the medium Florence Cook taken by the renowned British scientist William Crookes in 1874. Crookes (whose cathode ray tube was essential to the discovery of X-rays and later to the development of television) was one of a number of prestigious nineteenth- and early-twentieth-century scientists (others included the theorist of evolution Alfred Russel Wallace and the physicist Oliver Lodge) who embraced Spiritualism for at least some period of their lives. Like most photographs of full-body manifestations, the Crookes photographs display tacky stage managing and an eerie visual quality, oscillating between the amusing and the truly creepy. Later Spiritualist séances were photographed both by their advocates (as in the pictures of the medium Eva C. [see fig. 23]) and by investigative bodies such the Society for Psychical Research, which was organized by scientists and scholars sympathetic to Spiritualist claims but desirous

fig. 24 Unknown Photographer
Untitled, ca. 1850
Daguerreotype
3 5/8 x 3 1/4 in. (9.2 x 8.3 cm)
San Francisco Museum of Modern Art,
Accessions Committee Fund

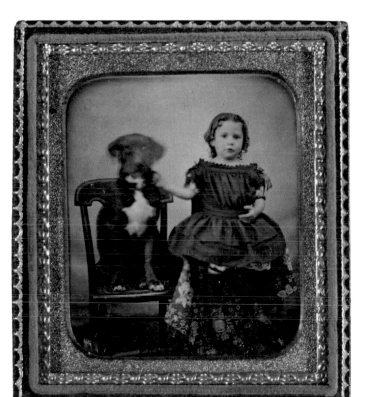

of testing them as rigorously as they knew how. Photographs showing mediums dripping ectoplasm from their noses or mouths (or even more alarming orifices), suspended phantoms, and wax impressions of spirit hands and other artifacts were published in Spiritualist tracts and placed in the journals and files of investigative societies.

But more fascinating to my mind than photographic records of séances are the pictures that record phenomena invisible to any witness but the camera (and sometimes even mediums). Photography became a Spiritualist tool, a means of penetrating and revealing the invisible aspect of the spirit world. The long exposure times of the nineteenth century frequently caused "ghosts" to appear on photographic plates: if someone moved or left the frame while the shutter remained open, the camera recorded a semitransparent trace rather than a solid figure (see fig. 24). Or, in this era of glass negatives, a plate might be reused without proper cleaning and thus produce ghostly double exposures. Such images could also be created intentionally as a form of photographic amusement. Soon after the Civil War, William H. Mumler, a commercial photographer in New York, produced pictures featuring "extras" that he claimed to be products of (and the images of) spirits. The photographs showed, alongside conventional portraits, oddly virtual images of figures, often transparent or in apparently impossible orientations,

floating in space (see fig. 25). The pictures, Mumler claimed, revealed the spirits that surrounded those who sat for their portraits. The photographs therefore revealed a reality that Spiritualists claimed was omnipresent but invisible to the ordinary eye. On the eve of the development of photography as a scientific tool, spirit photography offered the fulfillment of the scientific ambitions of Spiritualist manifestations. Even before the perfection of high-speed exposures or Röntgen's X-rays, Mumler and the Spiritualists offered photographs that rendered visible a previously invisible dimension of human experience.

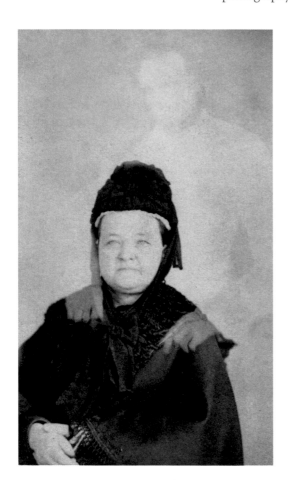

The logic of spirit photography was novel and this supplied part of its power. In Mumler's time commercial photography, though pervasive, had existed for less than a generation and had been subject to continuous technological development. Was photography itself a Spiritualist medium, inherently sensitive to the invisible world of spirits? If so, why were spirit photographs remarkable and infrequent? Spiritualists forged a solution, a synthesis of technology and the supernatural that endowed photography with a spiritual dimension and supplied Spiritualism with an apparently scientific form of evidence. It was not simply photography's chemical sensitivity to light that recorded the hitherto invisible emanations of the spirit world. Like a medium at a séance, a photographer like Mumler was a "sensitive" who "channeled" supernatural influences into the camera. In fact, the sensitized photographic plate played a more crucial role than the camera itself; some photographers claimed to be able to produce spirit images simply by resting a hand—or their subject's—on a plate (see pls. 141, 147–48, 156).

The scientific claim for spirit photography seemed to recall (and in Mumler's case even to anticipate) photography's ability to reveal otherwise unseen phenomena and subject them to observation and analysis. However, the fact that amateur and professional photographers had produced similar images for years, allied with religious prejudice against the new belief system, led to widespread attacks on Mumler and ultimately to his trial for fraud. The prosecution's case against Mumler took two tacks: it questioned the process by which he produced the photographs and it portrayed Spiritualist belief as contrary to Christian dogma. Spiritualism encountered perhaps even more resistance from the Protestant and Catholic churches than from scientists and rationalists. However, over the subsequent decades, as more spirit photographers appeared around the world, legal prosecutions also multiplied. Many photographers were successfully convicted, and their confessions were frequently accompanied by explanations of how their apparently supernatural images had been produced.

fig. 25 William H. Mumler
**Mary Todd Lincoln with the spirit of
Abraham Lincoln,** ca. 1870
Albumen print
3 ¾ x 2 ½ in. (9.5 x 5.7 cm)
Wm. B. Becker Collection / American Museum
of Photography

Spiritualism continued to hope that its phenomena might be scientifically verified, but its actual nature as a system of belief became increasingly evident in the tenacity with which its devotees clung to the authenticity of spirit photography, even as its devices were exposed as fraudulent. Spiritualism (along with its more intellectually sophisticated offshoot, Theosophy) exerted a more lingering influence through its effect on many of the earliest practitioners of modern art, from the artisans of Art Nouveau and the painters of enigmatic symbolist canvases at the turn of the century through the Expressionists, Futurists, and Surrealists of the following decades. As Linda Dalrymple Henderson has shown in her magisterial work on Marcel Duchamp, the confluence of new tools of science (exemplified by the X-ray), new technologies of representation (the cinema), and new systems of thought (Spiritualism) propelled a number of creative figures to rethink the means and purposes of the visual arts.[13] Modern artists aspired to portray something other than just the appearance of reality, which, it was often claimed, should be left to photographers. But this does not mean that either photography or the nature of the modern world became restricted to what the eye could see. The new scientific culture imbued daily life with forces that could not be witnessed directly. Crookes, in his 1896 presidential address to the Society for Psychical Research (which likely had an influence on Duchamp), claimed that the discovery of X-rays shifted our sense of reality away from the tangible and visible evidence of the senses and toward a universal sensation of vibration, the oscillation of energy that lay behind electricity, magnetism, and perhaps the nature of consciousness itself.[14] Could photography provide the sort of sensitive medium that could capture this new vibrating, rather than visual, universe? In the 1890s the French doctor Hippolyte Baraduc used photographs to record abstract visual patterns he believed were produced not by ghosts, but rather by the invisible energy of thought and emotion (see pl. 141), recalling Hoffmann's fantasy of a magnifying lens that could reveal not just the material structure of the brain but the very process of thought. If such claims now seem part of an innocent past, this may be because the imaging of invisible processes has moved more recently toward technologies such as the MRI, while artistic representations of the invisible have tended to substitute irony for faith. The belief that photography could discover a new spiritual world now seems naive and perhaps a bit touching, but capturing the invisible remains an ultimate horizon for both scientific and artistic practice.

13 See Linda Dalrymple Henderson, Duchamp in Context: Science and Technology in the Large Glass and Related Works (Princeton, NJ: Princeton University Press, 1998).
14 Ibid., 6.

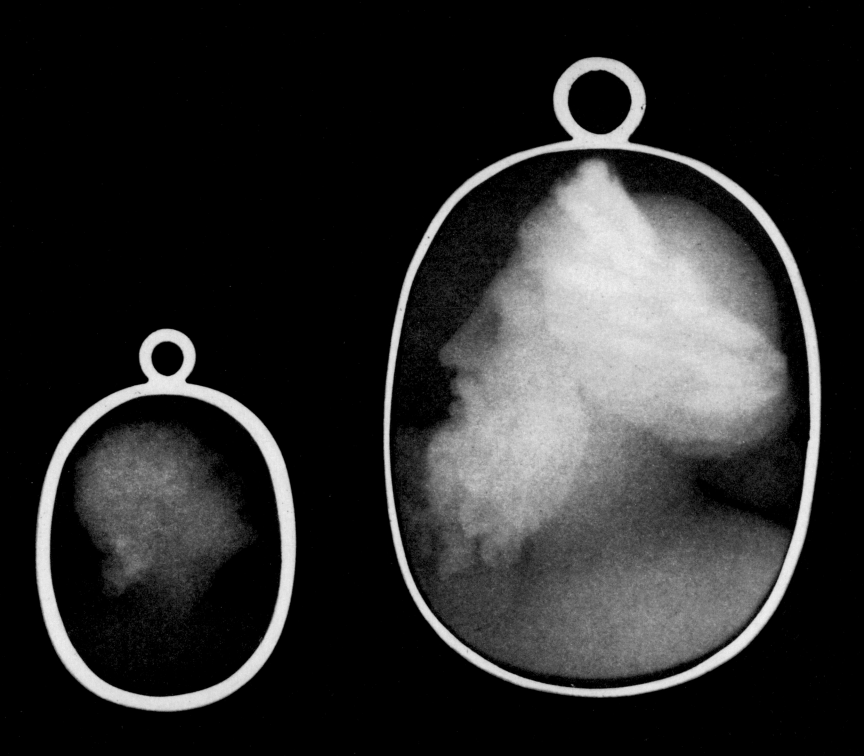

"ALMOST A GAME OF CHANCE": JOSEF MARIA EDER AND SCIENTIFIC PHOTOGRAPHY

Maren Gröning

Josef Maria Eder and Eduard Valenta
Cameos in gold settings, 1896
Detail of pl. 118

THE AUSTRIAN CHEMIST JOSEF MARIA EDER (1855–1944) was one of the most important scientific photographers in the nineteenth century. He was also a highly effective propagandist, a skill that proved crucial to the establishment, in 1888, of a special school, the Lehr- und Versuchsanstalt für Photographie und Reproduktionsverfahren (Training and Research Institute for Photography and Reproduction Techniques), in Vienna. It was not the first such institution to be established: the French Conservatoire des arts et métiers, for example, was founded in Paris in 1794. However, in the late nineteenth century—a time of great controversy concerning the fundamental position of photography in scientific pursuits—Eder's school became a model institution with an international reputation.[1] An examination of the circumstances surrounding the school's founding, as well as the eventual conflict between its twin goals of research and training, does much to illuminate the state of scientific photography in Europe at that time.

Contrary to a notion widespread in the nineteenth century and frequently resuscitated today, the establishment of photography as a tool and an object of scientific research was by no means accomplished without friction. That would have required, on the one hand, a general recognition that photography was not a simple input-output machine, but rather a technical pursuit involving different mechanical parts that could be handled or combined in a variety of ways; and, on the other, a sense that technical and scientific achievement were not one and the same. In 2000 the art historian André Gunthert published an

1. See Monika Faber, "Josef Maria Eder and Scientific Photography 1855–1918," and Astrid Lechner, "Fine Arts Photography at the Graphische Lehr- und Versuchsanstalt in Vienna 1888–1955," in *The Eye and the Camera: The Albertina Collection of Photographs,* ed. Monika Faber and Klaus Albrecht Schröder (Paris: Seuil, 2003), 146–69, 172–99.

extensive essay on this topic. In it he refers to an 1879 lecture given at the Sorbonne in Paris by Alphonse Davanne, then president of the Société française de photographie. The focus of Davanne's talk was the lack of academic recognition of photography.

As Gunthert points out, the idea that photography should be accepted as a scientific discipline was a daring one; the new medium had been met with considerable skepticism, especially in the late nineteenth century, with respect to its ability to make precise and reliable images of the visible world. Once it crossed the threshold of the invisible, it was impossible to prove its systematic basis.[2] There was no single, accepted notion of what scientific photography might be, and in Davanne's time only a very few were willing to bridge this epistemological gap by openly embracing the "medium's heuristic function"—its service as an aid to learning, discovery, or problem solving through experimental methods, especially trial and error.[3] To achieve this ideal required a fundamental grasp of photography's inherent qualities and potential uses, rather than a more limited view of it as a literal transcription of reality. Although it was common at the time to refer to photography as a science, it was usually so termed in order to make it more socially acceptable or to defend its legitimacy. As late as 1889, on the occasion of the fiftieth anniversary of the first publication on photography, Davanne was still boasting of the honor paid to the Société française de photographie by the attendance of "science personified," the noted astronomer Pierre Jules César Janssen, at one of the Société's 1876 meetings. It was the scientist's reputation that mattered: an "utterly symbolic victory still unsupported by facts."[4]

What did Eder have to say about this controversy? It is still generally thought that Eder's role in the history of photography was not so much that of a scientist as a historian. This may reflect the fact that of his many independent writings, only *Die Moment-Photographie in ihrer Anwendung auf Kunst und Wissenschaft* (Instantaneous Photography as Applied to Art and Science, 1886) and *Geschichte der Photography* (History of Photography, 1932) were made available to international readers in translation. Even his fellow German speakers reached the conclusion early on that it was precisely Eder's interest in historical matters—clearly unusually intense for a scientist—that constituted the "enduring value of his works."[5] There is no question that for Eder the scientific respectability of photography was a matter of serious, even urgent concern. Yet in his best-known work, *History of Photography*, there are but few traces of such programmatic intent. And not because the issue was pushed aside by aesthetic considerations; in fact, there is only marginal discussion of photography as art.[6] The problem is rather that in his diachronic view of the field of photography Eder appeared to see virtually no tensions, breaks, or contradictions. He offered little, theoretically or methodologically, to back up his argument. The only controversy surrounding his work is its apparent nationalistic slant.

2 See André Gunthert, "La retine du savant. La fonction heuristique du savant," Études photographiques 7 (May 2000): 29–48. One notable example was the issue of how to reproduce the structure of the spectrum represented by Fraunhofer lines. According to Klaus Hentschel, the conflict between traditional (manual) graphic methods and new photographic ones only increased as photographic techniques improved. See Hentschel, Mapping the Spectrum: Techniques of Visual Representation in Research and Teaching (New York: Oxford University Press, 2002), 192.

3 See Gunthert, 31. He borrows here from an 1888 statement by Albert Londe, the house photographer at the Salpêtrière Hospital, who defined this function as photography's "capacity to lead, beyond its documentary purposes, to 'results that we could not have obtained without it.'" See Londe, La photographie moderne: Pratique et applications (Paris: G. Masson, 1888), 158.

4 Quoted in Gunthert, 34, 35.

5 Otto Krumpel, "Dr. Josef Maria Eder und seine Stellung in der Entwicklung der Photographie und ihren Techniken," in Fritz Dworschak and Otto Krumpel, Dr. Joseph Maria Eder: Sein Leben und Werk zum 100. Geburtstag (Vienna: Graphische Lehr- und Versuchsanstalt, 1955), 48.

6 Eder's comments on this subject, though brief, show that he was perfectly capable of moving with the times. The chapter on the beginnings of art photography added to the fourth edition of History of Photography mentions that the writers and curators Max Lehrs in Dresden and Heinrich Schwarz in Vienna were responsible for the art-historical reevaluation of early photographs by David Octavius Hill; see Josef Maria Eder, Geschichte der Photographie, 4th edition (Halle, Germany: Knapp, 1932), 483. In Edward Epstean's American translation Lehrs's name was dropped; see Eder, History of Photography, trans. Edward Epstean (New York: Columbia University Press, 1945), 348.

However, Eder vehemently rejected that very accusation in the foreword to the last edition of *History of Photography*, and in so doing distanced himself from other contributions to the literature, "particularly several of recent German origin." Of course, it is possible to see this as confirmation of a bias to which he had given little thought. At the same time, Eder's history is considered the paradigm of the sort of linear, not to say streamlined, narrative of the achievements and advances of photography to which today's postmodern critics, especially, object. One might mention the radical approaches of Peter Geimer and Geoffrey Batchen, who advocate that in the interest of a more sophisticated presentation of the subject, studies of the history of photography should include, on principle, works that were either failures or subsequently disintegrated, and also carefully consider all conceivable information preserved in photographs. Timm Starl, who recently described Eder as personifying the nineteenth century's "technical," almost antipictorial concept of photography, nevertheless concedes that Eder did keep in mind the question of how photographs are made, even if he did not choose to engage with their aesthetic aspect, which Eder deemed too arbitrary to address.

Here I would like to call attention to two texts in which Eder's unquestioned dialectical (not to say polemical) gifts can be better appreciated. The first is a lecture he gave on January 29, 1885, at the Österreichisches Museum für Kunst und Industrie, Vienna, proposing "the introduction of photography in art schools and the creation of a photography research institute in Vienna." Here, Eder took up a proposal made as early as 1879 by Emil Hornig, then president of the Vienna Photographic Society, who had argued for a scientifically based "research studio for photography" to be subsidized by the state. In many respects Hornig's thinking resembled that of his near contemporary Davanne, inasmuch as he felt that closer contact between photographic practice and the "spirit of scientific research" would bring about a "higher development." Hornig noted that since the late 1850s the cultivation of the medium had increasingly become the province of practitioners "who can hardly devote themselves to time-consuming investigations without unduly neglecting their business, who are moreover inclined as a rule to keep secret from their competitors any discoveries they have made, and finally who by virtue of their training often lack the necessary scientific qualifications and are therefore insufficiently familiar with the principles of proper research." He repeatedly called for the publication of the newest photographic methods "without reserve."

Similarly, among Eder's primary targets in his 1885 lecture were "professional photographers" or "practitioners" with a narrow-minded focus on profits. Lamenting the commercial sector's resistance to innovation, he noted "the remarkable fact that the majority of the discoveries in photochemistry have been made not by photographers, but by scientifically trained dilettantes, physicians, chemists, who have undertaken their researches at their

7. Eder, **History of Photography**, ix. One might note that nationalistic debate, in a modern sense, was officially frowned on by the Habsburg dynasty, which wanted to be perceived as a multiethnic, though definitely monarchic, state.

8. See Peter Geimer, "Was ist kein Bild? Zur 'Störung der Verweisung,'" in Ordnungen der Sichtbarkeit: Fotografie in Wissenschaft, Kunst und Technologie (Frankfurt, Germany: Suhrkamp, 2002), 313–41; Geoffrey Batchen, "When This You See: Photography, History, Memory" (lecture, Dutch Eyes, Amsterdam, January 20, 2005), http://www.dutch-eyes.nl/stw/01ABatchenLecture.pdf (accessed May 17, 2008), and Timm Starl, "Bilderatlas und Handbuch. Zu einigen Aspekten der fotogeschichtlichen Darstellungen bei Josef Maria Eder und Hermann Krone," in Der Photopionier Hermann Krone: Photographie und Apparatur; Bildkultur und Phototechnik im 19. Jahrhundert, ed. Wolfgang Hesse and Timm Starl (Marburg, Germany: Jonas Verlag, 1998), 215–24.

9. Rudolf Junk, Eder's successor as director of the Graphische Lehr- und Versuchsanstalt, published a review of the 1932 edition of Eder's **Geschichte der Photographie** in which he commented that "Eder was and is not 'so completely surrounded with love and admiration'—as the afterword [the Eder biography by Hinricus Lüppo-Cramer] concludes. He is no cuddly lamb wreathed in roses but rather a contentious man who wields a sharp blade." Junk, "Geschichte der Photographie: Von Hofrat Prof. Dr. Josef Maria Eder," **Photographische Korrespondenz**, no. 817 (1932): 159.

10. See Josef Maria Eder, "Über die Einführung der Photographie an Kunstschulen und die Errichtung einer photographischen Versuchsanstalt in Wien," **Mittheilungen des k. k. Österreichischen Museums für Kunst und Industrie** (1885): 409–14, 441–43.

11. See Emil Hornig, **Memorandum über die Bedeutung und Nothwendigkeit eines Versuchsateliers für Photographie in Wien** (Vienna: Dr. Emil Hornig, 1879).

12. Ibid. Hornig probably knew about Davanne's appearance at the Sorbonne the same year, for the Société française de photographie and the Vienna Photographic Society had maintained friendly relations for some time.

own expense and by voluntarily taking time from their careers."[13] Eder goes on to conclude: "In such circumstances the development of photographic methods has become almost a game of chance, and even now, under the present conditions, the development of a number of processes must still be credited to coincidence." Eder's concern was not entirely unwarranted; in the field of photochemistry in the late nineteenth century there were doubtless a number of "ambitious charlatans who relied on the gullibility of photographers," while photography was equally notorious for providing a haven for all sorts of "quacks and profiteers."[14] In any case, Eder did put his finger on the problem: the "practitioners" were disinclined to share their knowledge and the "dilettantes" all too ready to do so; the public perception of photography (and clearly of photochemistry as well) was therefore too limited and vague.

As for Eder's response to the situation, it must be noted that he, far more effectively than his colleague Hornig, was able to tap into the groundswell of particularly creative and constructive reformist thinking that Austria was experiencing at the time, one that called for both social reform and a reexamination of educational policies. This culminated in the concept of state trade schools, an idea put forward by Baron Armand von Dumreicher in 1875. A major feature of Dumreicher's scheme was a reemphasis on general subjects such as German, mathematics, history and geography, physics, and mechanics. He ultimately saw to it that the business of vocational training was shifted entirely from the Ministry of Trade to the Ministry of Education.[15] The Dumreicher reform was certainly influenced by international competition—a similar movement emerged in France after the Franco-Prussian War, resulting in state support of astronomy in particular. But Dumreicher's idea was to improve Austria's standing by offering progessive research and learning to average, middle-class trade professionals without academic degrees and with relatively short-term commercial interests. Since the founding of the Österreichisches Museum für Kunst und Industrie had been a first step in the direction of the state trade schools Dumreicher would later achieve, simply by choosing it as the forum for his 1885 lecture Eder could be sure that his remarks would be interpreted in the context of reform.[16] The following year Eder allied himself with the Central Commission for Vocational Education Affairs, established as an advisory body within the Ministry of Education, by publishing in its official organ an article on "Photography as a School Subject."[17] In this text, a significant reworking of his earlier argument, Eder emphasized even more strongly that photography could no longer be considered "a very simple, unexacting matter," even less a mere "subordinate trade." He also repeated his demand that photography be recognized as having a "generally instructive effect," in that it sharpened one's appreciation for causal relationships and awareness of errors of all kinds. It would therefore help to develop the ability, as he put it, "to work purposefully." Here he expressly referred to an important focus in the new curriculum:

13 Here one notes a somewhat confusing conflation of photochemistry and photography. See Eder, "Über die Einführung," 412.

14 Hermann Wilhelm Vogel, quoted in Hentschel, 254, 423.

15 Dumreicher had a doctorate in law, and in 1869 had entered a civil service career. See Josef Schermaier, "Die berufsbildenden Vollzeitschulen—ein bedeutender Bildungsfaktor im österreichischen Bildungswesen," Salzburger Beiträge zur Erziehungswissenschaft 5, no. 1 (Spring 2001): 63–85, available online at http://www.sbg.ac.at/erz/salzburger_beitraege/fruehling2001/inhalt_1_2001.html (accessed April 14, 2008).

16 The first of its kind on the continent, the museum was established in 1864 on the model of London's South Kensington Museum (now the Victoria & Albert), and has been associated with a school of applied arts since 1868.

17 Josef Maria Eder, "Die Photographie als Schuldisziplin," Supplement zum Centralblatt für das gewerbliche Unterrichtswesen in Österreich (1886): 17–21.

instruction in drawing. The most diverse forms of visual design and spatial planning—freehand, geometrical, ornamental, and mechanical drawing—had been accorded a major role (up to twenty hours per week). Given that precedent, how could one so completely ignore the possible contribution of photography, "though it is the most important ancillary science to the drawing disciplines"?[18] This question was perhaps the most logical and persuasive of the arguments with which Eder confronted those responsible for Dumreicher's educational reform in the Austrian Ministry of Education in 1885 and 1886. He must have made a considerable impression, for in 1887 the ministry decided to establish the Lehr- und Versuchsanstalt für Photographie und Reproduktionsverfahren as a separate affiliate of a state trade school; it opened in 1888 with Eder as its first director. The Austrian authorities spent an astonishing sum of money in subsequent years to improve the standing of photography, both in its scientific applications and in its artistic and commercial uses. Spending continued through the spectacular 1909 International Photographic Exhibition in Dresden and the 1914 International Exhibition of the Book Industry and Graphic Arts in Leipzig, where Austrian photographers and graphic designers exhibited in their own pavilion.

In 1897 a book publishing and illustration department was added to Eder's institute. That same year the school obtained its final charter and came to be known as the Graphische Lehr- und Versuchsanstalt (GLV). The full course for regular day students, who could enter at age fourteen after fulfilling their grammar school requirements, took three years. But there were also various evening classes available to practicing photographers who wished to round out their qualifications or specialize. Finally, there was a "photography laboratory for amateurs"—that is, for people of varied interests over the age of eighteen. All who wished to study at the GLV were required to pay tuition, though fees could be waived for native Austrians submitting proof of financial need or at the director's discretion.[19]

The GLV comprised four divisions: the Institute for Photography and Reproduction Techniques; the Institute for Book Publishing and Illustration; the Research Institute; and the Graphics Collection, Apparatus Collection, and Professional Library (now for the most part housed in Vienna's Albertina on permanent loan). Here I will focus specifically on the Research Institute, whose mission, according to the charter, was "the performance of scientific research in the fields of photography, photochemistry, and related subjects."[20] At first the division was administered by Eder alone (in addition to his role as GLV director). In 1892 he surrendered the Research Institute post to the chemist Eduard Valenta, with whom he had worked at Vienna's Technische Hochschule in the early 1880s and who had been his brother-in-law since 1885. It appears that the Research Institute was furnished from the start with scientific laboratories and the most up-to-date equipment. Yet it clearly made its facilities generally accessible in such

18. Ibid., 18.
19. See charter of the K. k. Graphische Lehr- und Versuchsanstalt in Wien, no. 8591 (approved May 29, 1897), 3–9.
20. Ibid., 20.

fig. 26 Josef Maria Eder and Eduard Valenta
X-ray photograph of the hand of the
industrialist Höfft with embedded bullet, 1896
Glass lantern slide
1 ⅞ x 1 ⅕ in. (4.7 x 3 cm)
Albertina, Vienna, permanent loan from the Höhere
Graphische Bundes-Lehr- und Versuchsanstalt,
Vienna

fig. 27 Josef Maria Eder and Eduard Valenta
X-ray photograph of gallstones, 1896
Glass lantern slide
2 x 3 in. (5 x 7.5 cm)
Albertina, Vienna, permanent loan from the Höhere
Graphische Bundes-Lehr- und Versuchsanstalt,
Vienna

a way that it was able to stay on top of breaking developments.[21] The GLV—that is to say either Eder or Valenta—was routinely kept informed by figures who were very well known and by others who still had their careers ahead of them. An especially significant example of this resulted in Eder and Valenta's experiments with X-rays, perhaps their most famous area of research (see pls. 118–21). They had learned of Wilhelm Conrad Röntgen's discovery through the physiologist Sigmund Exner in late 1895, and within a month they had replicated Röntgen's apparatus and tested its function. The text of their beautiful 1896 portfolio *Versuche über Photographie mittelst der Röntgen'schen Strahlen* (Research on Photography with Röntgen Rays)—unlike the restricted number of its photogravure plates—represents the entire scope of Eder and Valenta's experiments. The corresponding photographs, preserved as lantern slides (see figs. 26–27) in the historical collections of the GLV, were apparently used for lectures at the school and for the general public. Not long afterward, in December 1896, Eder and Valenta were ready to test the still highly speculative theories advanced by Leopold Freund, who had only recently obtained his doctorate, regarding not only the diagnostic virtues of X-rays but also their therapeutic effects (see fig. 28).[22] Eder promoted the constant exchange of scientific information at the GLV through his own activities. He made use of its infrastructure as founding editor of the *Jahrbuch für Photographie und Reproductionstechnik* (1887–1931), and also in his

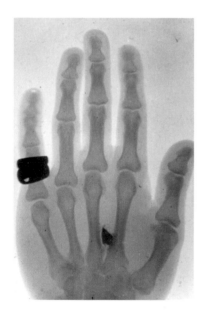

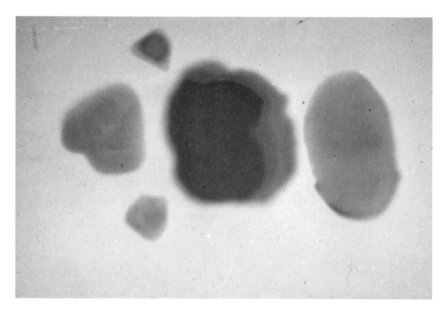

21 The most detailed evidence remains Valenta's report in the Festschrift marking the twenty-fifth anniversary of the founding of the GLV. See Josef Maria Eder et al., Die K. k. Graphische Lehr- und Versuchsanstalt in Wien 1888–1913 (Vienna: Graphische Lehr- und Versuchsanstalt, 1913), 29–38. See also 84–85.

22 See "K. k. Lehr- und Versuchsanstalt für Photographie und Reproductionsverfahren. Dr. Freunds Versuch über die Wirkung der X-Strahlen auf die behaarte menschliche Haut," Photographische Correspondenz (1897): 135–36.

role as professor of photochemistry at the Technische Hochschule (1892–1925). The *Jahrbuch*, which was filled with contributions by internationally known experts, would come to serve as a primary source for Eder's ongoing additions to his monumental *History of Photography.*[23]

It now appears that Eder was guilty of a favoritism toward the Research Institute, which became more apparent after he retired as director of the GLV in 1923. After a brief interregnum under Eduard Valenta, in 1924 the directorship was assumed by Rudolf Junk, a philologist, graphic designer, and cofounder of the Austrian Werkbund. Eder believed that in making the appointment, the Ministry of Trade (which had borne political responsibility for the GLV since 1908) had been unduly influenced by the notion "that in photography and graphic reproduction techniques it is the artistic element that is of primary importance." He felt that under such circumstances the GLV could only be "administered," and would soon exhibit a tendency toward mere "vocational, craftsmanly training."[24] Eder was now preaching virtually without restraint. He more or less directly accused art of lacking innovation—at least in the field of photography and "graphic reproduction techniques," which were now suddenly the chief focus of the GLV (in contrast to book publication and illustration). Not least, he accused the new administration of having reduced the effectiveness of the Research Institute, forcing it to operate in less space, and of cutting its special ties to the Technische Hochschule, which Eder had personally encouraged. This did not necessarily limit its activity, however, unless one believed that the Research Institute's scientific importance was dependent on the amount it spent on technology and materials. But it also did not foster an environment conducive to modern research or development. Essentially, they had to make do with the paradox of a foreseeable open future—in this particular case, to quote Gunthert once again, photography's heuristic function.[25]

The manifold functions and activities of Eder's Lehr- und Versuchsanstalt are clearly mirrored in its collections, whose history has yet to be reconstructed in detail. Significant holdings include, for example, an extremely rich selection of historical and (then) modern lenses; a donation of three important collections of early lithographs (from Emmanuel Kann) and posters (from Ottokar Mascha and Walter Wynans); and the collection of reproduction prints of the Wiener Gesellschaft für vervielfältigende Kunst. In 1926 the historical collections of the Photographische Gesellschaft in Wien (founded in 1861) were lodged at the GLV, and in 1930 they were gifted permanently. There is also a remarkable group of more than four hundred daguerreotypes, many of unknown origin.[26] The collection of scientific photographs, one of the most interesting areas of the archive today, is composed primarily of samples sent to Eder from all over the world, accompanying articles submitted for publication in the *Jahrbuch.*

fig. 28 Studio of the Graphische Lehr- und Versuchsanstalt
**Patient of the dermatologist Leopold Freund
with Naevus pigmentosus pilosus,** 1896
Glass lantern slide
2 2/5 x 1 3/5 in. (6 x 4 cm)
Albertina, Vienna, permanent loan from the Höhere
Graphische Bundes-Lehr- und Versuchsanstalt,
Vienna

23. Until 1914 the journal was edited by Eder alone. He edited vol. 29 (1921, by which time it had been renamed the Jahrbuch für Photographie, Kinematographie und Reproduktionsverfahren) with Eduard Kuchinka. The final issues, nos. 30 (1928) and 31 (1931), were once again edited by Eder alone. The GLV's official organ was Photographische Correspondenz (from 1903 Photographische Korrespondenz). On the Jahrbuch as a source of updates to History of Photography, see Josef Maria Eder, Geschichte der Photographie, vol. 1.1, Ausführliches Handbuch der Fotografie, 2nd ed. (Halle: Knapp, 1891), 147. On its function as a "news center," see Faber, 146.

24. See Josef Maria Eder, "Die Entwicklung der Graphischen Lehr- und Versuchsanstalt auf Grund des technischen Versuchswesens," Mitteilungen des österreichischen staatlichen Versuchsamtes 16 (1927): 102–8.

25. The original concept of the GLV seems astonishingly modern even today. Yet Eder's share in it still needs to be determined more precisely. See Ann McCauley, "Writing Photography's History before Newhall," History of Photography 21, no. 2 (Summer 1997): 89–90nn9–11.

26. See Eduard Kuchinka, "Die Sammlungen der Graphischen Lehr- und Versuchsanstalt (Bundesanstalt) in Wien," Photographische Korrespondenz 64 (1928): 82–87; and Robert Zahlbrecht, Die historischen Sammlungen der Graphischen Lehr- und Versuchsanstalt (Vienna: Graphische Lehr- und Versuchsanstalt, 1963).

After Eder's retirement and the death of the curator Eduard Kuchinka in 1931, the collections of the GLV ceased to be developed.[27] At the same time, the holdings began to lose their function as tools for teaching and research. Several efforts were made to transform the collections into a public museum, but none succeeded. In 2000 everything related to photography was transferred as a permanent loan to the Albertina, where it was comprehensively catalogued for the first time, ensuring better access in the future for all who are interested.

Translated from the German by Russell Stockman

27. See Zahlbrecht, 9.

PLATES

MICROSCOPES

The microscope has been an object of curiosity since the seventeenth century. As an optical instrument studied by physicists, the projection microscope, along with the camera obscura, contributed significantly to the development of photography. The principal inventors of the new medium, including William Henry Fox Talbot and Louis-Jacques-Mandé Daguerre, made use of the solar microscope at various stages of their discoveries, taking advantage of its intensified light to overcome the relative insensitivity of early photographic plates.

This early application of photography coincided with the growing use of the microscope in the natural sciences and medicine. Yet even as it was becoming an indispensable scientific tool, microscopic observation was frequently discredited by the exaggerated conclusions of negligent scholars and fantastical illustrations by uninformed artists (see fig. 29). Talbot, a savvy botanist, saw in photography the ideal means of reproducing exactly, without any graphic elaboration, the infinitesimal and innumerable details of the microscopic field (see pls. 1–3). The physicist and astronomer Dominique François Arago, in his July 3, 1839, presentation of the daguerreotype in Paris, evoked the scientific usefulness of the medium, touting its precision and rapid execution as qualities that could help scientists avoid human error, facilitate teaching and exchange, resolve controversies, and lead to true discoveries. Technological advances in scientific photography added to the enthusiasm for the medium—without, however, making converts of all scientists.

On March 4, 1840, the physicist Andreas Ritter von Ettingshausen created a rare full-plate daguerreotype before his Austrian colleagues. This talented practitioner, who had trained with Daguerre, sought to overcome the vagaries of natural light and demonstrate the scientific value of the medium. With the help of hydrogen light and painstaking preparation, a five-minute exposure sufficed to record the fine cellular structure of a section of clematis (pl. 4). Another fervent advocate of photography, the physician Alfred Donné, spoke highly of the precision of daguerreotypes and their value in the laborious process of learning to use the microscope efficiently. One of the few professors teaching microscopy at the medical school in Paris, Donné published his *Cours de microscopie complémentaire des études médicales* in 1844–45. Due to the impossibility of mechanically reproducing daguerreotypes, the atlas's eighty-six illustrations were traced from unique plates made by his skillful assistant, the photographer Jean Bernard Léon Foucault, and then engraved by hand (see pl. 5). Even if the artist's contribution undermines Donné's argument for the authenticity of the book's reproductions, the publication was the first of its kind. Books containing photoengraved illustrations became increasingly common beginning in the 1860s, encouraged by the development of new printing processes.

Photomicrography became even more widespread with the 1851 advent of the wet collodion glass negative, whose transparency enabled easy and pristine reproduction. The master in this domain was the Frenchman Auguste-Adolphe Bertsch. The superior sharpness and variety of his microscopic portraits (see fig. 3; pls. 6–15) are proof of his efficient rapid collodion process and sophisticated microscopes. A photographer with a

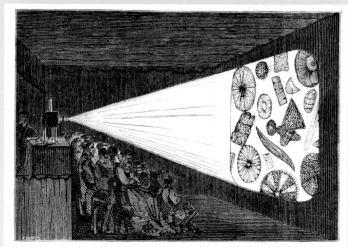

fig. 30
Illustration in **La chambre noire et le microscope**
(The Camera and the Microscope), 1869, by Jules Girard,
showing Girard projecting a photomicrograph
of diatoms during a lecture

Fig. 8. — Application de la photomicrographie à l'enseignement. Projection à la lanterne éclairée par le gaz oxhydrique d'une épreuve positive sur verre de diatomées marines.

passion for natural science, Bertsch exhibited specimens of botany, entomology, and mineralogy, enlarged between fifty and five hundred times using monochromatic, polarized light, at a number of world's fairs and in photographic exhibitions at the Société française de photographie in Paris. Although praised by advocates of the new medium, these delicate images made little impact on the scientific community. Drawing, which allowed for the addition of color and the grouping of disparate details, retained certain advantages over the monochrome photograph. Only a few biologists, neurologists, geologists, and other specialists sought out professional photographers to help them document their research or overcame technical obstacles by developing methods suited to their disciplines. One such figure, the anatomical pathologist Joseph Janvier Woodward, incorporated photomicrography into his study of diseases diagnosed among American soldiers who died during the Civil War, and also projected photographs to illustrate lectures.

In the 1880s the use of photomicrography expanded conspicuously in scientific laboratories and among amateurs. Fed by the general enthusiasm for photography's revelation of the invisible, the practice also benefited from advances in optics, microscopic technology, and ever-faster photographic techniques. If stereo views rendered some microscopic structures three-dimensional (see pls. 22–27), panchromatic plates, sensitive to the entire spectrum, enlarged the field of vision. By using colored screens corresponding to tinted preparations, Fernand Monpillard was thus able to reveal features not visible through direct observation (see pl. 31).

These and other experiments went some way toward making photomicrography an object of study and sometimes also an instrument for microscopic measurement. A. Thouroude's work (pl. 30) bears witness to experiments conducted by the bacteriologist Robert Koch: microbes such as the tubercle bacillus are now part of the repertoire arranged around an immense enlargement of the diatom *Pleurosigma angulatum*. This extremely small algae, a subject of keen interest for opticians and micrographers, was used to test the power of microscope lenses. The astonishing geometric regularity of diatoms made them, along with fleas, fashionable subjects for scientific imaging, especially toward the end of the nineteenth century. The diversity of their shapes could also create artistic compositions such as those of Hans Hauswaldt (pl. 32). Like Jules Girard in France (see fig. 30), Hauswaldt, a German crystallographer, helped popularize scientific discoveries through public projections of photographic glass lantern slides. Continuing a long tradition of scientific presentations to general audiences, such events combined the dissemination of knowledge with the pleasure of discovering the beautiful world of the infinitely small.

Carole Troufléau-Sandrin

Translated from the French by Alison Anderson

William Henry Fox Talbot **Photomicrograph of moth wings**

ca. 1840
Calotype negative

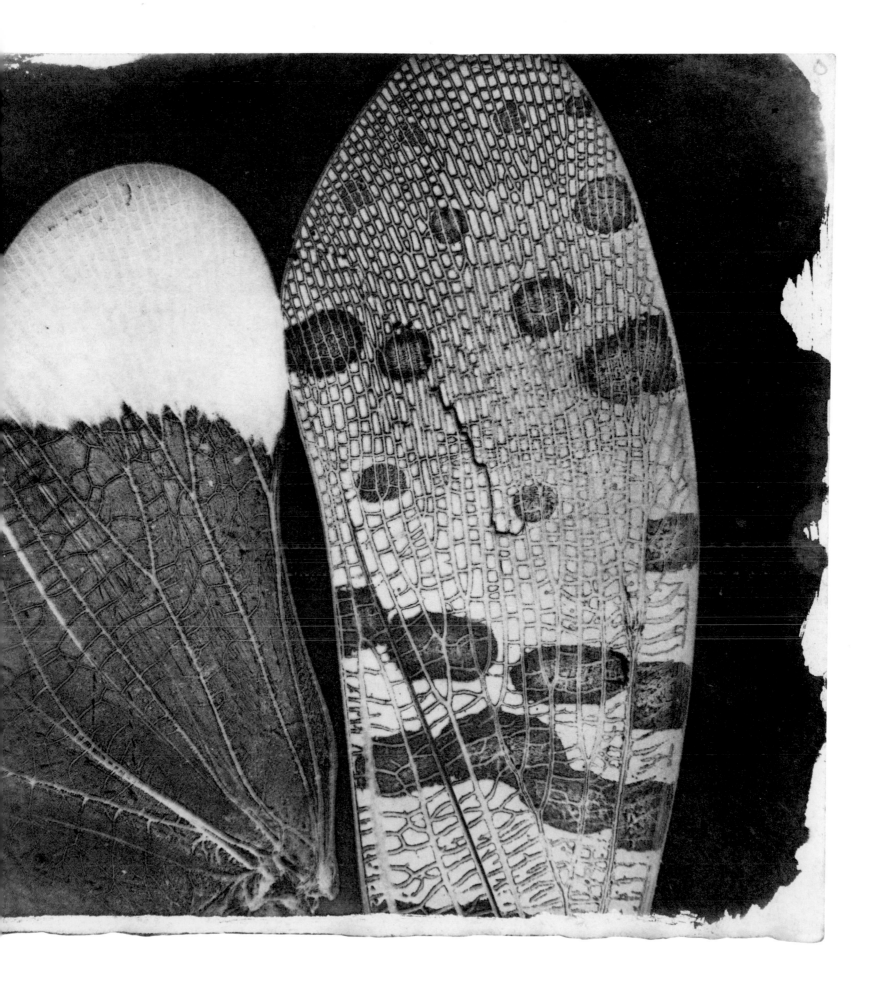

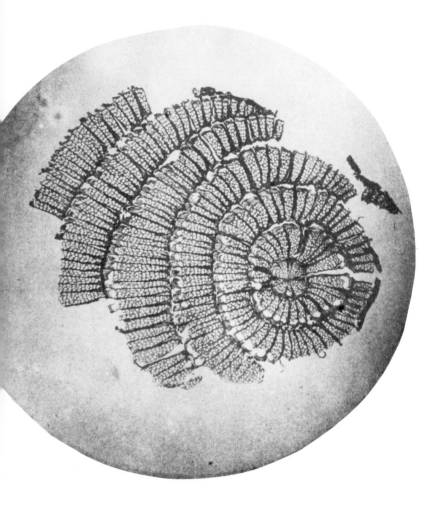

2

William Henry Fox Talbot **Photomicrograph of a plant stem**
ca. 1839
Salt print

3

William Henry Fox Talbot **Photomicrograph of diatoms**
ca. 1839
Salt print

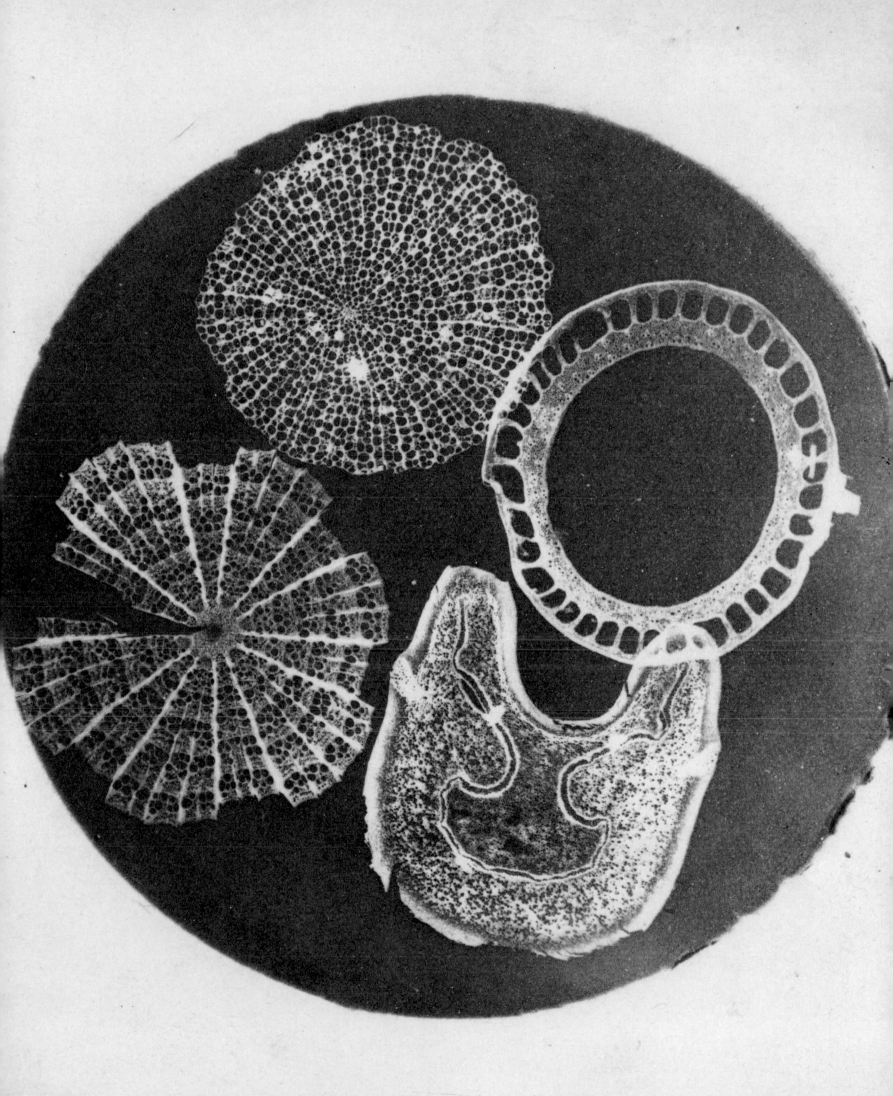

4

Andreas Ritter von Ettingshausen **Cross section of a clematis stem, March 4, 1840**

1840
Daguerreotype

5

Jean Bernard Léon Foucault **Ferments of sweet urine**

1844
Daguerreotype

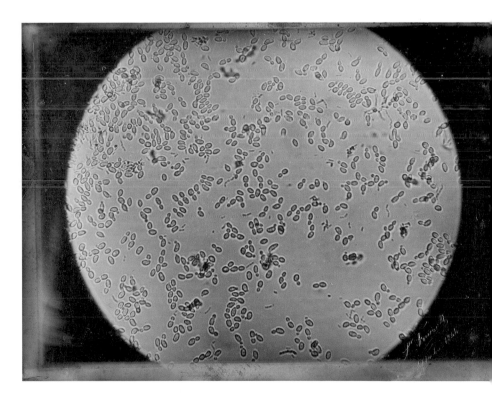

Trachée de la Chenille Processionaire Grossʰ 100 Diamètre

6

Auguste-Adolphe Bertsch **Mouth of the processionary caterpillar, enlarged one hundred diameters**

ca. 1857
Salt print

7

Auguste-Adolphe Bertsch **Salicin crystals (polarized light)**

1857
Albumen print

18

Jules Girard Wood of a fir tree: Concentric ligneous zones, magnified
eighty times; young one-year-old stem, magnified thirty times

1868
Two albumen prints mounted on board

19

Peter Lackerbauer Crystallized pyrogallic acid (sol. alcohol), magnified five times

1868
Albumen print

TELESCOPES

Until the early twentieth century, the technical challenges posed by astrophotography were so significant that it remained largely the domain of professional science. Despite these hurdles, photography was applied to nearly every aspect of astronomical investigation over the course of the nineteenth century, from the study of the moon and planets, to the analysis of the sun and other stars, to the documentation of celestial events such as solar eclipses or comets.

In 1839 Louis-Jacques-Mandé Daguerre had been unsuccessful in his attempts to capture the moon with his newly invented daguerreotype, because of the plate's insensitivity to its faint light. He noted, however, that the lunar rays did have some effect on the emulsion, which encouraged Dominique François Arago, in his presentation of Daguerre's invention to the French Chamber of Deputies in July of that year, to imagine that photography might aid astronomers in their endeavors to map the heavens, one of the greatest scientific ambitions of the day. Arago's hopes for photography were shared by his fellow astronomers; in 1851 and 1852 John Adams Whipple and George Phillips Bond produced a remarkable series of daguerreotypes of the moon at Harvard's observatory (see fig. 1; pl. 41) that sparked the imagination of the general public and scientists alike (the pioneering astrophotographer Warren De la Rue claimed that these pictures inspired his own career). Yet for much of the century aspirations for the medium outstripped its results; until the development in the 1870s of gelatin silver bromide negatives (dry plates), which were much more sensitive to light, photography's contributions to astronomy were limited.

The vast gap between the dream and its achievement was not lost on Pierre Puiseux, an assistant astronomer at the Paris Observatory, who reminded his colleagues in 1899 that "once again, we have been able to measure the interval separating the birth of an idea, however just and universally accepted, from its complete realization."[1]

Charles Fabre, the author of one of the earliest encyclopedias of photography, clearly explained the medium's advantages to the field: "Determining the exact position of the celestial bodies and establishing a catalogue of the stars is certainly the most tedious branch of astronomical observation, and yet it is one of the most useful, for it is the only way to obtain what one might refer to as 'the geography of the Heavens.' By fixing on a sensitive plate the position, at a given time of year, of all the heavenly bodies we can see, photography enables us to complete a laborious task that would otherwise have taken astronomers several generations; moreover, photography allows one to avoid the errors and omissions that are of necessity part of any work of this nature."[2]

By the time Fabre wrote this in 1890, some fifty years after the invention of photography, most technical obstacles had been overcome through decades of intensive technological innovation and chemical experimentation. The daguerreotype of the sun (fig. 2) produced by Hippolyte Fizeau and Jean Bernard Léon Foucault in 1845, for example, was obtained using a guillotine shutter. The development of this device—at a time when the function of a modern shutter was achieved by manually removing and replacing the lens cap—anticipated a technology

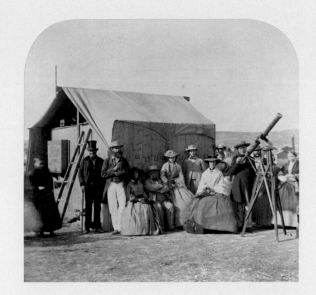

fig. 32
George Downes
**Eclipse expedition to Spain (including astronomers
Warren De la Rue and George Airy),** ca. 1860
Albumen print
5 5/16 x 6 1/2 in. (13.5 x 16.5 cm)
Wilson Centre for Photography

that would not be in wide use for some thirty-five years.
The demands of science became the driving force behind the
development of photographic processes; the existing technology
could not keep pace with the era's scientific ambition.

Astronomical photographers also borrowed techniques
from other areas of photographic practice, as when De la Rue,
in 1858, began experimenting with stereoscopic photography
to demonstrate that the moon was round (see pls. 47–50).
Astronomers employed chronophotography to document
phenomena that occurred over a period of time. The transit
of Venus across the sun in 1874 was a critical moment for the
scientific community: it is one of the rarest astronomical
phenomena, and scientists hoped it would offer an opportunity
to calculate the earth's distance from the sun. At least sixty
scientific parties were dispatched around the globe to observe,
measure, and document its passage, and many hoped to use
photography in their efforts. Most notably, the astronomer
Pierre Jules César Janssen developed, specifically to capture
this event, a photographic revolver that used a daguerreotype
plate (see pl. 59). Though his results were largely unsuccessful,
Janssen continued to view photography as integral to his work,
and in 1877 he obtained the first detailed photographs of the
sun's surface at the Meudon Observatory (see pl. 57). These
pictures helped determine the star's physical constitution,
and he published a paper the following year on the "new facts
regarding the Sun's constitution as revealed by photography."[3]

The project that Arago had first imagined in 1839—to
map the heavens photographically—was finally undertaken a

half-century later. Impressed by the brothers Paul and Prosper
Henry's use of photography in their studies of celestial bodies
(see pls. 63–64, 67), Ernest Mouchez, the director of the
Paris Observatory, launched a massive international effort
to construct a photographic chart of the stars. In 1887 he
convened the first Astrophotographic Congress, where
astronomers from sixteen nations agreed to jointly produce
a photographic atlas of the sky, the *Carte du ciel*. Though the
atlas was never completed, the photographic plates produced
during this and other nineteenth-century efforts continue
to be of use to astronomers today, though their data is now
analyzed by sophisticated computers instead of human eyes.

Marie-Sophie Corcy

Translated from the French by Alison Anderson

1. Pierre Puiseux, "Sur quelques progrès récents accomplis à l'aide de la photographie
 dans l'étude du ciel," **Annales du Conservatoire national des arts et métiers** 1
 (1899): 319–20.
2. Charles Fabre, **Traité encyclopédique de photographie**, vol. 4 (Paris: Gauthier-Villars,
 1890), 195–96.
3. See Jules Janssen, "Sur des faits nouveaux touchant la constitution du Soleil révélés
 par la photographie," **Bulletin de la Société française de photographie** (1878): 22–25.

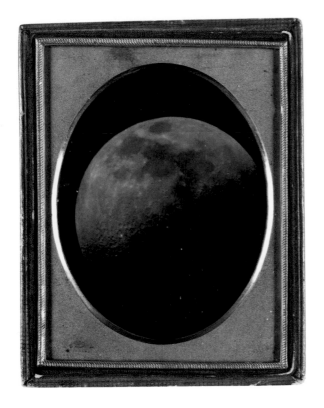 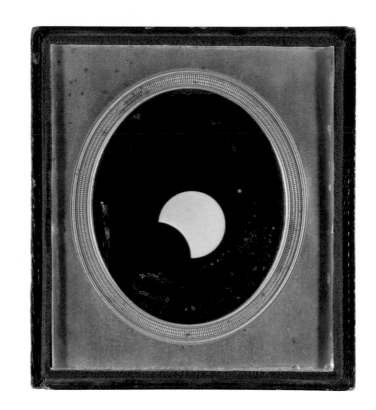

41

John Adams Whipple and George Phillips Bond **Moon**

1851
Daguerreotype

42

John Adams Whipple and George Phillips Bond **Partial eclipse of the sun, July 28, 1851**

1851
Daguerreotype

43

Samuel Dwight Humphrey **Daguerreotype of the moon, Canandaigua, New York, September 1, 1849**

1849
Daguerreotype

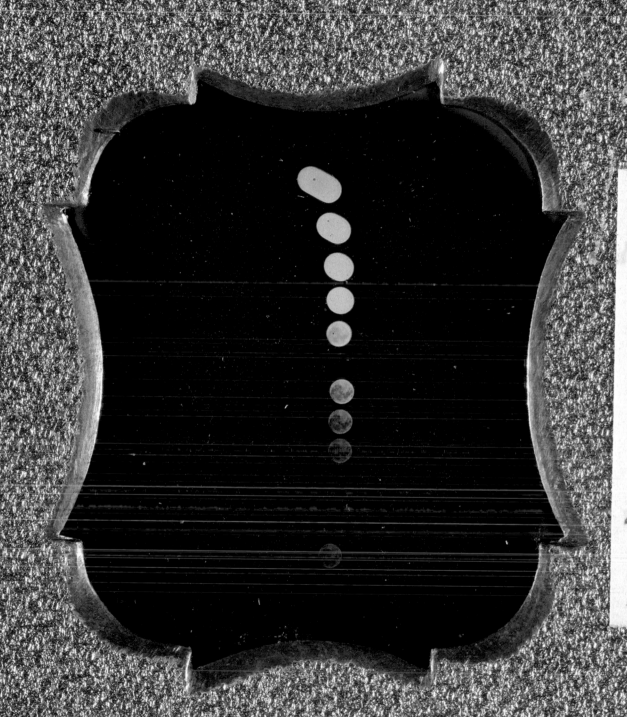

Moon

2 /M
6 A.S.
30 "
15 "
5 "
3. "
2 "
1 "
1/2 "

56

Carleton E. Watkins **Solar eclipse**

1889
Albumen print

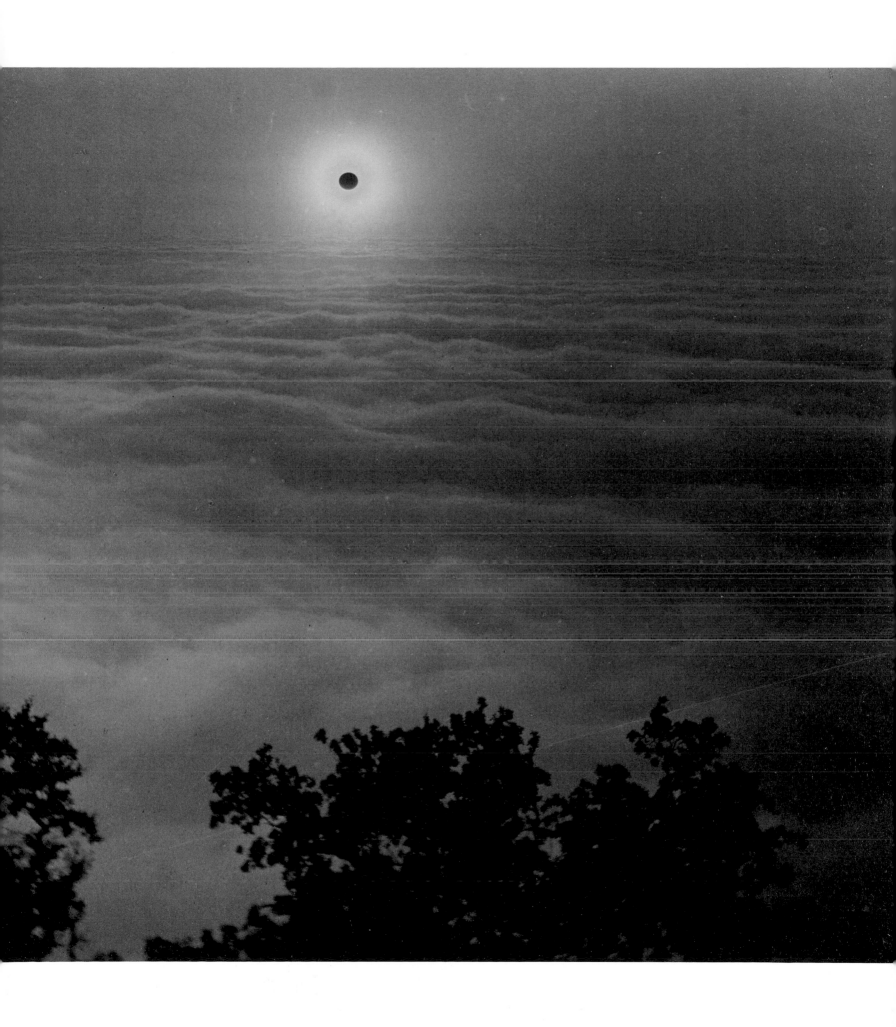

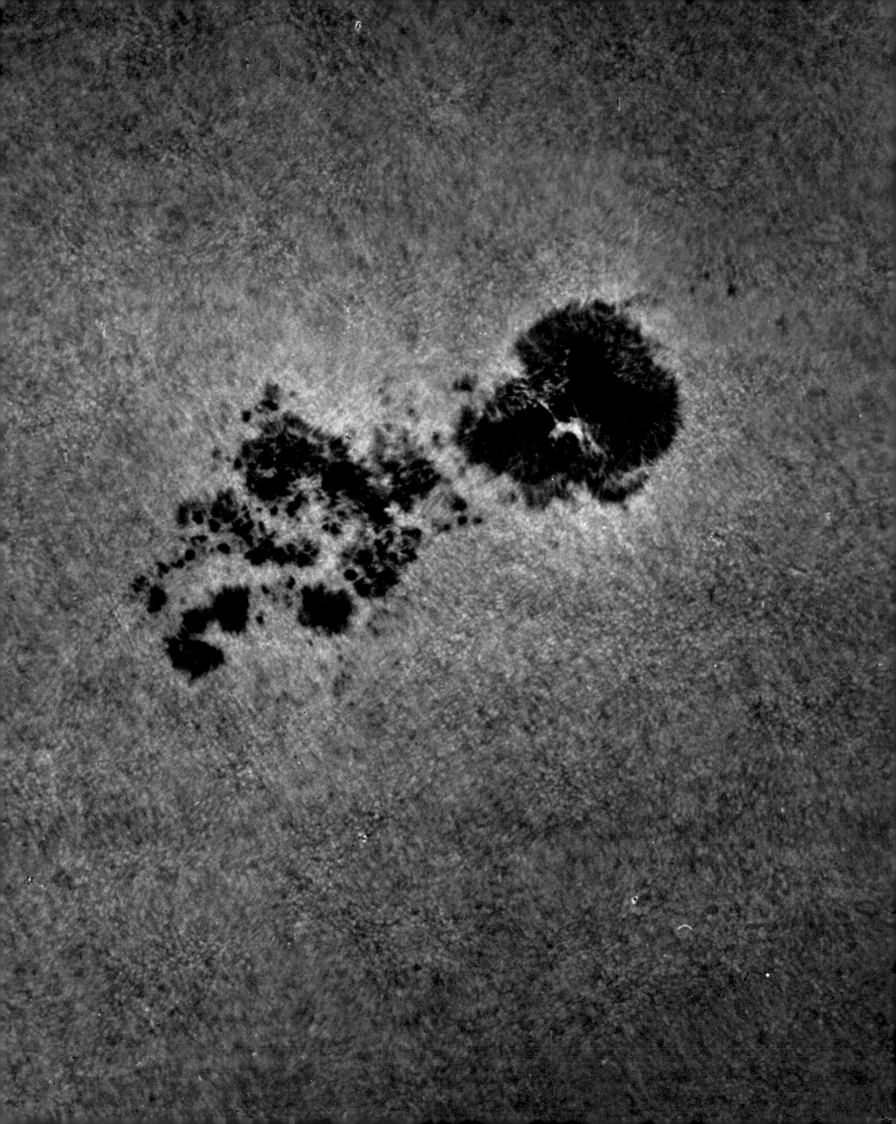

57

Pierre Jules César Janssen **Surface of the sun**

1885
Woodburytype

58

Hermann Wilhelm Vogel **Solar spectrum photographed with pure and colored bromyrite**

1874
Albumen print

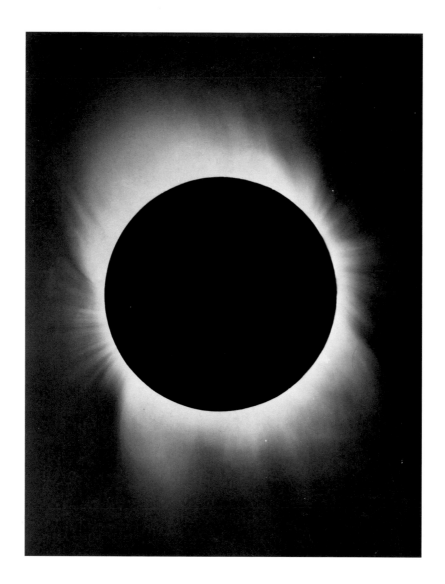

61

Unknown Photographer **Solar eclipse**

1900
Gelatin silver print

62

Edward Emerson Barnard and George Willis Ritchey **Solar corona photographed during
the total eclipse of May 28, 1900**

1900
Printing-out paper print

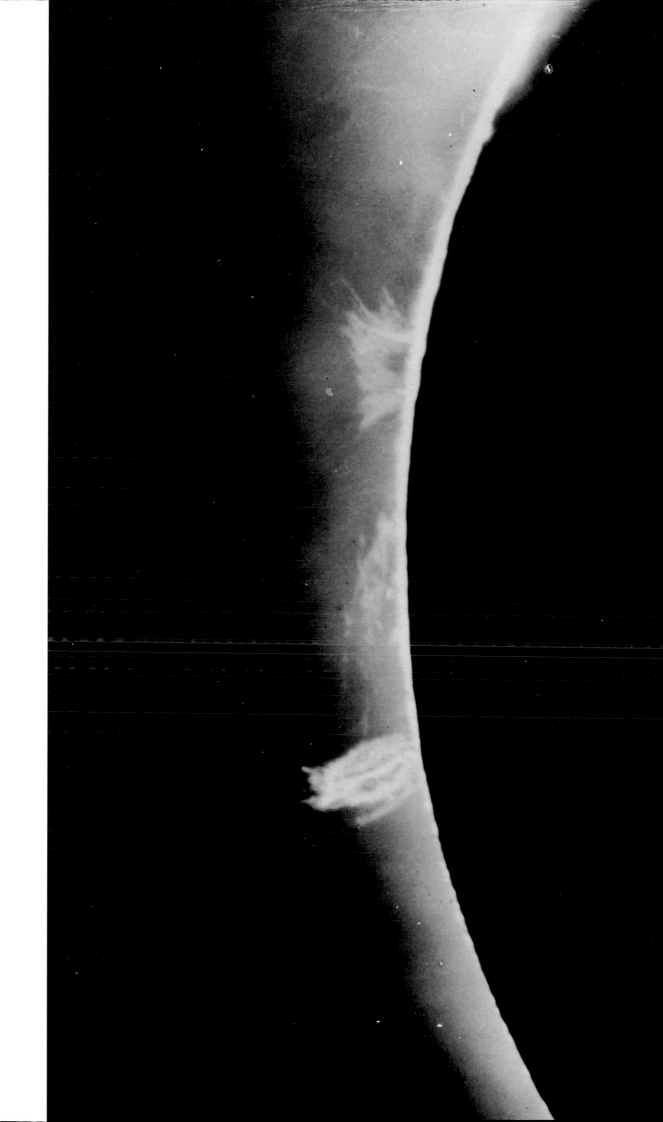

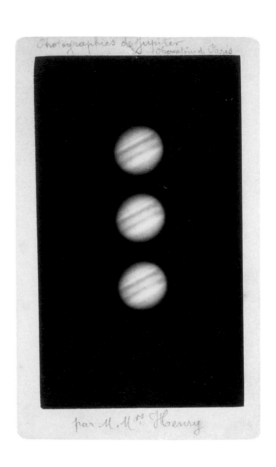

63

Paul Henry and Prosper Henry Saturn, December 21, 1885:
Direct enlargement (eleven times), Paris Observatory

1885
Albumen print

64

Paul Henry and Prosper Henry Jupiter, April 13, 1886

1886
Albumen print

65

Ferdinand Quénisset Jupiter and its moons

ca. 1897
Gelatin silver print

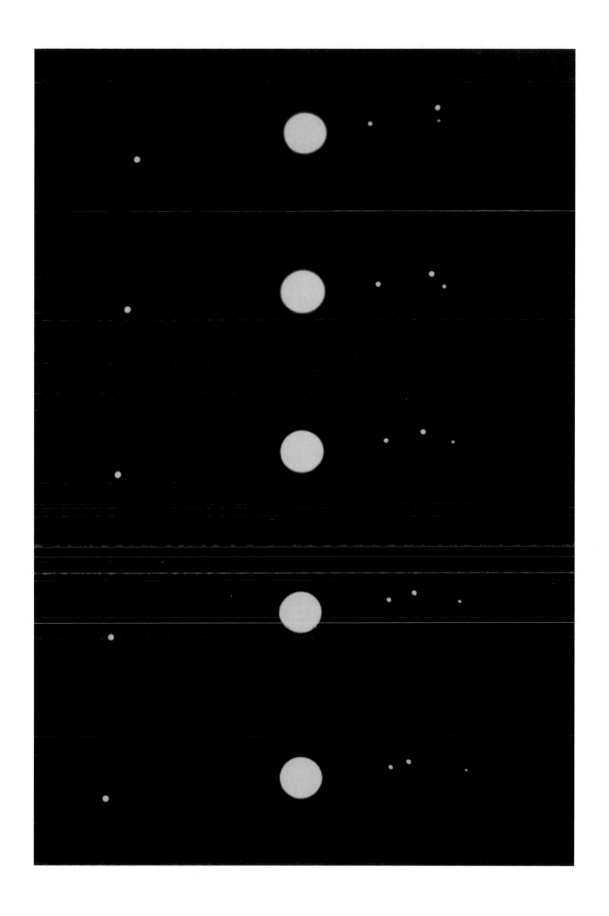

66

Unknown Photographer **Determination of the position of the celestial pole by photography, October 28, 1897**

1897
Gelatin silver print

67

Paul Henry and Prosper Henry **Lyra nebula**

ca. 1885
Albumen silver print

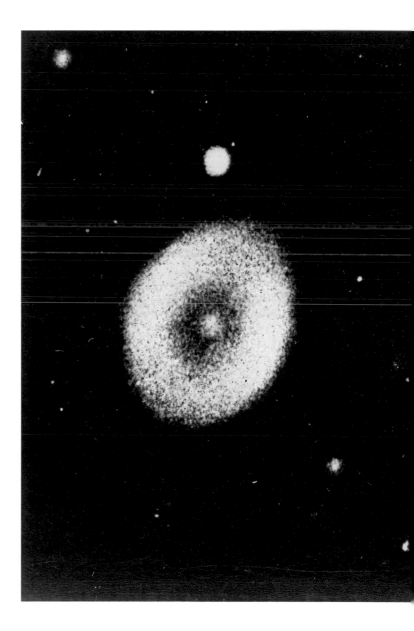

72

Maximilian Franz Josef Cornelius Wolf and Johann Palisa **Star map,** from the album
Photographische Sternkarten (Photographic Star Maps)

1903
Gelatin silver print

73

Maximilian Franz Josef Cornelius Wolf **The Milky Way**

ca. 1900
Gelatin silver bromide print

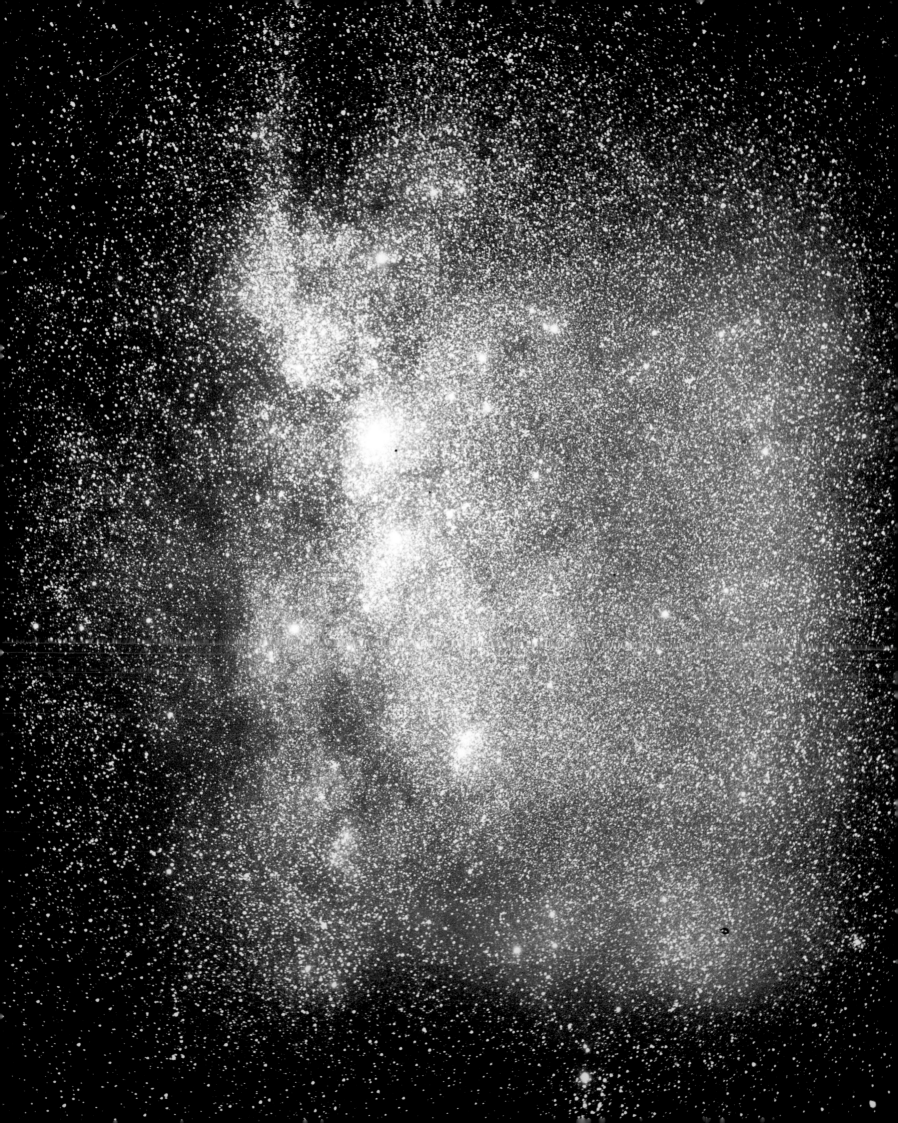

fig. 33
Cartoon in the **San Francisco Illustrated Wasp** (July 27, 1878)
satirizing Eadweard Muybridge's motion studies

MOTION STUDIES

Before the advent in the 1870s of highly sensitive dry plates, motion was an obstacle to creating clear, readable photographs, as even the slightest movements would register as blurs or streaks on slow, handmade emulsions. For a small cadre of innovators, however, motion presented an opportunity to push the boundaries of the medium in order to arrest action at increasingly higher speeds. Some were accomplished photographers intent on improving technology and expanding the applications of the medium, while others were trained scientists for whom photography was an experimental tool providing access to realms beyond the range of human sight.

Considering the technological constraints, it is not surprising that the earliest photographic motion studies capture only the slowest of movement. Two such examples are Samuel Dwight Humphrey's daguerreotype of the moon (1849; pl. 43) and Pierre Jules César Janssen's record of the transit of Venus (1874; pl. 59), both of which chart the incremental passage of celestial bodies across the heavens. Significantly, the revolver camera Janssen developed to record this astronomical phenomenon was later adapted by the French physiologist Étienne-Jules Marey to freeze split-second action.

The earliest photographs in this section are perhaps not so readily recognizable as motion studies as those that follow. These cameraless photograms (pls. 74–75), made in 1869 by Dr. Charles Ozanam with the assistance of the photographer Édouard Baldus, record a simulated pulse made by a pulsograph, a device Ozanam invented to study the cardiovascular system. Produced with the aid of a moving plate, they graphically represent the rhythmic undulations of artificial blood as it was pumped through a transparent tube, mimicking the behavior of actual blood in human arteries. The wavelike results prefigure computer readouts on modern heart rate monitors.

Once a mechanized shutter could snap closed more rapidly than a blink of the human eye, the camera was employed to reveal previously indeterminable kinetic aspects, leading to discoveries pertinent to various scientific disciplines as well as the practice of art. The use of photography to study animal and human locomotion was launched in 1872, when Leland Stanford, railroad baron and horse aficionado, hired the photographer Eadweard Muybridge to test the theory of unsupported transit, which held that when all four hooves of a galloping horse left the ground they were tucked underneath the animal's belly rather than splayed out like a rocking horse. In 1878, after many failed attempts, Muybridge proved the theory correct, freezing the motion of a horse at midstride and stunning the world with his widely published results. Stanford subsequently sponsored the construction of a track that Muybridge rigged with trip wires attached to a bank of cameras with automatic shutters, which enabled him to document photographically the movement across time and space of horses, other animals, and even human subjects (see fig. 21; pls. 76–78).

Despite the trappings of systematized, rational science (such as grids and rulers adopted from anthropological photography), the value of Muybridge's work is largely aesthetic. His method produced beautiful photographs but not reliable or verifiable scientific data. In fact, as the media historian Marta

fig. 34
Étienne-Jules Marey
**Zoetrope in which are arranged ten figurines
of a seagull in sequential positions of flight,** 1887
Albumen print
4 1/2 x 6 5/8 in. (11.4 x 16.9 cm)
Courtesy Hans P. Kraus, Jr., Inc., New York

Braun has demonstrated, Muybridge often destroyed any potential scientific relevance by manipulating the sequencing of his prints to make them more aesthetically pleasing. His work—particularly his magnum opus, *Animal Locomotion* (1887)—did, however, revolutionize the practice of art by demonstrating the physiological inaccuracy of centuries-old conventions for depicting humans and animals in motion. Many important artists of the period, including Auguste Rodin and James McNeill Whistler, used Muybridge's photographs as models to ensure the anatomical correctness of their drawing

Inspired by Muybridge, Marey used photography to transform his own rigorously empirical physiological investigations.[1] Whereas Muybridge used a bank of twelve to twenty-four cameras, often trained at different angles, Marey used just one, enabling him to control his results by photographing subjects from a fixed perspective. By layering consecutive exposures on a single plate, he demonstrated the duration and continuity, rather than the fragmentation, of movement over time (see fig. 22; pls. 79–84). Among other applications, Marey's findings were used by the French government to improve military training and by the American efficiency expert Frederick W. Taylor to streamline methods of industrial production. More abstractly, the graphic decomposition of time that resulted from these photographic experiments had repercussions in philosophy and, later, modern art.[2]

Both Marey and Muybridge were also pioneers of protocinematic technology, constructing optical devices modeled after the zoetrope to simulate continuous movement (see fig. 34).

They inspired many followers, including Albert Londe, a student of Marey's who constructed a camera with multiple lenses that he trained on patients under the care of Jean-Martin Charcot at the Salpêtrière Hospital in Paris (see pls. 96–97). These photographs, as well as Londe's later X-rays (pl. 116), graphically demonstrate the nineteenth-century concern with mapping physiological differences between purportedly fit and unfit human bodies. Perhaps the most skilled technician of this group, the Prussian Ottomar Anschütz, met Muybridge in Philadelphia and adapted his multiple-camera method to create elegant, highly detailed motion studies that were prized for their naturalistic appearance (see pls. 86–94). Lastly, Ernst Mach, the Austrian physicist whose last name is now synonymous with speed, used photography to study attributes of the flight of projectiles. Mach discovered that by brightly illuminating with an electric spark the impact of a bullet on a target, he could photograph the resultant shock waves and subsequently calculate their velocity (see pl. 95).

Erin O'Toole

1. Marey had previously conducted locomotion experiments using a mechanized stylus of his own invention dubbed the sphygmograph. Before Marey abandoned its use, Ozanam and Baldus modified the device to document artificial pulses photographically.
2. Marcel Duchamp's **Nude Descending a Staircase** (1912) is perhaps the best-known work of modern art that reflects the influence of Marey's work. Italian Futurists such as Giacomo Balla, Umberto Boccioni, and the Bragaglia brothers were also intrigued by the decomposition of time and movement in Marey's photographs.

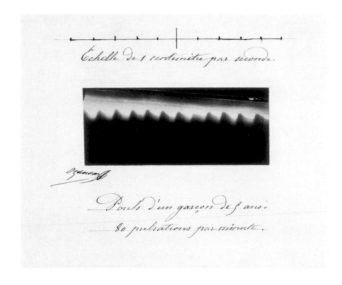

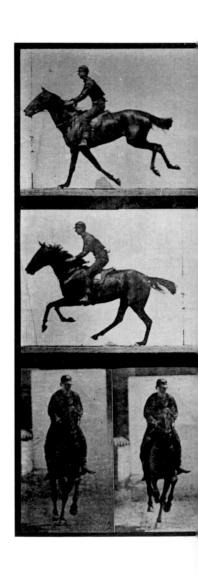

74

Charles Ozanam and Édouard Baldus **Pulse of a forty-three-year-old man in a moment of excitation, sixty-two beats per minute: Very strong pulse**

1869
Albumen print

75

Charles Ozanam and Édouard Baldus **Pulse of a five-year-old boy, eighty beats per minute**

1869
Albumen print

Eadweard Muybridge **Bouquet with rider**

ca. 1887
Collotype

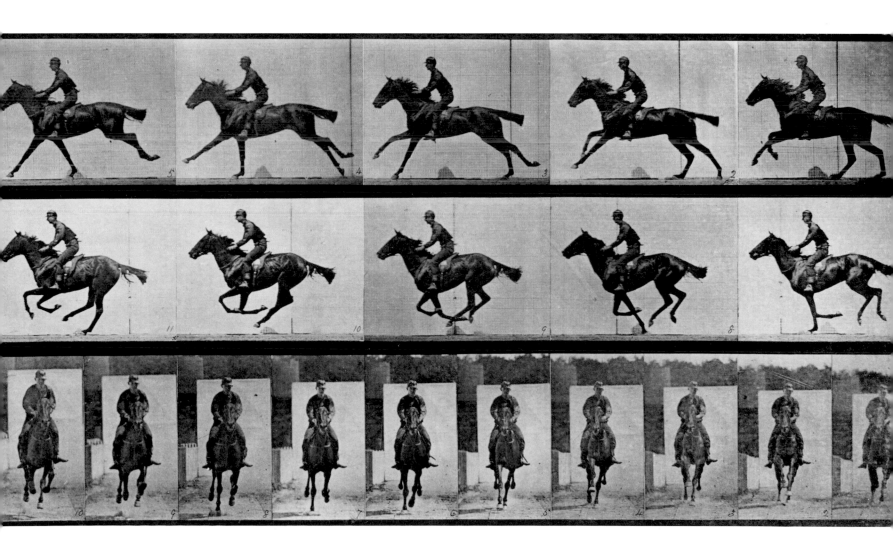

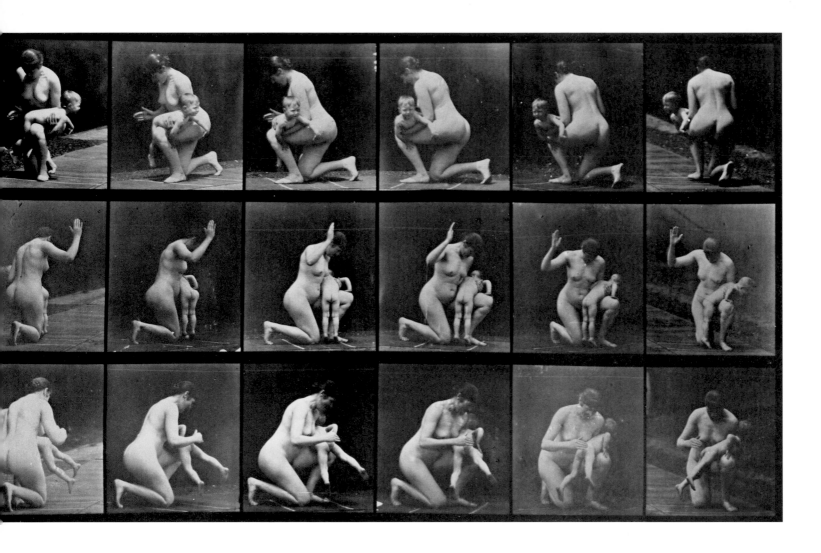

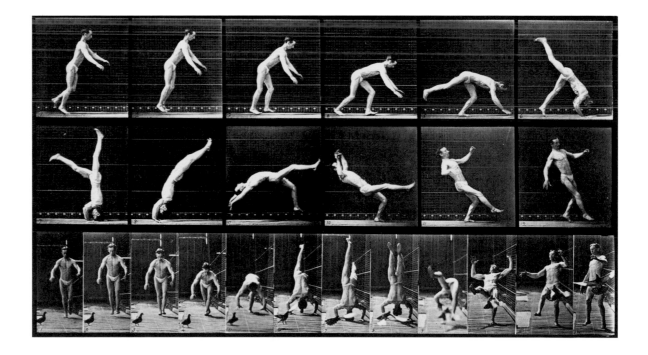

79

Étienne-Jules Marey and Charles Fremont **Chronophotograph of two men with mallets**

1894
Gelatin silver print

80

Étienne-Jules Marey **Flight of a heron**

ca. 1883
Albumen print

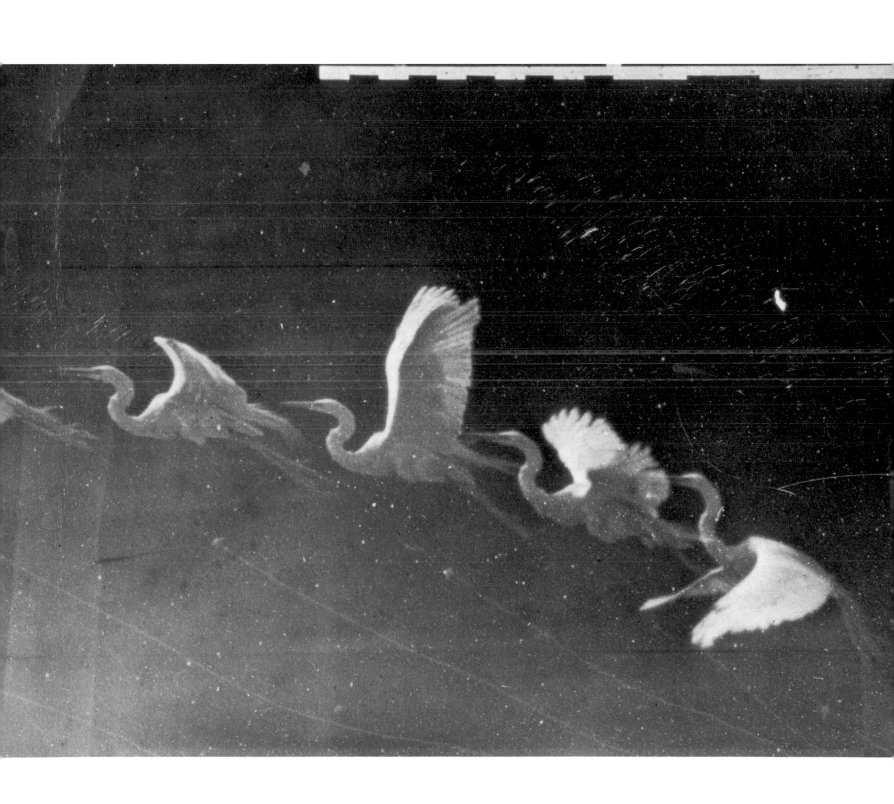

81

Étienne-Jules Marey **Fragment of a chronometric filmstrip of a running hen**

ca. 1894
Printing-out paper print

82

Étienne-Jules Marey **Charvier, test with Prony brake (twelve kilograms force)**

ca. 1894
Gelatin silver print

83

Étienne-Jules Marey **Aquatic locomotion: Sequential study of the movements of a swimming skate**

1892
Gelatin silver print

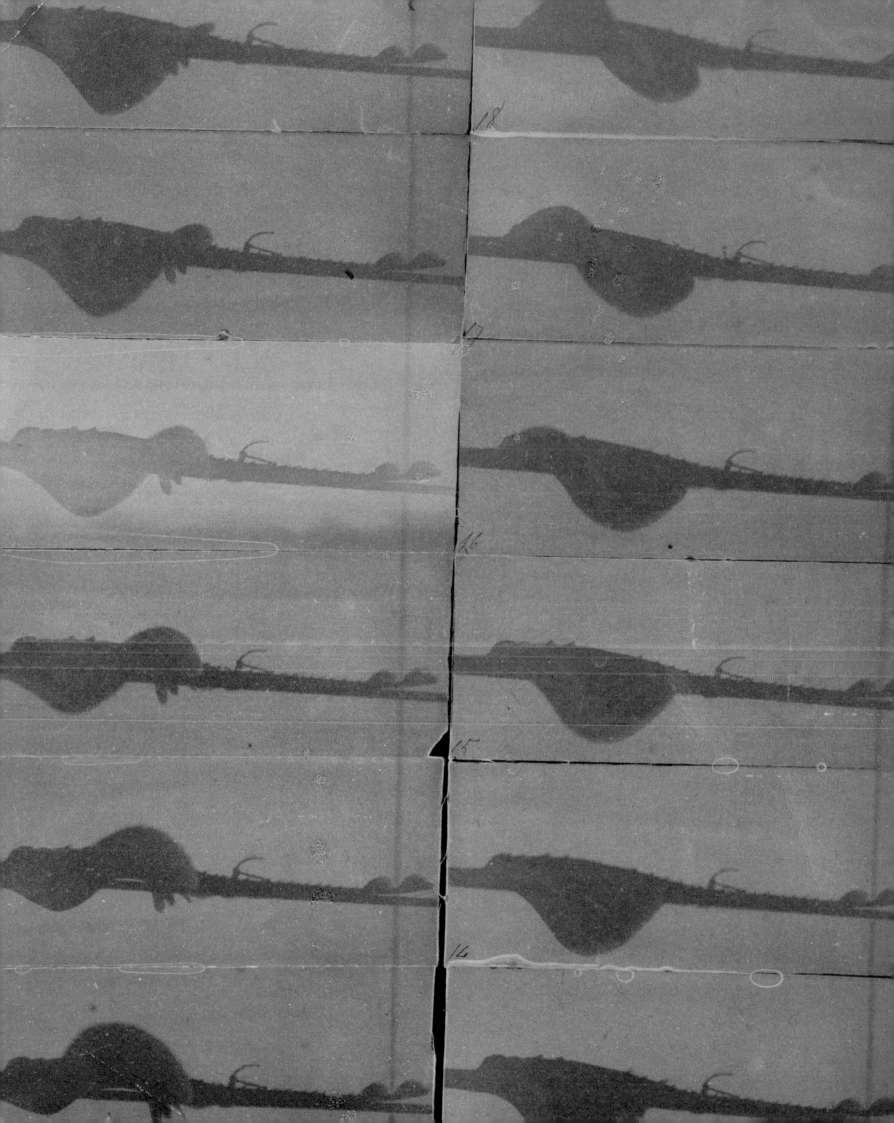

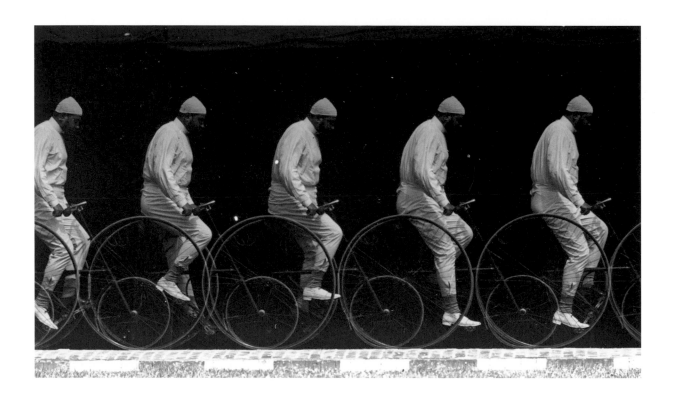

84

Étienne-Jules Marey **Chronophotograph of a man on a bicycle**

1885–90
Glass lantern slide

85

Thomas Eakins **Marey wheel photographs of Jesse Godley**

1884
Cyanotype

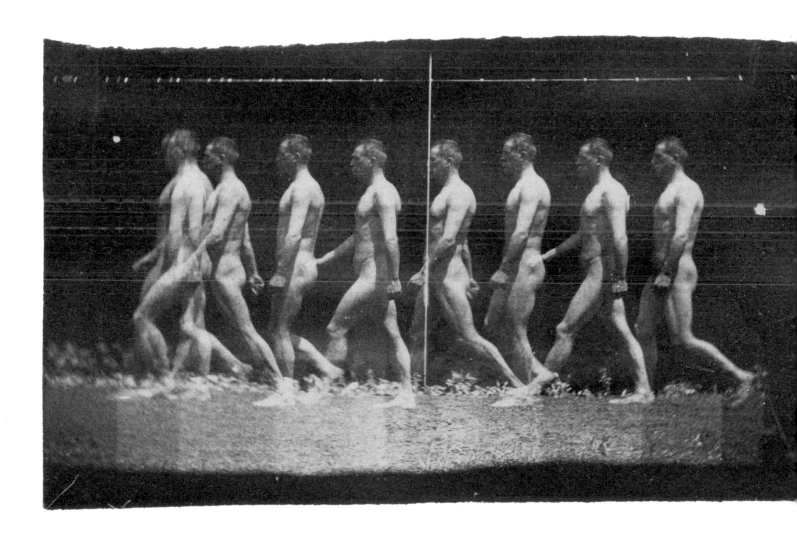

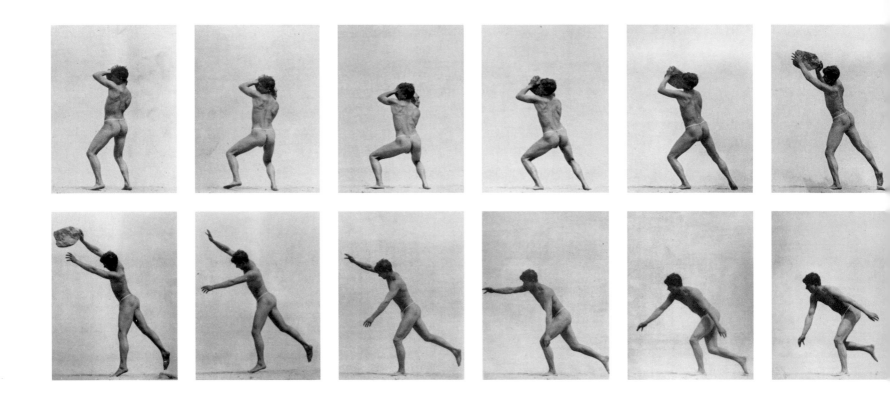

94

Ottomar Anschütz **Throwing a stone**

1887
Albumen prints

Ernst Mach **Instantaneous photograph of a flying bullet**

1893
Gelatin silver prints

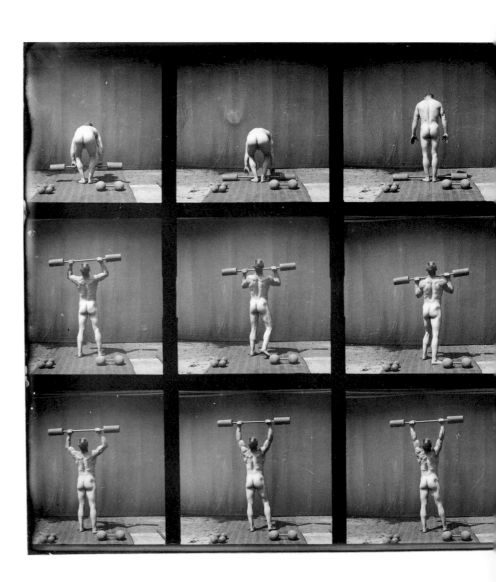

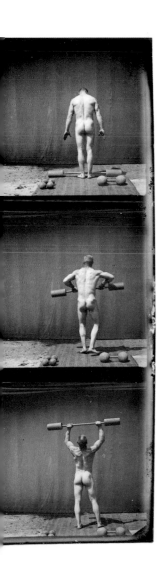

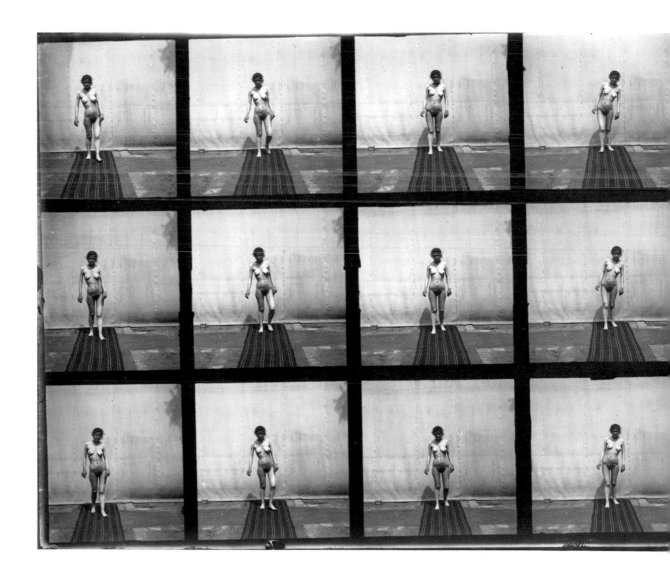

fig. 35
Illustration in **La Nature** (May 18, 1889)
showing a public demonstration of electricity

ELECTRICITY
AND MAGNETISM

In 1802, shortly after witnessing Alessandro Volta demonstrate his new invention, the battery, Napoléon I established a prize to encourage "those who, through their experiments and discoveries, advance the study of electricity and galvanism in ways similar to those of [Benjamin] Franklin and Volta." Though the prize was not awarded again for some fifty years, the next few decades saw remarkable strides in this area of research. In the 1820s alone, the men whose names are still synonymous with the field—André-Marie Ampère, Michael Faraday, and Georg Simon Ohm—discovered some of the most fundamental principles of electricity and electromagnetism. In 1852 Louis Napoléon Bonaparte renewed the French government's support, instituting the Volta Prize "for the author of the discovery that will enable Volta's battery to be used economically, either by industry as a source of heat, or for lighting, or for chemistry, or for mechanics, or for applied medicine." The prize was awarded in 1864 to Heinrich Daniel Ruhmkorff (inventor of an induction coil), in 1880 to Alexander Graham Bell (inventor of the telephone), and in 1888 to Zénobe Théophile Gramme (inventor of the Gramme dynamo).

Electricity did not occupy the attention of scientists alone; it also captured the imagination of the public, particularly after Samuel F. B. Morse's spectacular demonstration of his electromagnetic telegraph in 1844. Electricity was poorly understood, however, by general audiences, and it provoked as much anxiety as it did hope for improved modern living. Exhibitions and fairs, such as the 1855 Universal Exposition in Paris, provided the public with opportunities to discover the wonders of electricity

through dramatic demonstrations (see fig. 35). It was not until much later in the century that the practical applications of electricity would became more widely featured: at the 1881 International Electrical Exposition in Paris, for example, Thomas Alva Edison's arc lights and incandescent lightbulbs amazed the fair's attendees, and at the 1893 World's Columbian Exposition in Chicago the entire site was brightly illuminated using Nikola Tesla and George Westinghouse's powerful alternating current (see fig. 36).

Although electricity was an ongoing subject for scientific entertainment, serious research continued to be conducted in laboratories, where photography served as a crucial tool for understanding electrical phenomena. The photographic reproduction of electric sparks, lightning, and magnetic effects gave scientists the documents with which to study and interpret those phenomena. At the same time they gave vivid form to a mysterious and hitherto invisible force. Between 1883 and 1904 one popular science journal, *La Nature*, devoted no fewer than six articles to the subject of photographing sparks and electrical effluvia, and another eight to the photography of lightning.

Eugène Adrien Ducretet, a manufacturer of scientific instruments, was among those who carried out experiments in this field of research (see pl. 101). The astronomer Ferdinand Jules Quénisset described these early findings in a treatise on the use of photography in physics and meteorology: "A few years ago Mr. Ducretet obtained magnificent prints without having to use a camera. He created a spark in a dark room, right against the photosensitive plate. In this way he obtained a sinuous line

fig. 36
Photograph of Nikola Tesla showing an electrical current
generated in his Colorado Springs laboratory, 1899

of fire absolutely identical to a flash of lightning."[1] In 1888 the astronomer Étienne Léopold Trouvelot repeated the experiments Ducretet had performed four years earlier and described the resulting images, now known as "Trouvelot figures" (see pls. 112–14), thus: "The images created by the opposing poles are completely different in nature and form. The image created by the positive pole is one of sinuous lines full of branches; from its main branches stem thousands of long, lacy fibers, not unlike seaweed. The image produced by the negative pole is very different: its principal branches are, in general, made up of straight lines that are often broken at right angles, which makes them look somewhat like the lightning bolt in the hands of Jupiter. This image, with its infinitely more gracious forms, resembles the leaf of a latanier palm."[2]

Photography would also play a critical role in the debate among scientists about the structure and duration of lightning (see figs. 11–12; pls. 102–9). According to the meteorologist and popularizer of science Gaston Tissandier, "Photographs of lightning, which record the phenomenon and allow us to study it, have shown us details that the eye would be absolutely powerless to register. We have already noted . . . that in the past a great number of meteorologists affirmed that zigzag lightning rarely had branch strokes. We have shown our readers reproductions of photographs of lightning of this type that contradict that assertion, and in which there are innumerable branch strokes: no doubt these . . . were scarcely visible to the naked eye."[3]

A great deal of research on electricity in the nineteenth century focused on finding ways to harness its power safely for practical use, both domestic and industrial. At the same time, however, significant investigations of electromagnetism—and, by extension, the makeup and behavior of light—laid the foundation for the quantum theory that revolutionized physics in the twentieth century.

Marie-Sophie Corcy

Translated from the French by Alison Anderson

1. Ferdinand Jules Quénisset, Applications de la photographie à la physique et à la météorologie (Paris: C. Mendel, n.d.), 37.
2. Étienne Léopold Trouvelot, "La photographie appliquée à l'étude des décharges électriques," Comptes rendus des séances de l'Académie des sciences 107 (1888): 684.
3. Gaston Tissandier, "Les éclairs reproduits par la photographie," La Nature (1891:2): 368.

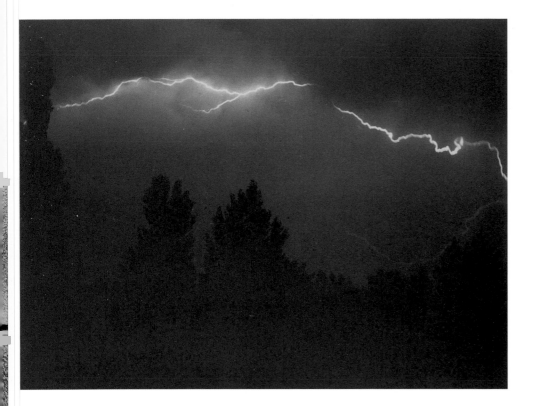

108

Eugen Gothard **Photograph of lightning, August 8, 1886**

1886
Albumen print

109

A. H. Binden **Lightning**

1888
Gelatin silver print

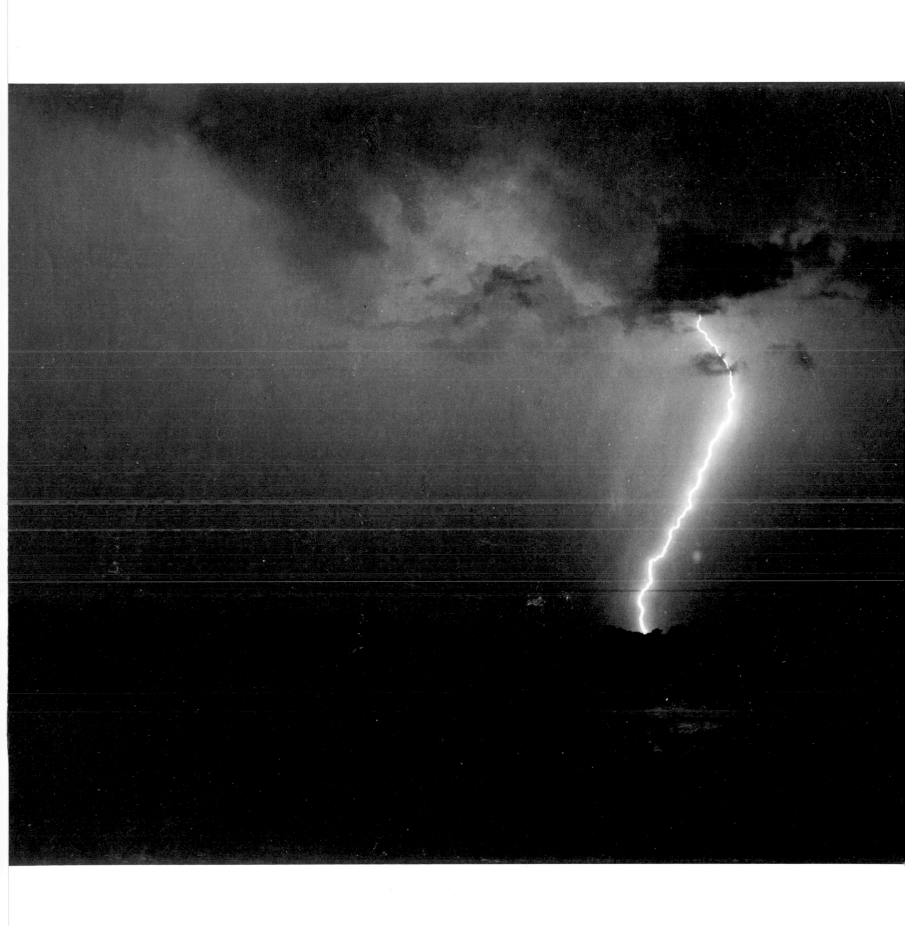

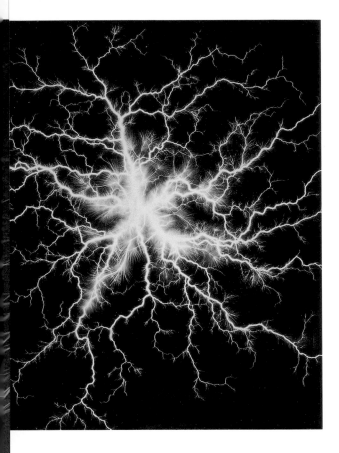

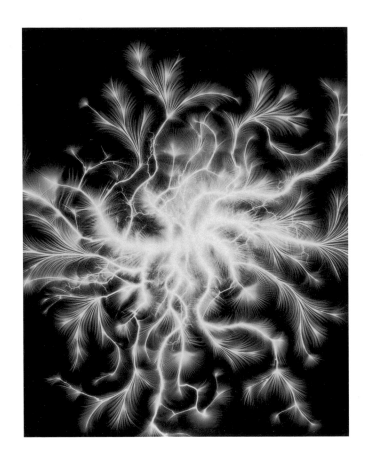

112–13

Étienne Léopold Trouvelot **Direct electric sparks obtained with a Ruhmkorff coil
or Wimshurst machine, also known as "Trouvelot figures"**

ca. 1888
Printing-out paper prints

114

Étienne Léopold Trouvelot **Electric effluvia on the surface and circumference of a coin**

ca. 1888
Printing-out paper prints

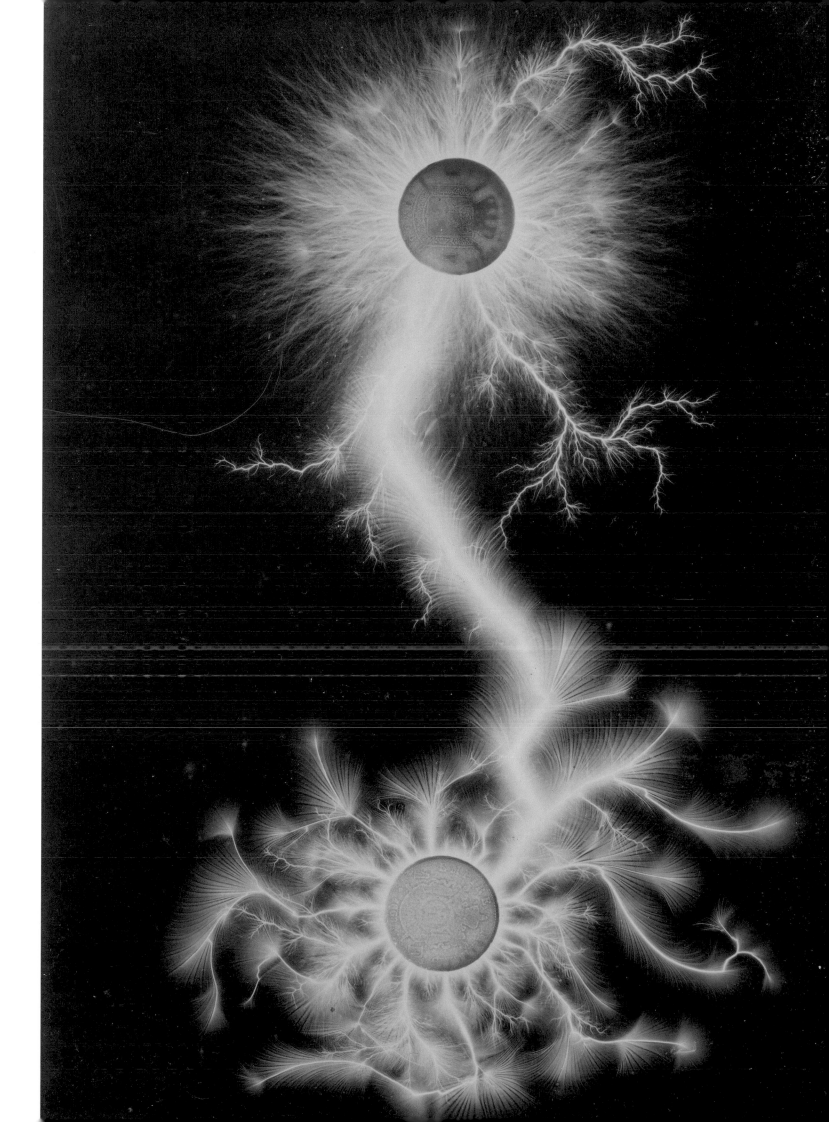

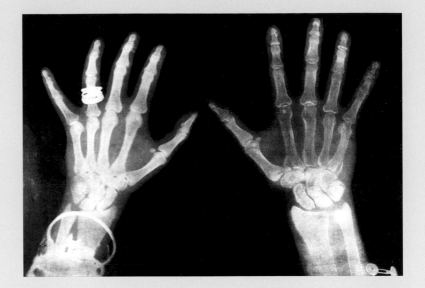

X-RAYS

On November 8, 1895, Wilhelm Conrad Röntgen, a physics professor in Würzburg, Germany, made a startling discovery. While working with a Crookes tube in his laboratory, he observed a peculiar glow emanating from a nearby fluorescent screen. After repeated experiments he ascertained that the glow was caused by radiation emitting from the tube, but that the properties of the rays were highly peculiar. They were not refractable like visible light, nor could they be magnetically deflected, as cathode rays could. Most noteworthy, however, was their ability to penetrate a variety of opaque substances: wood, paper, rubber, and even human flesh. The rays not only passed through these objects as if they were utterly insubstantial, but they made marks on photographic plates placed behind them, leaving shadowy pictures of the objects' interiors. Unable to pinpoint the exact nature of his discovery, Röntgen called them X-rays.

He submitted his findings at the end of December 1895 to the Würzburg Physico-Medical Society in a paper entitled "A New Kind of Ray." To prove his remarkable claims, Röntgen included with his text several equally remarkable photographs, including an eerie picture of his wife's hand. Though her flesh was barely visible, Mrs. Röntgen's bones and wedding ring were shockingly apparent. He sent copies of these pictures, along with reprints of his paper, to several eminent scientists in Europe, one of whom passed them along to the editor of the Vienna newspaper *Neue Freie Presse*. Within days every newspaper had picked up the story.

The announcement of Röntgen's discovery was followed in quick succession by a flurry of proposed uses for X-rays. The picture of Mrs. Röntgen's hand revealed clearly the technology's potential medical applications. For the first time doctors might visualize the interior anatomy of a living person—without surgery—to identify broken bones and locate foreign objects (see pl. 129). Within a year of their discovery the rays' ability to penetrate opaque substances had been marshaled for forensic investigations: to examine unopened luggage for contraband, identify the dead, and distinguish between real and imitation gemstones (see pl. 136). It was also suggested that they could be used for reading minds, and even as a pregnancy test that respected the modesty of the Victorian patient.

Scientific, popular, and photographic journals extolled X-rays' ability to see through opaque objects, illustrating reports with pictures that demonstrated their uncanny powers of revelation. The graphic quality of the pictures was beautifully suited to halftone reproduction, and articles were accompanied not only by Röntgen's original photographs, but also by a slew of inventive compositions ranging from animal skeletons to eyeglasses in leather cases to feet in shoes. The most lavishly illustrated text was by the Austrian scientist and early historian of photography Josef Maria Eder, who (with Eduard Valenta) published *Versuche über Photographie mittelst der Röntgen'schen Strahlen* (Research on Photography with Röntgen Rays) a mere month after Röntgen's discovery became public. Eder and Valenta described in detail their procedure, the improvements they had made to Röntgen's apparatus, and the fifteen photogravures made from X-rays that accompanied their publication. Though the text maintains a strictly factual, even

THE NEW ROENTGEN PHOTOGRAPHY.
" Look pleasant, please."

clinical, tone, the pictures are clearly composed for aesthetic impact (see pls. 118–21). To underscore the dramatic look of the pictures, Eder and Valenta experimented with their tonal values: whereas some are printed as negatives, others are reversed and printed as positives to powerful effect. Many scientists chose to exploit the visual drama of the X-ray images. Victor Chabaud, for example, made one picture (pl. 135) to demonstrate the effectiveness of the focus tube he had designed. It is a veritable catalogue of materials, demonstrating the relative opacity of a metal-rimmed dinner plate, an ivory-handled knife, and the carapaces of two crayfish. Yet his photograph is more evocative of an invitation to a surrealist dinner party than an objective scientific document.

To the general public, these pictures were not medical diagnoses waiting to be made or data to be deciphered, but rather spectacular glimpses into realms normally opaque to human vision. Röntgen's apparatus was easy to re-create (and X-ray kits were quickly available on the commercial market), leading to a brief efflorescence of X-ray "portraiture." Inspired by Röntgen's example, private citizens and public figures (including the Duke and Duchess of York [fig. 37] and the Emperor and Empress of Russia [pls. 124–25]) had their hands X-rayed to see their own bones. The flood of X-ray-inspired poetry and cartoons that followed Röntgen's announcement offers rare insight into the powerful hold of X-ray vision on the popular imagination. These fanciful reactions imagined X-rays as an assault on privacy, threatening to lay bare personal secrets and private activities. Before the rays' merciless vision,

attempts to conceal one's true nature through posture or costume would be in vain (see fig. 38). X-rays' ability to transform living bodies into ghastly skeletons also served as a potent reminder of human mortality; even Mrs. Röntgen remarked, upon seeing her bones, that she had seen the shadow of her death.

The impact of Röntgen's discovery was most profound, however, on the field of physics. In 1896 Henri Becquerel was pursuing Röntgen's findings by experimenting with uranium salts, and in so doing discovered radioactivity. Becquerel constructed an apparatus that allowed the three types of radiation emitted by uranium salts to come in contact with the photographic plate (see pls. 139–40). In these abstract, graphical images, the traces on the paper are physical manifestations of the invisible rays.

Corey Keller

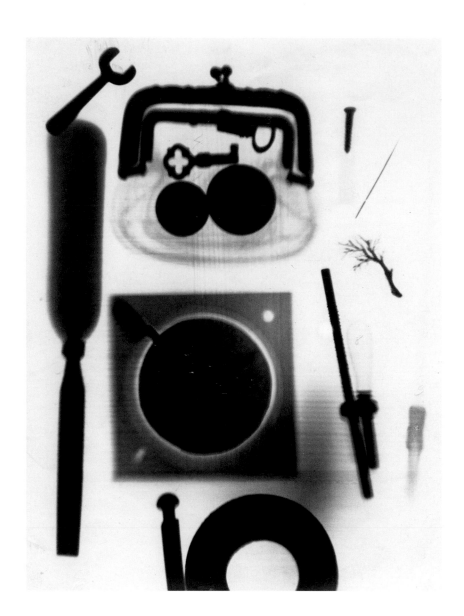

115

Eugène Adrien Ducretet **X-ray of various objects**
ca. 1896
Printing-out paper print

116

Albert Londe **X-ray of a six-fingered hand**
ca. 1896
Printing-out paper print

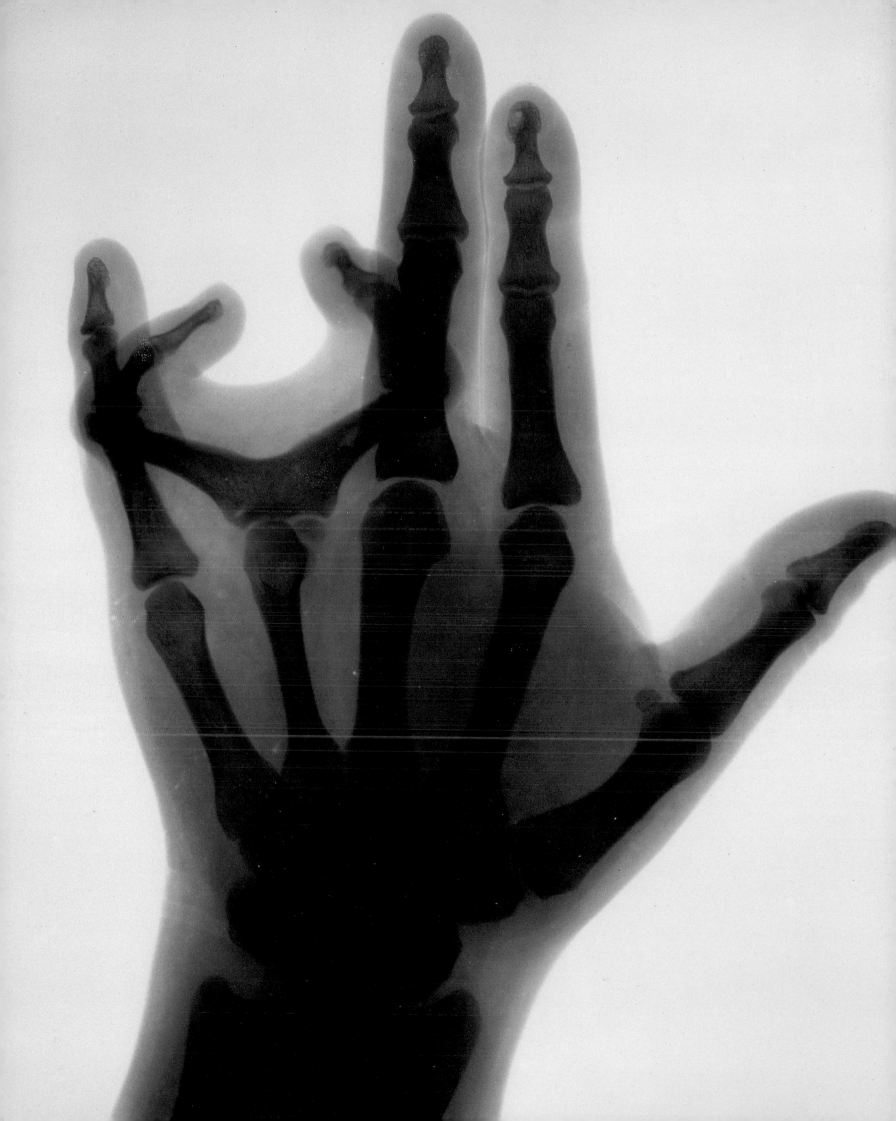

Docteur BERNARD

AVRANCHES

117

Bernard Héon **X-ray of a pelvis**
1897
Cyanotype

118

Josef Maria Eder and Eduard Valenta **Cameos in gold settings**
1896
Photogravure

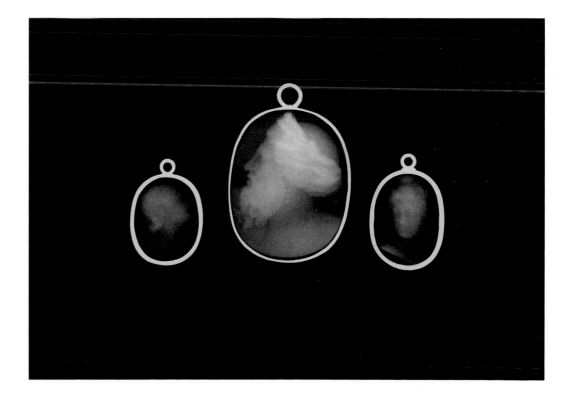

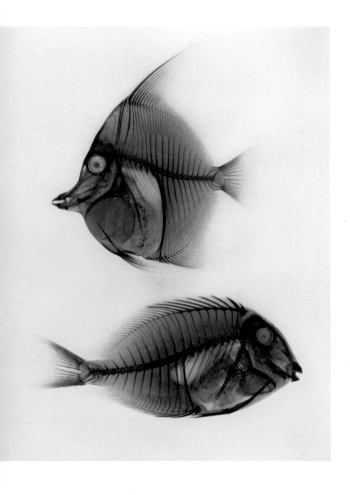

119

Josef Maria Eder and Eduard Valenta <u>Zanclus cornutus, Acanthurus nigros</u>

1896
Photogravure

120

Josef Maria Eder and Eduard Valenta Table of the permeability of various
substances to Röntgen rays

1896
Photogravure

121

Josef Maria Eder and Eduard Valenta <u>Chamaeleon cristatus</u>

1896
Photogravure

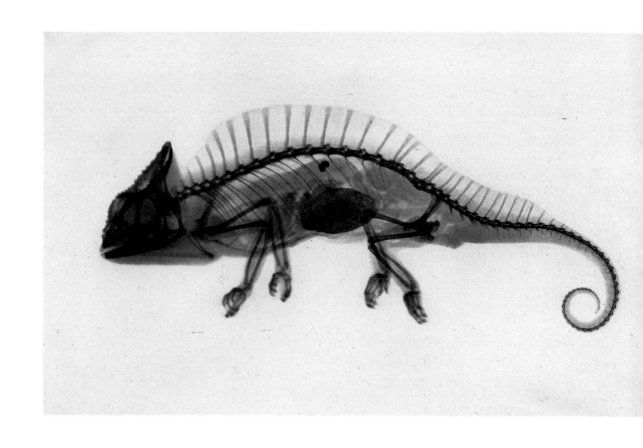

Radiographie exécutée par M. Chabaud avec un Tube Villard modèle 1898.

122

Victor Chabaud **X-ray of a thorax (adult, twenty years old)**

1898
Printing-out paper print

123

Charles Infroit **X-ray of the fetus of a river dolphin (<u>Platanista</u>)**

ca. 1900
Gelatin silver print

126

Joseph Jougla **X-ray of a woman wearing a hat**
ca. 1897
Printing-out paper print

127

Joseph Jougla **X-ray of a foot in a shoe**
ca. 1897
Printing-out paper print

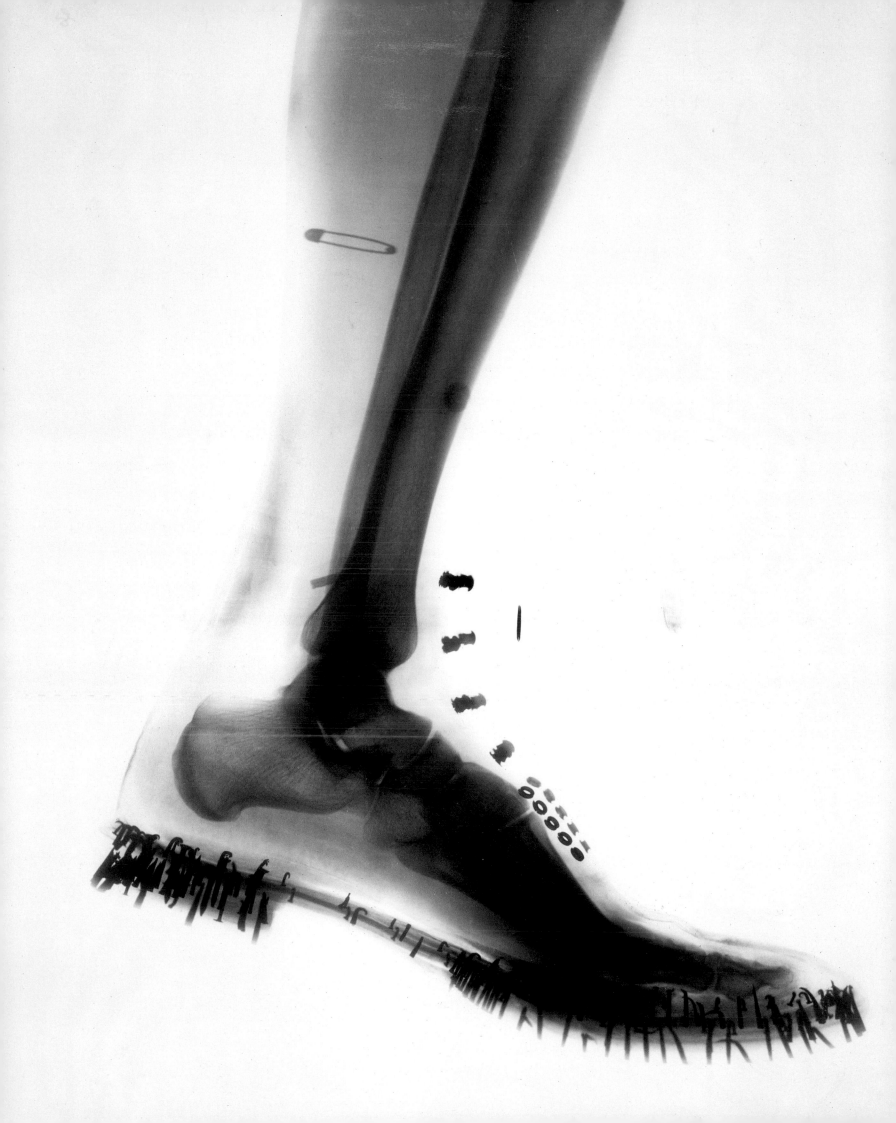

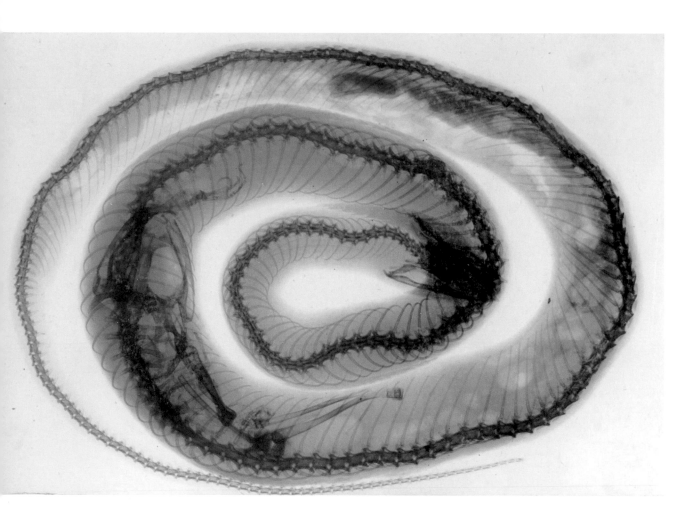

128

George Lefort **X-ray of a snake digesting a frog**
1898
Printing-out paper print

129

Unknown Photographer **X-ray of a hand showing shots embedded in flesh**
ca. 1898
Printing-out paper print

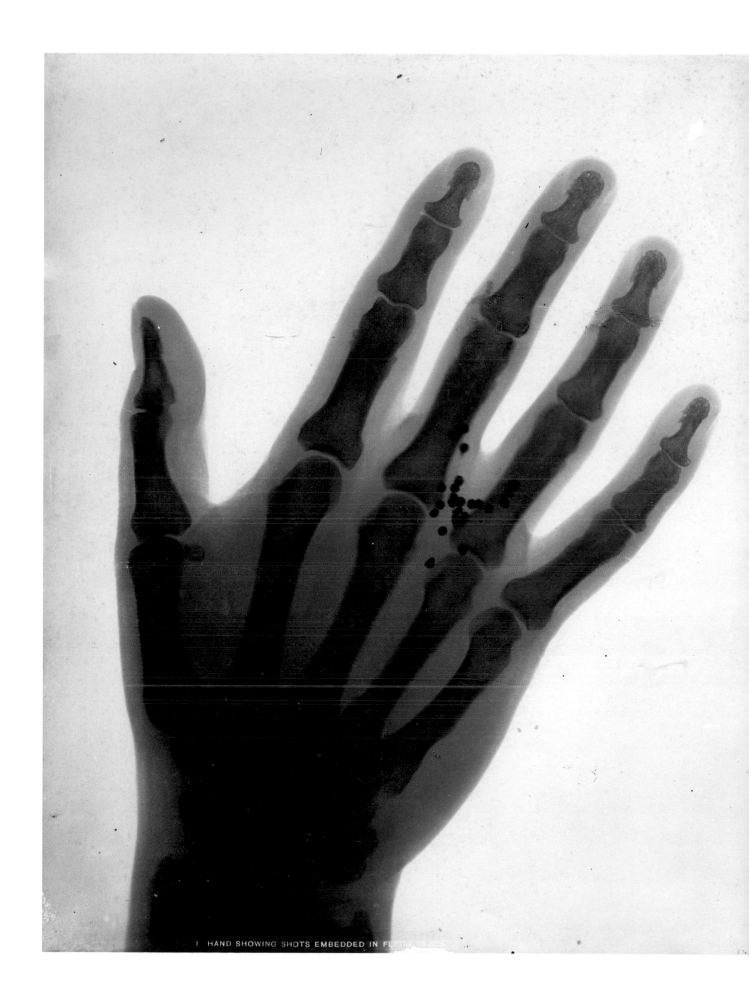

1 HAND SHOWING SHOTS EMBEDDED IN FL

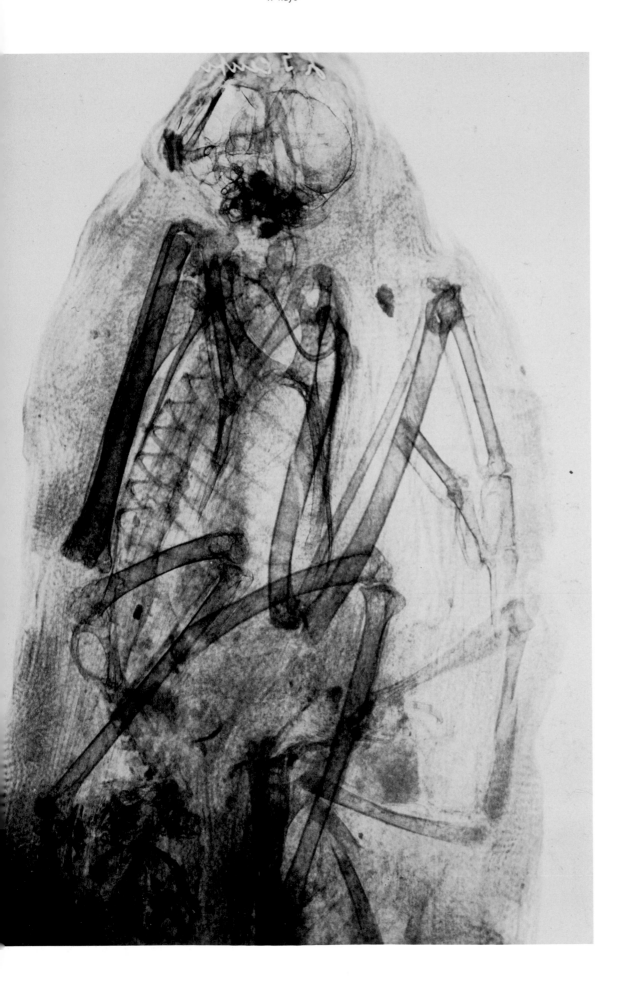

130

Henri van Heurck **X-ray of an ibis mummy**

1896
Printing-out paper print

131

Henri van Heurck **X-ray of a hand with a ring**

1896
Printing-out paper print

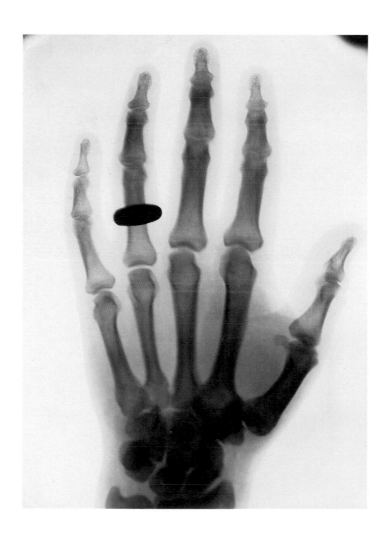

132

Albert Peignot **X-ray of a compass box**

1896
Printing-out paper print

133

Albert Peignot **X-ray of X-ray tubes**

1896
Printing-out paper print

134

Albert Peignot **X-ray of a frog and a turtle**

1896
Printing-out paper print

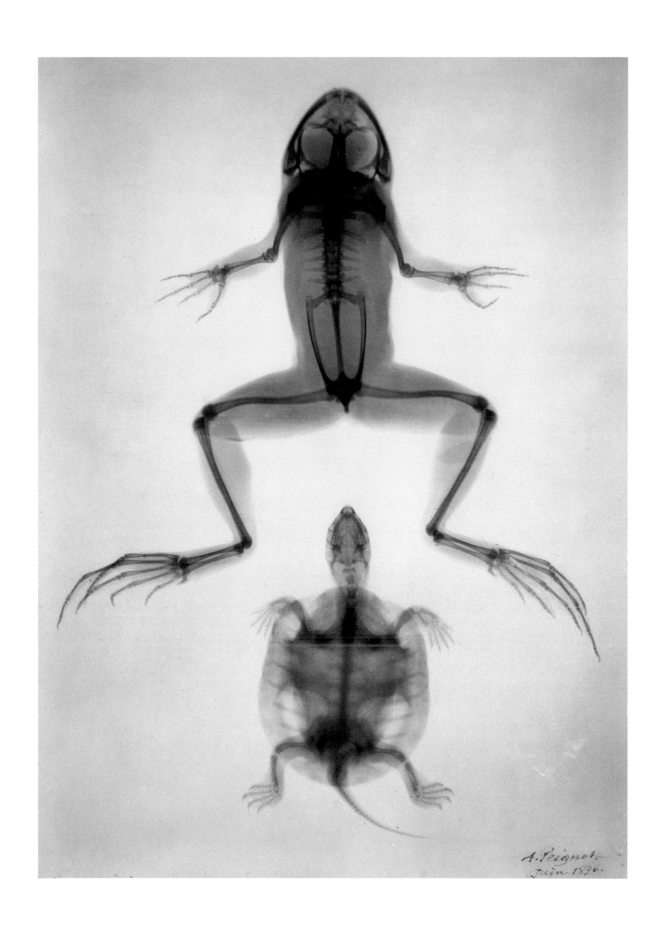

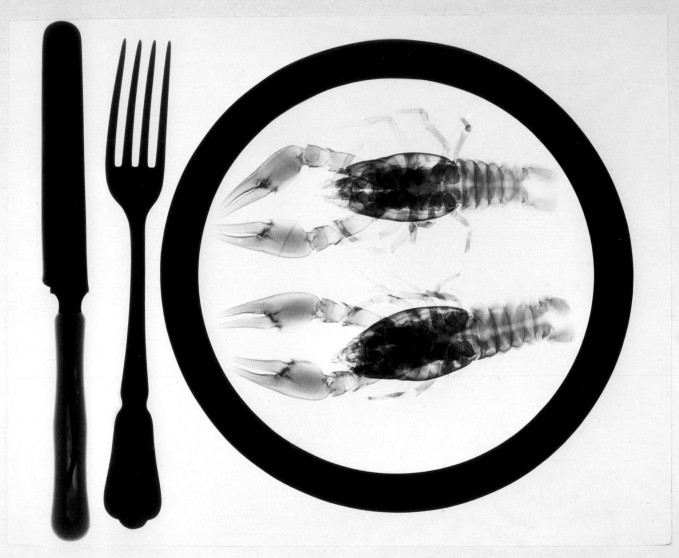

Radiographie exécutée par M. Chabaud avec un Tube Focus cylindrique, petit modèle.

135

Victor Chabaud **X-ray of a plate with crayfish: Radiograph executed by
Mr. Chabaud with a cylindrical focus tube, small model**

ca. 1897
Printing-out paper print

136

Walter König **Real and fake pearls**

1896
Printing-out paper print

137

Victor Chabaud **X-ray of a sea bream: Radiograph executed by**
Mr. Chabaud with a Colardeau-Chabaud tube, small model

ca. 1898
Printing-out paper prints

138

Victor Chabaud **X-ray of a skate**

1898
Printing-out paper print

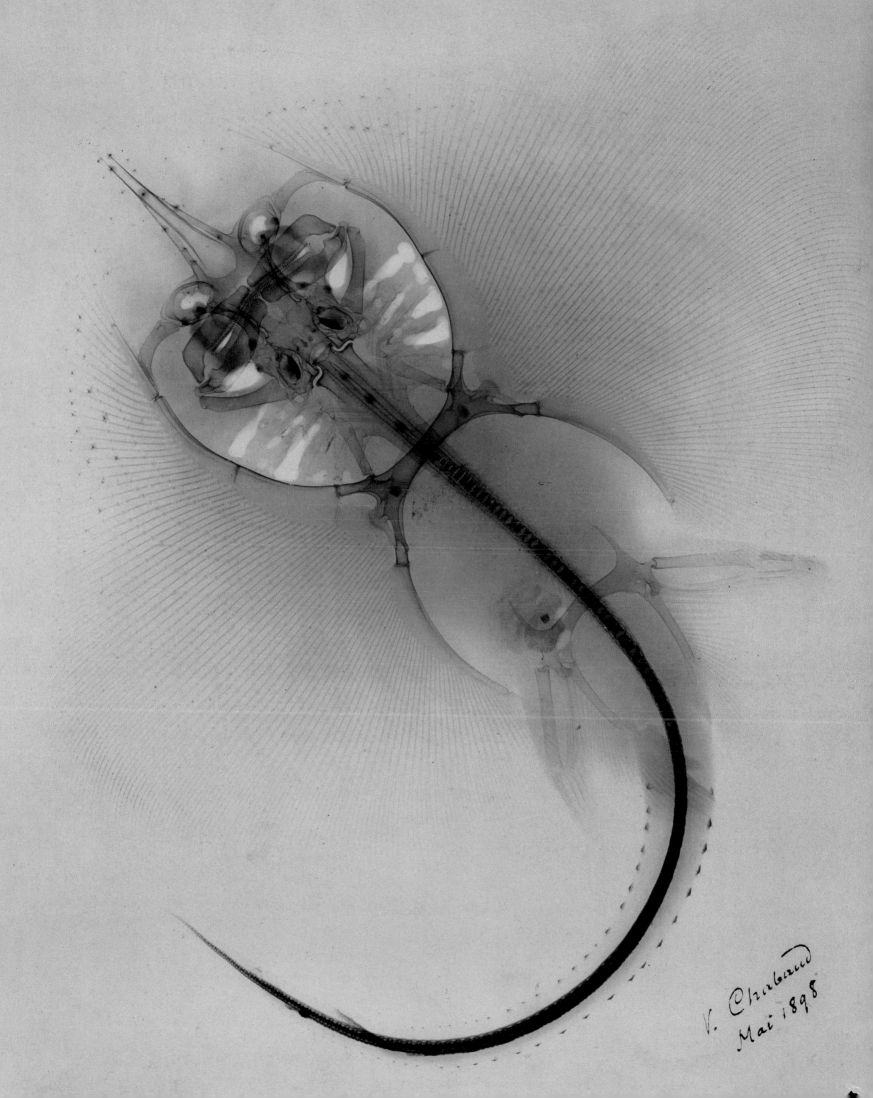

V. Chabaud
Mai 1898

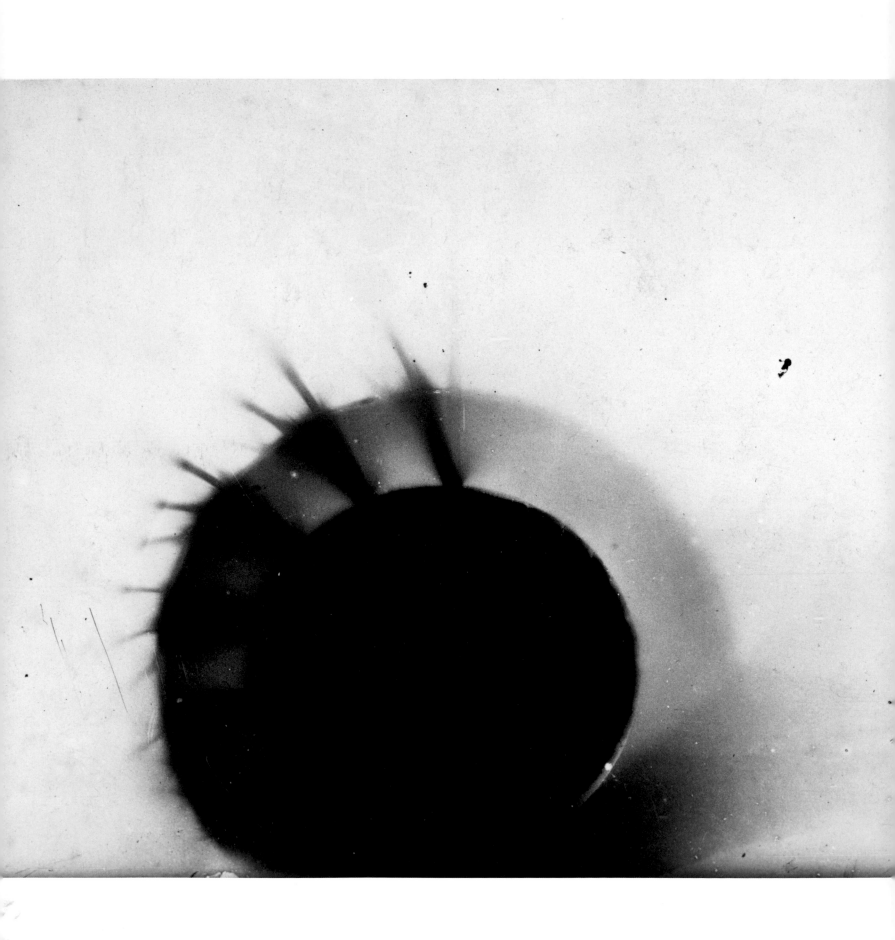

139

Antoine-Henri Becquerel **Rays emitted from a radioactive substance through a slitted screen**

1903
Gelatin silver print

140

Antoine Henri Becquerel **Rays emitted from a radioactive substance through a slitted screen**

1901
Gelatin silver print

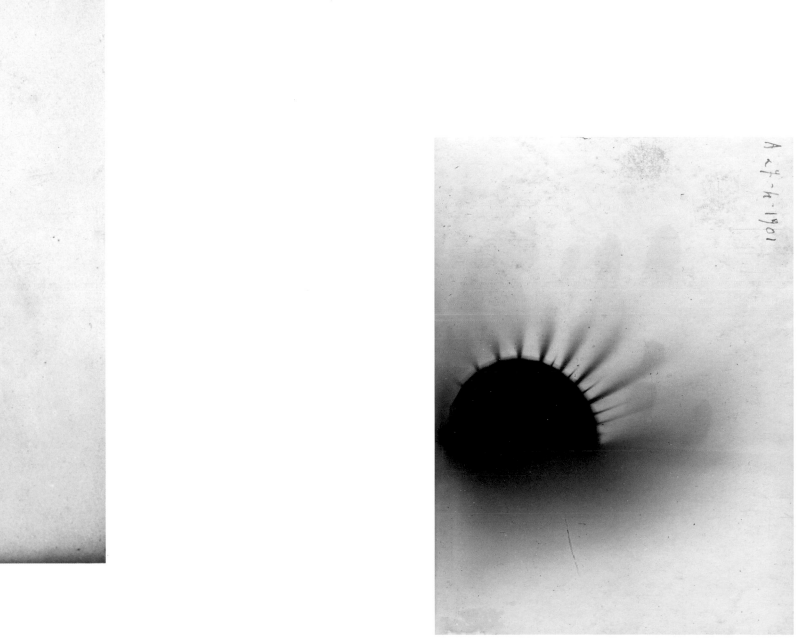

fig. 39
Cartoon in **Harper's Weekly** (May 8, 1869)
satirizing William H. Mumler's spirit photographs

SPIRIT PHOTOGRAPHY.

1. Mr. Dobbs, at the request of his Affianced, sits for his Photograph. Unconsciously happens in at Mumler's. | 2. Result—Portrait of Dobbs, with his Five Deceased Wives in Spirituo!!!

SPIRIT PHOTOGRAPHY

In 1861 William H. Mumler, a Boston jewelry engraver studying photography in his spare time, made a fortuitous mistake in the darkroom. Reusing a plate that had not been properly cleaned, he unintentionally created the first spirit photograph: a self-portrait that mysteriously included the ghostly apparition of a young girl floating by his side. Followers of Spiritualism, a popular occult movement founded in America in the late 1840s, seized upon this and similar photographs, claiming them as scientific evidence of the existence of ghosts and the possibility of communication between the dead and the living. To meet the demand for spirit photographs that followed their announcement in Spiritualist journals, Mumler soon devoted himself exclusively to their production (see fig. 25). Despite frequent ridicule in the press (see fig. 39) and widely publicized attempts by scientists and photographers to debunk spirit photography (including a trial in which Mumler was acquitted of charges of fraud), the pictures remained popular well into the twentieth century.[1] Attesting to the extent of the craze, thousands of spirit photographs—such as those assembled in an album by William J. Pierce, a San Francisco believer (see pls. 143–46)—have survived to the present day.

However unscientific they may appear to twenty-first-century eyes, spirit photographs are directly relevant to any investigation of science and photography in the nineteenth century. They depend on many of the same technologies and aesthetics as do genuinely scientific photographs, and they demonstrate photography's instrumental role in influencing public acceptance of scientific claims. Whereas scientists used photographic evidence to prove the existence of imperceptible microbes or distant stars, Spiritualists exploited the widespread fascination with science and credulity in the evidentiary value of photography to legitimize and promote their own beliefs, claiming that even the supernatural could be verified empirically by means of the camera. To better understand the complicated interrelationship of occultist and scientific uses of photography at that time, it is important to recall that invisible forces such as X-rays and electromagnetism—recent discoveries rendered visible through photography—appeared magical, otherworldly, and even frightening to average people. For many, it was quite logical to imagine that other strange and unknown forces might be lurking beneath the threshold of human perception; if it were possible to reveal bones and organs beneath the skin with the aid of invisible X-rays, it was equally plausible that a modern technology such as photography could reveal the presence of spirits in their midst. In fact, many scientists were believers themselves, or at least found Spiritualist claims credible enough to subject to experimentation.[2]

At the end of the century, adherents of animism adeptly coopted scientific terminology and methodology to legitimize their beliefs. Unlike Spiritualists, whose faith was dependent on the purported powers of the dead, animists were concerned with forces that emanated from the living, variously characterized as vital or universal fluid, animal magnetism, or the "od" (after the Norse god Odin). Many, such as Hippolyte Baraduc (pl. 141), Émile David and Jules-Bernard Luys (pl. 156), and Jakob Ottonowitsch von Narkiewitsch-Jodko (pls. 142, 149–50), were

fig. 40
Illustration in **Pour photographier les rayons humains**
(Photographing Human Rays), 1912,
by Fernand Girod, showing Hippolyte Baraduc
and Louis Darget's Portable Radiographer device

trained scientists who hoped that their findings might have future medical applications. Their "fluidic" photographs, made by placing a finger, hand, or forehead to a sensitized plate in a darkened room, formally resemble other types of scientific imagery. Baraduc and Narkiewitsch-Jodko, who enhanced their fluidic pictures by running a weak electrical current through the bodies of their subjects, made prints that are visually quite similar to those produced by Hermann Schnauss (see p. 8; pl. 147) and Étienne Léopold Trouvelot to demonstrate the behavior of electricity. It is only in intent that they differ.

After Wilhelm Conrad Röntgen's 1895 discovery, many animists argued that X-rays themselves were proof that a vital force coursed through animate and inanimate bodies. Perhaps the most blatant example of occultist appropriation of scientific terms and procedures is Baraduc and Louis Darget's Portable Radiographer, a primitive device with a head strap for securing a photographic plate to a subject's forehead (see fig. 40). Despite its name, the invention had no real relationship to X-rays: positing that thoughts were radiant, Baraduc and Darget asserted they could be recorded by this supposedly radiographic device.[3] Darget saw in the streaks and amorphous blobs that appeared on his plates symbols suggesting the contents of his subjects' minds (see pls. 152–55). Like a scientist, he assiduously documented the conditions of his experiments and provided an analysis of the results alongside each "thought photograph."

Erin O'Toole

1. Enthusiasm for spirit photographs persisted in America and Britain much longer than it did in France, where the 1875 conviction of the spirit photographer Édouard Isidore Buguet effectively destroyed public faith in their credibility. See Clément Chéroux, "Ghost Dialectics: Spirit Photography in Entertainment and Belief," in **The Perfect Medium: Photography and the Occult,** by Clément Chéroux, Andreas Fischer et al (New Haven, CT: Yale University Press, 2005), 51.
2. See Jennifer Tucker's engaging discussion of the difficulty photographers and scientists encountered in refuting spirit photographs in **Nature Exposed: Photography as Eyewitness in Victorian Science** (Baltimore: Johns Hopkins University Press, 2005), 82.
3. See Clément Chéroux, "Photographs of Fluids: An Alphabet of Invisible Rays," in **The Perfect Medium,** 114–25.

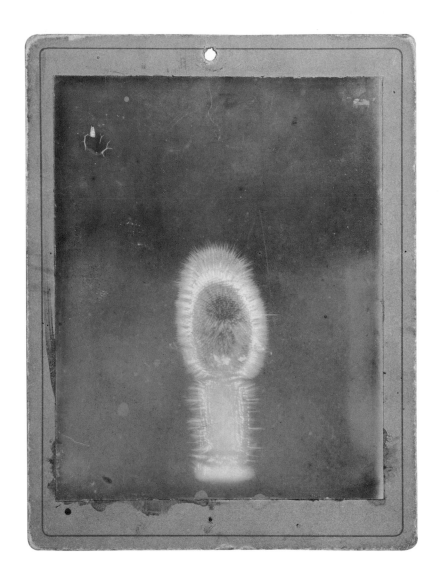

141

Hippolyte Baraduc **Photograph of the fluidic nimbus of a medium's thumb**

1893
Gelatin silver print

142

Jakob Ottonowitsch von Narkiewitsch-Jodko **Radiation of a very anemic young woman**

1895
Printing-out paper print

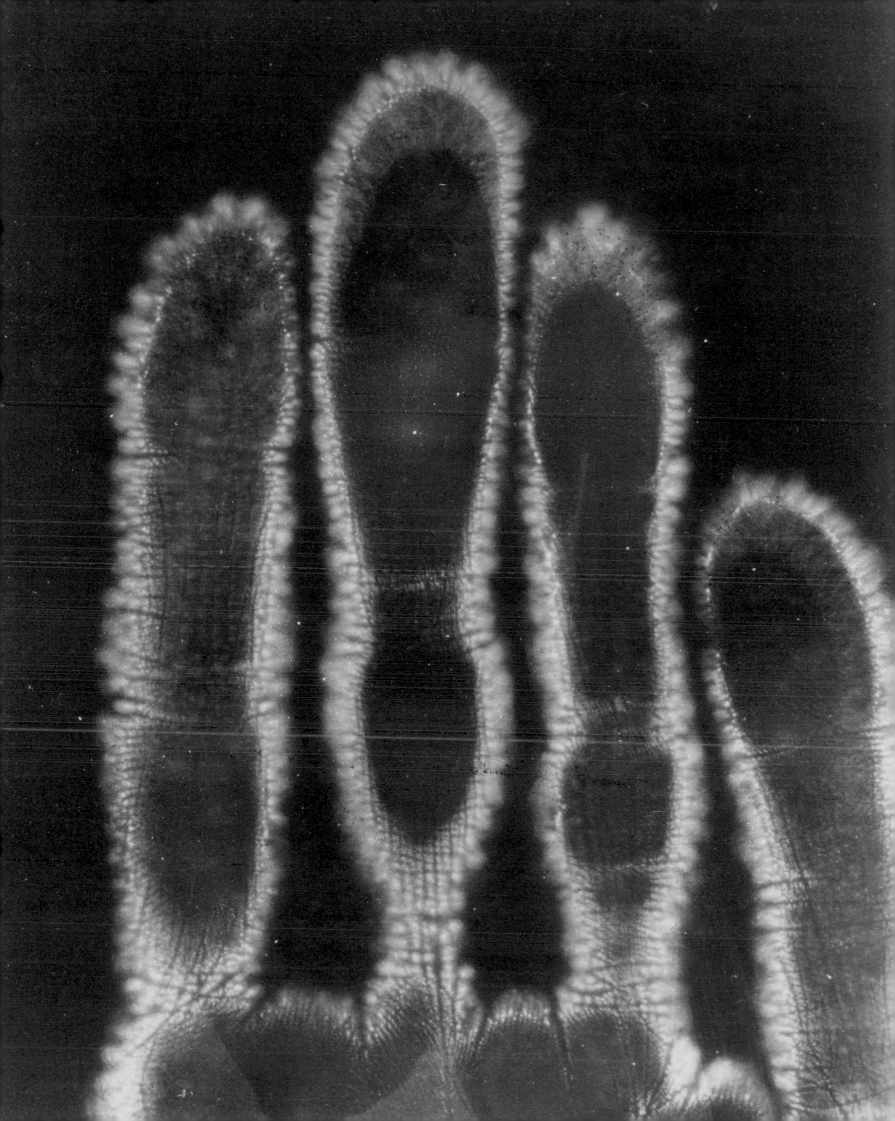

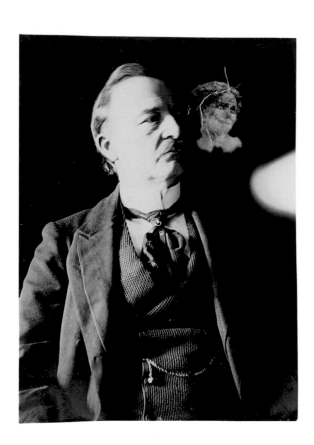

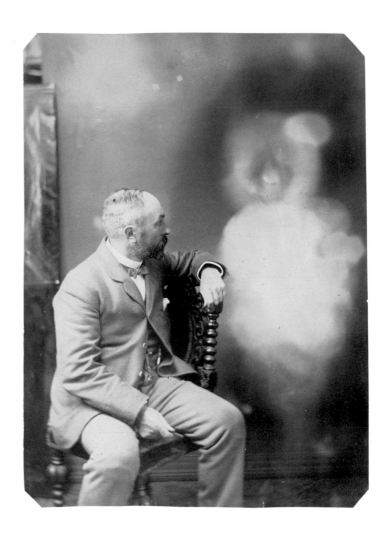

143–46

William J. Pierce Details from the album **Spirit Photographs**
ca. 1903
Gelatin silver prints

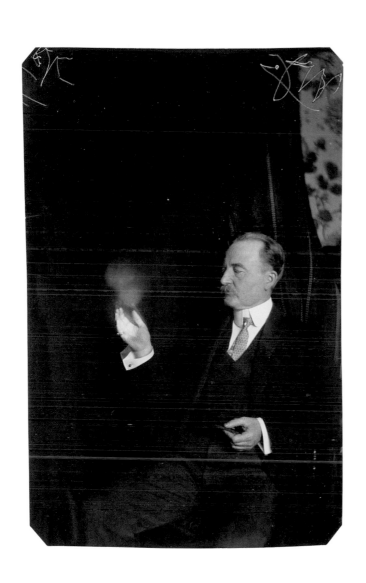

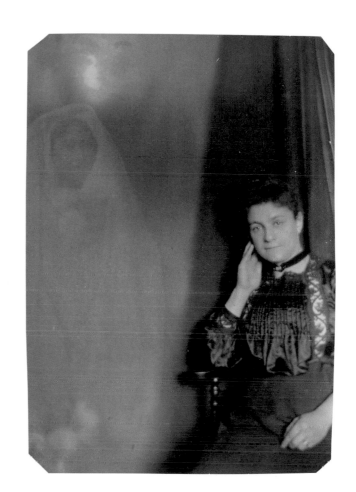

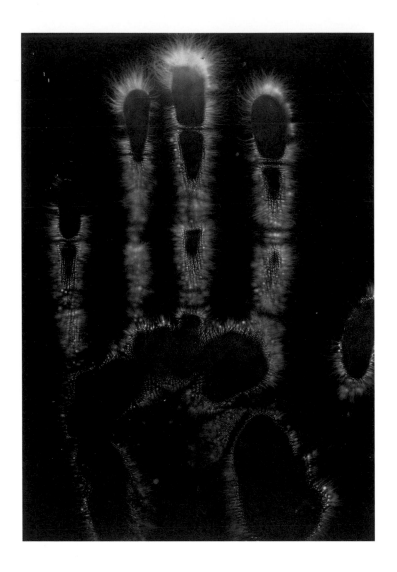

147

Hermann Schnauss **Electrograph of a hand**

1900
Albumen print

148

Adrien Majewski **Hand of Miss Majewski (digital effluvia)**

ca. 1898
Gelatin silver print

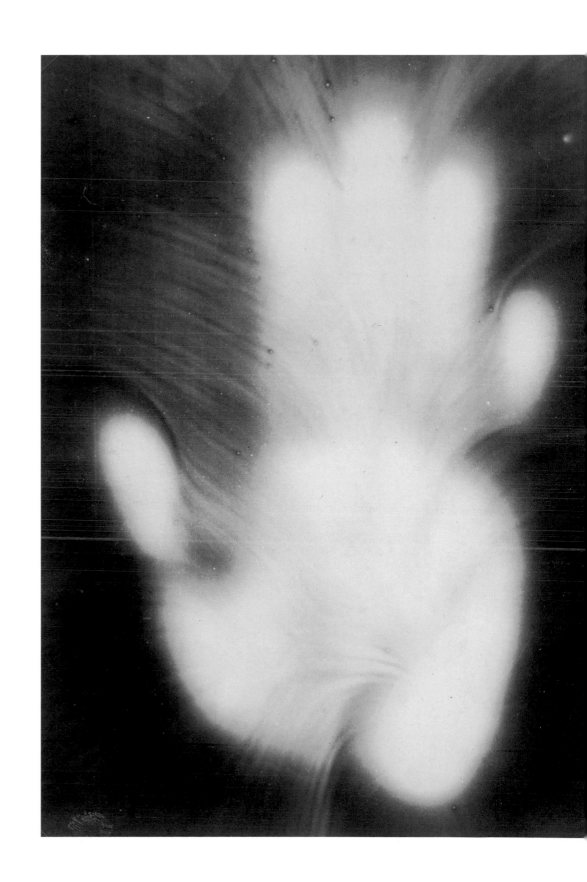

Jakob Ottonowitsch von Narkiewitsch-Jodko **Spark made on the surface of the body of a prostitute—well washed**

1895
Printing-out paper print

Jakob Ottonowitsch von Narkiewitsch-Jodko **Spark made on the surface of the body of a young girl**

1895
Printing-out paper print

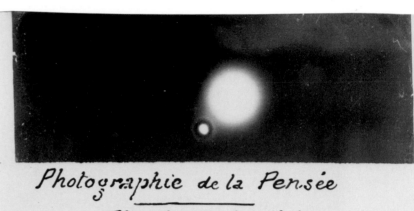

Louis Darget V-rays: Human radioactivity

ca. 1900
Gelatin silver print

Louis Darget Photograph of thought: Planet and satellite

1896
Printing-out paper print

153

Louis Darget **Photograph of a dream: The eagle**

1896
Gelatin silver print

154

Louis Darget **Photograph of thought**

1896
Gelatin silver print

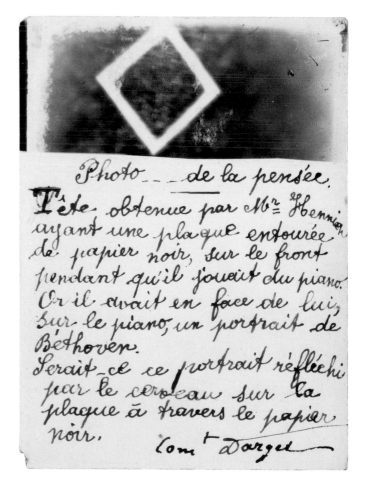

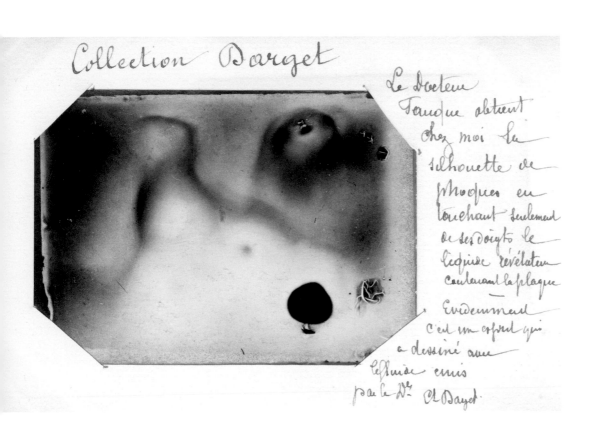

155

Louis Darget **Doctor Fauque**

ca. 1896
Gelatin silver print

156

Émile David and Jules-Bernard Luys **Fluidic emission of the fingers of two hands**

1897
Printing-out paper print

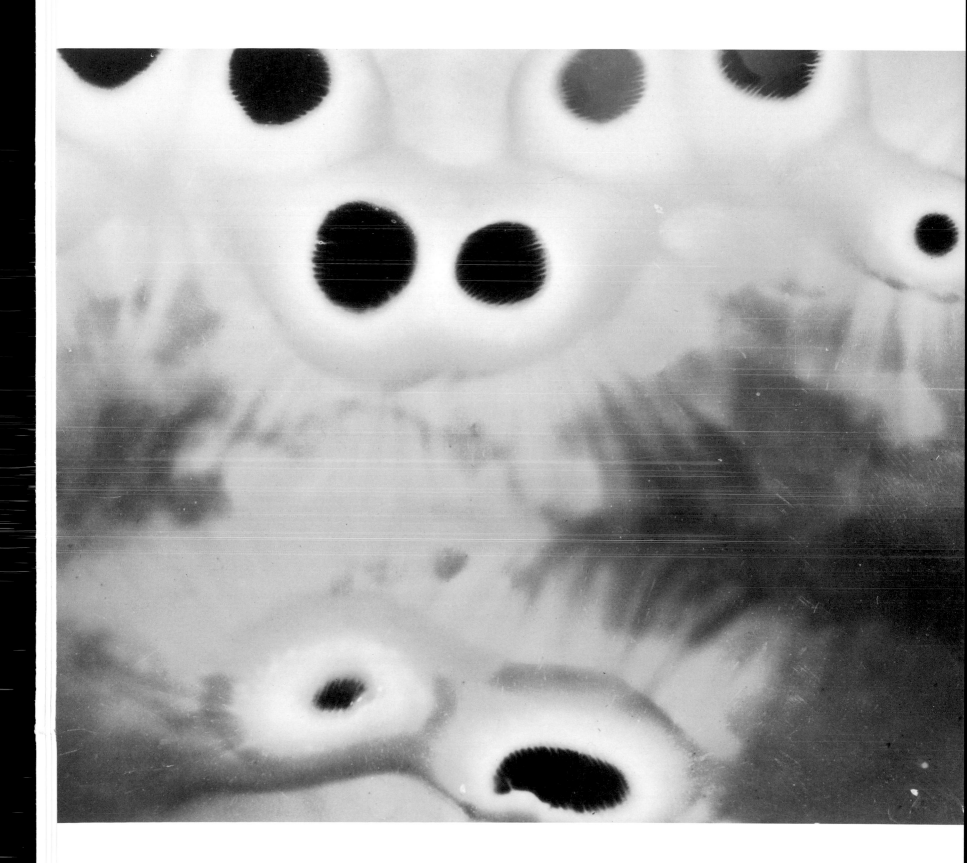

Spark made on the surface of the body
of a young girl, 1895 (pl. 150)
Printing-out paper print
3 x 3 1/16 in. (7.8 x 7.9 cm)
Courtesy Galerie Françoise Paviot, Paris

James Nasmyth and James Carpenter
British, 1808–1890 ; British, active ca. 1870s
The Moon: Considered as a Planet, a World,
and a Satellite, 1874
Book with twenty-four woodburytypes
11 7/16 x 8 15/16 in. (29.1 x 22.7 cm)
Stephen White Collection II, Los Angeles

The Moon: Considered as a Planet, a World,
and a Satellite, 1874
Book with twenty-four woodburytypes
11 7/16 x 8 15/16 in. (29.1 x 22.7 cm)
San Francisco Museum of Modern Art,
Accessions Committee Fund

Richard Neuhauss German, 1855–1915
Snowflakes, 1892
Gelatin silver print
4 3/16 x 4 3/16 in. (10.6 x 10.6 cm)
Albertina, Vienna, permanent loan of the Höhere
Graphische Bundes-Lehr- und Versuchsanstalt, Vienna

Adolphe Neyt Belgian, 1830–1892
Grains of starch, ca. 1869 (pl. 29)
Albumen print
8 x 6 in. (20.4 x 15.3 cm)
Société française de photographie, Paris

Isthmia enervis, ca. 1869 (pl. 28)
Albumen print
8 x 6 in. (20.4 x 15.3 cm)
Société française de photographie, Paris

Albert von Obermayer Austrian, 1844–1915
Pulverization of a ten-centimeter-long iron wire
by a strong electrical discharge, ca. 1893 (pl. 110)
Albumen print
6 1/2 x 8 11/16 in. (16.5 x 22.1 cm)
Albertina, Vienna, permanent loan of the Höhere
Graphische Bundes-Lehr- und Versuchsanstalt, Vienna

Charles Ozanam and Édouard Baldus
French, 1813–1889; French, 1824–1890
Pulse of a five-year-old boy, eighty beats
per minute, 1869 (pl. 75)
Albumen print
5 1/4 x 8 11/16 in. (13.5 x 22 cm)
Société française de photographie, Paris

Pulse of a forty-three-year-old man in a moment
of excitation, sixty-two beats per minute: Very
strong pulse, 1869 (pl. 74)
Albumen print
5 1/4 x 8 11/16 in. (13.5 x 22 cm)
Société française de photographie, Paris

Pulse of a sixty-two-year-old man, seventy beats
per minute, 1869
Albumen print
5 5/16 x 8 11/16 in. (13.5 x 22 cm)
Société française de photographie, Paris

Pulse of a twenty-nine-year-old man, sixty-six
beats per minute, 1869
Albumen print
5 1/4 x 8 1/4 in.(13.3 x 20.9 cm)
Société française de photographie, Paris

Albert Peignot French, active ca. 1890
X-ray of a compass box, 1896 (pl. 132)
Printing-out paper print
9 x 6 1/2 in. (22.9 x 16.5 cm)
Musée des arts et métiers, Conservatoire national des
arts et métiers, Paris

X-ray of a frog and a turtle, 1896 (pl. 134)
Printing-out paper print
9 x 6 1/2 in. (22.9 x 16.5 cm)
Musée des arts et métiers, Conservatoire national des
arts et métiers, Paris

X-ray of X-ray tubes, 1896 (pl. 133)
Printing-out paper print
9 x 6 7/8 in. (22.9 x 17.5 cm)
Musée des arts et métiers, Conservatoire national des
arts et métiers, Paris

William J. Pierce American, active early 1900s
Spirit Photographs, ca. 1903 (pls. 143–46)
Album with 274 gelatin silver prints
10 1/4 x 8 3/8 in. (26 x 21.3 cm)
San Francisco Museum of Modern Art,
Accessions Committee Fund

Ferdinand Quénisset French, 1872–1951
Jupiter and its moons, ca. 1897 (pl. 65)
Gelatin silver print
6 1/2 x 4 3/16 in. (16.5 x 10.6 cm)
Stephen White Collection II, Los Angeles

Lewis Morris Rutherfurd American, 1816–1892
Moon, New York, March 6, 1865, 1865
Albumen print
21 5/16 x 16 1/16 in. (54.2 x 40.8 cm)
The RPS Collection at the National Media Museum, Bradford,
England, purchased with the Assistance of the Art Fund

Georges Sagnac French, 1869–1928
Illusions qui accompagnent les défauts
d'accomodations (Illusions That Accompany
the Defects of Accommodation), 1897
Book with six albumen prints
9 11/16 x 6 3/4 in. (24.6 x 17.2 cm)
Courtesy Hans P. Kraus, Jr., Inc., New York

E. N. Santini French, 1847–1908
La photographie à travers les corps opaques
(Photography through Opaque Bodies), 1896
Book with two relief halftones
7 5/8 x 4 15/16 in. (19.4 x 12.5 cm)
San Francisco Museum of Modern Art, purchased through
a gift of K.C. Chiang and Joseph B. Hershenson

Hermann Schnauss German, 1857–1906
Electrograph of a brass wire gauge, 1900 (p. 8)
Albumen print
6 x 4 5/16 in. (15.2 x 11 cm)
Albertina, Vienna, permanent loan of the Höhere
Graphische Bundes-Lehr- und Versuchsanstalt, Vienna

Electrograph of a five-mark coin, 1900
Albumen print
6 1/8 x 4 7/16 in. (15.6 x 11.3 cm)
Albertina, Vienna, permanent loan of the Höhere
Graphische Bundes-Lehr- und Versuchsanstalt, Vienna

Electrograph of a hand, 1900 (pl. 147)
Albumen print
6 5/8 x 4 11/16 in. (16.9 x 11.9 cm)
Albertina, Vienna, permanent loan of the Höhere
Graphische Bundes-Lehr- und Versuchsanstalt, Vienna

Célestin-Adrien Soret French, 1854–1934
Cornea of a fly's eye, n.d.
Albumen print
7 1/16 x 5 in. (18 x 12.7 cm)
Albertina, Vienna, permanent loan of the Höhere
Graphische Bundes-Lehr- und Versuchsanstalt, Vienna

Taber Studio American, active ca. 1880–1910s
The moon, August 21, 1888—from negatives made with
the great telescope of the Lick Observatory, 1888
Albumen print
7 3/4 x 5 15/16 in. (19.7 x 15.1 cm)
San Francisco Museum of Modern Art,
gift of Gordon L. Bennett

William Henry Fox Talbot British, 1800–1877
Photomicrograph of diatoms, ca. 1839 (pl. 3)
Salt print
6 x 4 7/16 in. (15.2 x 11.3 cm)
National Media Museum, Bradford, England

Photomicrograph of a plant stem, ca. 1839 (pl. 2)
Salt print
5 9/16 x 7 in. (14.2 x 17.8 cm)
National Media Museum, Bradford, England

Photomicrograph of moth wings, ca. 1840 (pl. 1)
Calotype negative
4 7/16 x 6 1/16 in. (11.3 x 15.4 cm)
National Media Museum, Bradford, England

A. Thouroude French, dates unknown
Collection of photomicrographs, 1890 (pl. 30)
Albumen and printing-out paper prints
mounted on board
Overall: 17 3/16 x 36 7/8 in. (43.7 x 93.6 cm)
Société française de photographie, Paris

John Titlington British, dates unknown
Autographs of the sun taken with the heliautograph
of the Reverend William Selwyn of Ely,
July 25–August 4, 1862, 1862
Albumen prints
Overall: 5 5/16 x 61 7/16 in. (13.5 x 156 cm)
National Media Museum, Bradford, England

E. Touchet and A. Benoit French, dates unknown
Partial eclipse of the moon, September 15, 1894, 1894
Printing-out paper print
10 5/8 x 13 3/4 in. (27 x 35 cm)
Bernard Garrett Collection, Paris

Étienne Léopold Trouvelot French, 1827–1895
Direct electric sparks obtained with a Ruhmkorff coil or
Wimshurst machine, also known as "Trouvelot figures,"
ca. 1888 (pls. 112–13)
Printing-out paper prints
Five prints, each: between 8 7/8 x 6 11/16 in. (22.5 x 17 cm)
and 14 9/16 x 10 13/16 in. (37 x 27.5 cm)
Musée des arts et métiers, Conservatoire national des
arts et métiers, Paris

Electric effluvia on the surface and circumference
of a coin, ca. 1888 (pl. 114)
Printing-out paper print
8 7/8 x 6 11/16 in. (22.5 x 17 cm)
Musée des arts et métiers, Conservatoire national des
arts et métiers, Paris

Robert Ultzmann Austrian, 1842–1889
Mikroskopisch-Photographischer Atlas der Harnsedimente
(Photomicrographic Album of Urine Sediment), 1869
Album with sixty-three albumen prints
12 x 18 in. (30.5 x 45.7 cm)
The Metropolitan Museum of Art, Joyce F. Menschel
Photography Library Fund, 2006

Unknown Photographers
Magnetic fields of three magnets: Small horseshoe,
large horseshoe, and round, n.d. (pls. 99–100)
Gelatin silver prints
Three prints, each: 7 1/8 x 5 1/8 in. (18.1 x 13 cm)
Bernard Garrett Collection, Paris

Two views of an eclipse, n.d.
Gelatin silver print
2 13/16 x 5 7/8 in. (7.1 x 15 cm)
Bernard Garrett Collection, Paris

Unknown Photographers American
Photomicrograph of a flea made at the Throop
Institute, Pasadena, 1892
Cyanotype
4 7/8 x 3 5/8 in. (12.38 x 9.21 cm)
Stephen White Collection II, Los Angeles

Souvenir of the Visit of Lord and Lady Kelvin
to General Electric Company, 1897 (pl. 111)
Album with thirty-three platinum prints
12 x 14 ¼ in. (30.5 x 36.2 cm)
Courtesy Susan Herzig and Paul Hertzmann,
Paul M. Hertzmann, Inc., San Francisco

Solar eclipse, 1900 (pl. 61)
Gelatin silver print
8 ¾ x 6 ½ in. (22.2 x 16.5 cm)
Stephen White Collection II, Los Angeles

The Great Nebula in Andromeda, ca. 1900
Gelatin silver print
9 ¼ x 7 ¼ in. (23.5 x 18.4 cm)
Stephen White Collection II, Los Angeles

The Orion Nebula, ca. 1900 (pl. 68)
Gelatin silver print
9 ¼ x 7 ½ in. (23.5 x 19.1 cm)
Stephen White Collection II, Los Angeles

Pleiades—showing nebulous matter attached,
ca. 1900 (pl. 69)
Gelatin silver print
9 x 7 in. (22.9 x 17.8 cm)
Stephen White Collection II, Los Angeles

Great Comet, 1901 (pl. 71)
Gelatin silver print
6 x 5 ⅜ in. (15.2 x 13.7 cm)
Stephen White Collection II, Los Angeles

Unknown Photographers British or American
Polyzoon, Augula plumosa, magnified seventeen
times, ca. 1870s–80s (pl. 25)
Albumen stereograph
3 ⁷⁄₁₆ x 7 in. (8.7 x 17.8 cm)
San Francisco Museum of Modern Art,
gift of Gordon L. Bennett

Saws of a sawfly, magnified sixty-six times,
ca. 1870s–80s (pl. 26)
Albumen stereograph
3 ⁷⁄₁₆ x 7 ¹⁄₁₆ in. (8.7 x 17.9 cm)
San Francisco Museum of Modern Art,
gift of Gordon L. Bennett

X-ray of a hand showing shots embedded in flesh,
ca. 1898 (pl. 129)
Printing-out paper print
9 ½ x 7 ¾ in. (24.1 x 19.7 cm)
Bernard Garrett Collection, Paris

Unknown Photographers French
Passage of the moon over two hours,
Arachon, France, ca. 1870s (pl. 55)
Albumen print
4 ¾ x 6 ¾ in. (12.1 x 17.2 cm)
Joy of Giving Something, Inc., New York

Determination of the position of the celestial pole by
photography, October 28, 1897, 1897 (pl. 66)
Gelatin silver print
5 ⅛ x 7 ³⁄₁₆ in. (13 x 18.2 cm)
Bernard Garrett Collection, Paris

Comet, ca. 1900 (pl. 70)
Gelatin silver print
6 ⅛ x 6 ⁵⁄₁₆ in. (15.6 x 16 cm)
San Francisco Museum of Modern Art,
Members of Foto Forum

Hermann Wilhelm Vogel German, 1834–1898
Solar spectrum photographed with pure
and colored bromyrite, 1874 (pl. 58)
Albumen print
2 ¹⁵⁄₁₆ x 2 ¹⁵⁄₁₆ in. (7.4 x 7.4 cm)
Albertina, Vienna, permanent loan of the Höhere
Graphische Bundes-Lehr- und Versuchsanstalt, Vienna

Carleton E. Watkins American, 1829–1916
Solar eclipse, 1889 (pl. 56)
Albumen print
6 ½ x 8 ½ in. (16.5 x 21.6 cm)
J. Paul Getty Museum, Los Angeles

John Adams Whipple and George Phillips Bond
American, 1822–1891; American, 1825–1865
Moon, 1851 (pl. 41)
Daguerreotype
4 ¾ x 3 ¾ in. (12 x 9.3 cm)
National Media Museum, Bradford, England

Partial eclipse of the sun, July 28, 1851, 1851 (pl. 42)
Daguerreotype
2 ¾ x 3 ¼ in. (7 x 8.3 cm)
Harvard College Observatory

View of the moon, February 26, 1852, 1852 (fig. 1)
Daguerreotype
4 ¼ x 3 ¼ in. (10.8 x 8.3 cm)
Harvard College Observatory

Maximilian Franz Josef Cornelius Wolf
German, 1863–1932
The Milky Way, ca. 1900 (pl. 73)
Gelatin silver bromide print
11 ⅜ x 9 ⅛ in. (28.9 x 23.2 cm)
San Francisco Museum of Modern Art,
members of Foto Forum

Maximilian Franz Josef Cornelius Wolf and Johann Palisa
German, 1863–1932; Austrian, 1848–1925
Star map, from the album Photographische Sternkarten
(Photographic Star Maps), 1903 (pl. 72)
Gelatin silver print
10 ¼ x 14 in. (26 x 35.6 cm)
San Francisco Museum of Modern Art,
Accessions Committee Fund

Joseph Janvier Woodward American, 1833–1884
Epidermis of a frog, showing stomata between the
epithelial cells, 1863, from the album Microscopical
Photographs, 1870
Albumen print
5 x 5 in. (12.7 x 12.7 cm)
San Francisco Museum of Modern Art,
Accessions Committee Fund

Portion of a small vein, from the muscular coat of the
urinary bladder of a frog, 1863, from the album
Microscopical Photographs, 1870
Albumen print
5 x 5 in. (12.7 x 12.7 cm)
San Francisco Museum of Modern Art,
Accessions Committee Fund

Small artery, showing epithelium and circular muscular
fiber cells, from the mesentery of a frog, 1870, from the
album Microscopical Photographs, 1870
Albumen print
5 x 5 in. (12.7 x 12.7 cm)
San Francisco Museum of Modern Art,
Accessions Committee Fund

Army Medical Museum: Lecture on the Structure of
Cancerous Tumors and the Mode in Which Adjacent
Parts Are Invaded, 1873
Album with seventy-four albumen prints
14 x 12 ½ in. (35.6 x 31.8 cm)
Joy of Giving Something, Inc., New York

This catalogue is published by the San Francisco Museum of Modern Art
in association with Yale University Press on the occasion of the exhibition
Brought to Light: Photography and the Invisible, 1840–1900, organized
by Corey Keller for the San Francisco Museum of Modern Art.

Exhibition Schedule

San Francisco Museum of Modern Art
October 11, 2008–January 4, 2009

Albertina, Vienna
March 20–June 6, 2009

Brought to Light: Photography and the Invisible, 1840–1900, is
generously supported by the George Frederick Jewett Foundation.

Director of Publications: Chad Coerver
Managing Editor: Karen A. Levine
Art Director: Jennifer Sonderby
Designer: James Williams
Publications Assistant: Amanda Glesmann

Library of Congress Cataloging-in-Publication Data

Brought to light : photography and the invisible, 1840–1900 / edited by
Corey Keller; with essays by Jennifer Tucker, Tom Gunning, Maren Gröning.
 p. cm.
 Exhibition held at the San Francisco Museum of Modern Art, Oct. 11,
2008–Jan. 4, 2009 and at the Albertina Vienna, Mar. 20, 2009–June 6,
2009.
 Includes bibliographical references and index.
 Summary: "Published in conjunction with an exhibition at the San
Francisco Museum of Modern Art. Explores nineteenth-century photogra-
phy's impact on science and popular culture. Includes reproductions of
nearly 200 vintage photographs and scholarly essays by exhibition
curator Corey Keller, cultural historian Jennifer Tucker, and film historian
Tom Gunning" —Provided by Publisher.
 ISBN 978-0-300-14210-5
 1. Photography—Scientific applications—History—19th century—Exhibi-
tions. 2. Photography—Social aspects—History—19th century—Exhibi-
tions. I. Keller, Corey. II. San Francisco Museum of Modern Art. III.
Graphische Sammlung Albertina.
 TR692.B76 2008
 779.074'79461—dc22
 2008024251

Published in association with
Yale University Press, New Haven and London
www.yalebooks.com

Front cover and page 8:

Hermann Schnauss
Electrograph of a brass wire gauge, 1900
Albertina, Vienna, permanent loan of the Höhere Graphische
Bundes-Lehr- und Versuchsanstalt, Vienna

Back cover:

Maximilian Franz Josef Cornelius Wolf
The Milky Way, ca. 1900 (detail of pl. 73)
San Francisco Museum of Modern Art, members of Foto Forum

Frontispieces:

Page 2: Albert Peignot, **X-ray of X-ray tubes,** 1896 (detail of pl. 133).
Page 3: Wilson Alwyn Bentley, **Snowflake,** before 1905 (detail of pl. 40).
Page 4: Étienne Léopold Trouvelot, **Direct electric spark obtained with
a Ruhmkorff coil or Wimshurst machine, also known as a "Trouvelot
figure,"** ca. 1888 (detail of pl. 113). Page 5: Étienne-Jules Marey and
Charles Fremont, **Chronophotograph of two men with mallets,** 1894
(detail of pl. 79). Page 6: Arthur E. Durham, **Photomicrograph of a fly,** ca.
1865 (detail of pl. 17). Page 7: Unknown photographer, **Comet,** ca. 1900
(detail of pl. 70).

Photography credits appear on page 215.

Printed and bound in Italy by Editoriale Bortolazzi Stei.

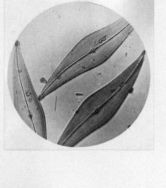

de Sapin

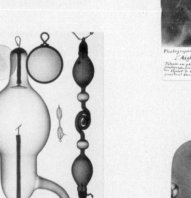

Photographie du Rêve
L'Aigle

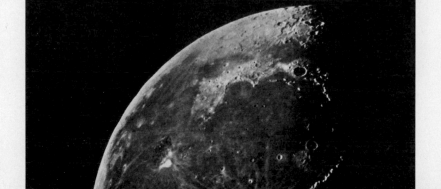

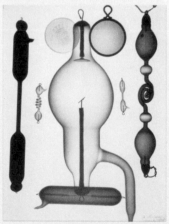

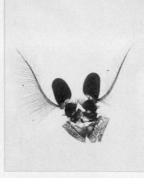
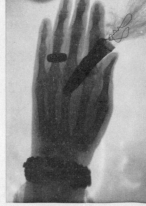